CROCHET
kaleidoscope

Shifting Shapes and Shades Across **100 MOTIFS**

Sandra Eng

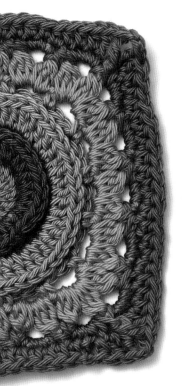
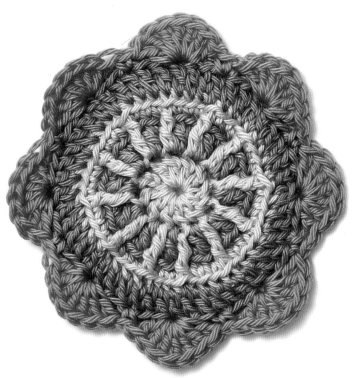
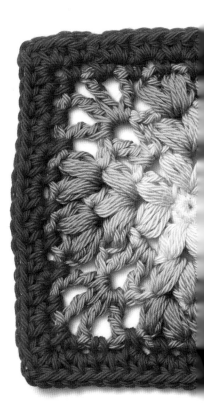

Interweave®

 Interweave®

An imprint of Penguin Random House LLC
penguinrandomhouse.com

ISBN 978-1-63250-613-9

Printed in Mexico
10 9 8 7 6 5

dedication
To the lights of my life,
Adeline and Bryson.

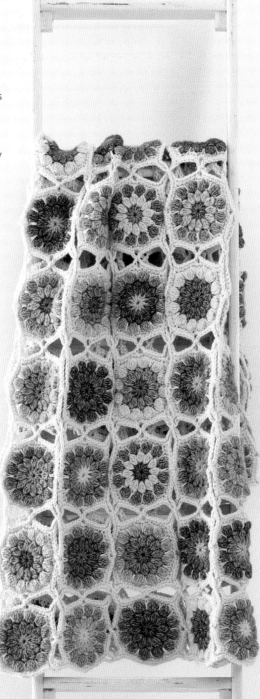

EDITORIAL DIRECTOR
Kerry Bogert

EDITOR
Maya Elson

TECHNICAL EDITOR
Karen Manthey

ART DIRECTOR
Ashlee Wadeson

COVER DESIGNER
Ashlee Wadeson

INTERIOR DESIGNER
Julia Boyles

ILLUSTRATOR
Karen Manthey

PHOTOGRAPHER
George Boe

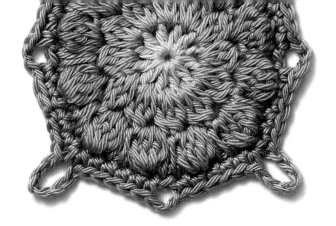

contents

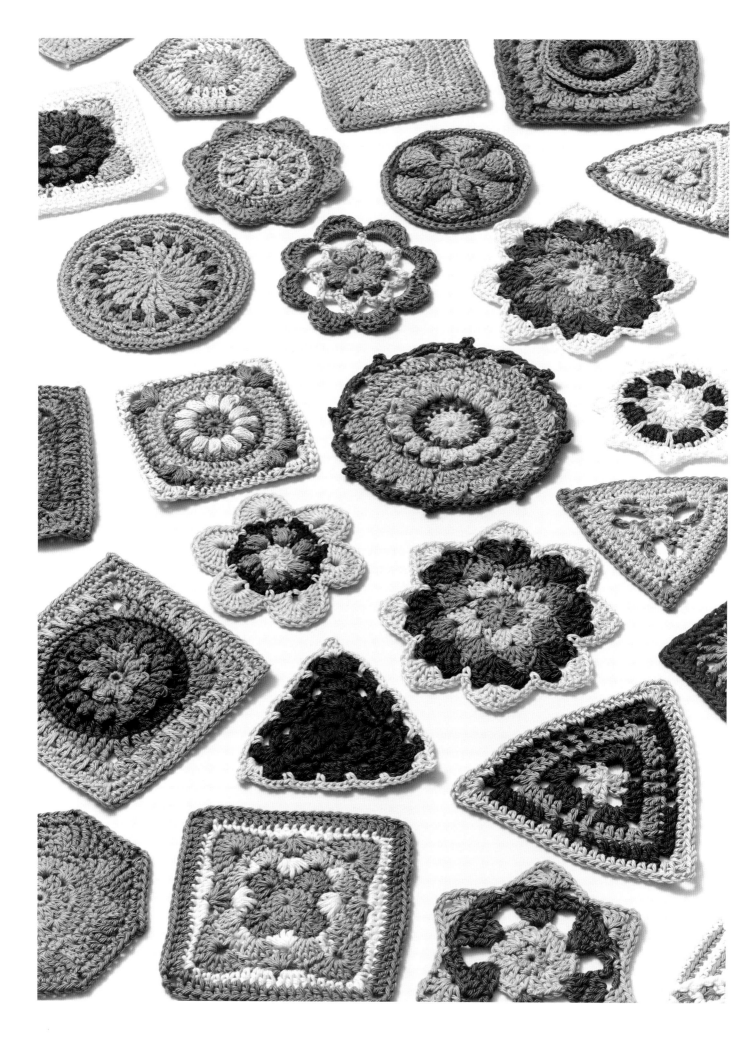

introduction

Crochet Kaleidoscope was born out of my love of crochet, color, and geometry. While most of you likely share my love of crochet and color, my fascination with geometry is perhaps somewhat more obscure. Nevertheless, I imagine that many of you also find delight in the ways you can combine crocheted shapes to create intricate and exquisite tapestries.

Motifs are the bread and butter of crochet. From the humble, ubiquitous granny square to more complex and detailed shapes, motifs comprise the building blocks of an endless array of crocheted projects. The versatility of working with individual motifs is unparalleled; from one shape, you can create a blanket, a shawl, a cushion, or a rug. The possibilities are limited only by your imagination (and perhaps the size of your yarn stash!).

When I set out to write this book, I wanted to create shapes that could highlight the ways in which different combinations of colors, whether across a single motif or an entire project, could shift the appearance of the motif or project. In the same way that a twist of a kaleidoscope shifts what you see through the eyepiece, changing up yarn colors, or the order in which you use them, can alter the look of a crocheted piece. *Crochet Kaleidoscope* offers not only a compendium of crochet motifs of varying shapes and sizes, but also a compilation of alternative ways of working with the colors in motifs to achieve a variety of effects.

As you peruse the motifs in this book, try to envision what each might look like when worked in a different color scheme, or if you alter the rounds on which you change colors. What appears as a flower in one palette may be transformed into a more abstract shape when worked in an alternate palette. Motifs comprised of a single color will contribute to a very different finished object than motifs worked in multiple colors. I offer a substitute palette and/or order of colors for many of the motifs in this book; you can use these alternates as a concrete guide, or as more of a suggestion for how to begin experimenting with your own color ideas. I also offer color choice guidelines in the first chapter to kick-start your own exploration process.

Take some risks, reach beyond your color comfort zone, and let your imagination run wild when it comes to considering how to apply your own unique color schemes to the motifs in this book. With every turn of the crochet kaleidoscope, you're sure to land upon new and exciting ideas to apply to individual motifs, and to projects as a whole.

Happy Hooking!

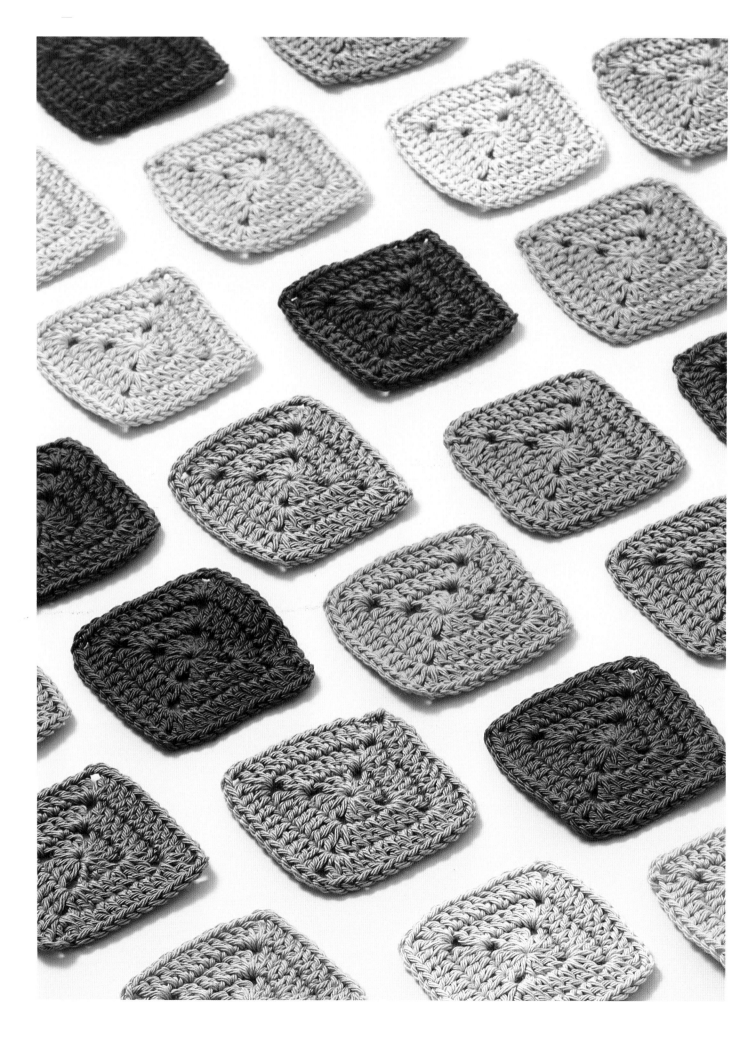

color me creative
A GUIDE TO CHOOSING COLORS IN CROCHET

Choosing yarn colors for a crochet project can become a project unto itself. We all know a good color combination when we see one, or at least which ones resonate with our personal taste, but how do we systematically go about choosing the "right" set of colors for a particular pattern? Absent guidance from the pattern writer, questions abound: How many colors should I choose? Pastel, bold, or neutral? In what sequence will the colors best complement each other? Which colors will best emphasize this pattern's attributes? And so on.

If you're like me and have no formal training in art or color, you might find yourself at a loss as to where to start. Over the years that I have been crocheting, my tastes in colors and my methods for choosing them have evolved. For example, the first blanket I crocheted included colors I liked individually, but that did not necessarily coordinate well together. Now I keep an eye out for ways in which colors complement or contrast with each other, and have worked to branch out beyond my color comfort zone. I have honed my eye for color though trial and error, feedback from others, and a whole lot of practice. I'll share some of the tips I've picked up over time in this chapter.

Favorite Colors

There is no "right" or "wrong" when it comes to selecting yarn colors. What looks good to you is most important. Everyone has a favorite color, or set of colors. What you are drawn to is what you are drawn to; there doesn't have to be a rhyme or reason to it. Looking around your living space and peering into your closet, you will likely see your favorite colors reflected in your choice of home décor and clothing. Using your favorite colors is a solid starting point for choosing project colors. With time, you may find yourself wanting to push beyond the familiar into less-charted color territory. In my experience, this is when things really start to get fun!

Color Theory 101

If we want to get more technical, we can turn to color theory for guidance. Open up any beginning art techniques book, and you're sure to come across a color wheel, onto which the entire spectrum of colors is mapped. Color theory, as related to the color wheel, can tell us about how colors mix and which groupings of colors appear more harmonious than others.

TERMINOLOGY

Before we delve into using the color wheel to guide color choice, let's review some relevant terminology. Hue refers to the position of a particular color on the color wheel; when we say "blue," or "red," or "yellow," what we are referring to is hue. Analogous colors are those that lie adjacent to each other on the color wheel. For example, red and orange are analogous to each other. By contrast, complementary colors are found directly across from each other on the color wheel. These include pairings such as red and green, or blue and orange. Finally, different variations of hues can be created by adding white or black to lighten or darken a particular color. You can create different tints by adding white to a color, and different shades by adding black. When it comes to yarn, "adding" white or black simply refers to choosing a lighter or darker variation of a color.

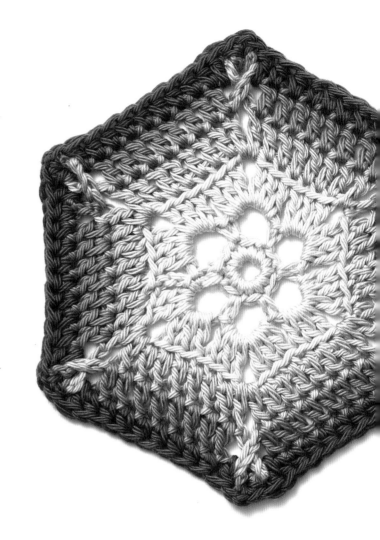

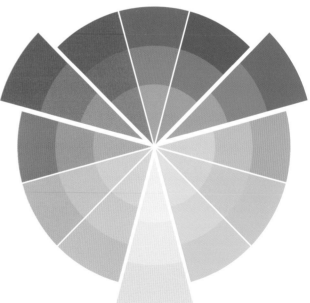

A color wheel can help you choose and group colors.

PAIRING COLORS

Color theorists assert that both complementary and analogous pairings of colors can contribute to aesthetically pleasing palettes. Depending on your taste, groupings of complementary colors might seem too bold of a contrast. In this case, a palette based on split complementary colors can lend to a more visually pleasing combination. Split complementary refers to pairing one hue with another hue that is analogous to the complementary color of the first hue. For example, combining blue with red-orange and/or yellow-orange, rather than with pure orange.

One rule of thumb on which I rely often in choosing colors for motifs is to start with a main color, add one or two different shades or tints of the same color (darker or lighter), one or two complementary **(PALETTE 1)** or split complementary **(PALETTE 2)** colors, and a neutral color, such as white, cream, grey, or tan.

Alternately, I also enjoy beginning with a main color, adding one or more of its analogous colors, and finishing with a neutral color. Because these palettes do not contain contrasting colors, they tend to feel "softer." **(PALETTES 3 AND 4)**

Finally, I am partial to working with palettes that rely on one main color and different shades or tints of that color, with the possible addition of one or more neutral colors. When arranged in order from light to dark (or vice versa), this kind of color grouping is often referred to as "ombré," and can create a soft gradient that many will find appealing. **(PALETTES 5 AND 6)**

CONTRAST PALETTES

Palette 1: *A complementary contrast palette plus a neutral is bold and feels harmonious.*

Palette 2: *A split complementary contrast palette plus a neutral is pleasing without being too bold.*

ANALOGOUS PALETTES

Palettes 3 & 4: *Main colors with analogus colors plus a neutral feel "softer."*

GRADIENT PALETTES

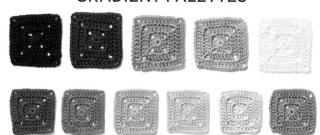

Palettes 5 & 6: *Main colors paired with different shades and tints of that color produces an appealing effect.*

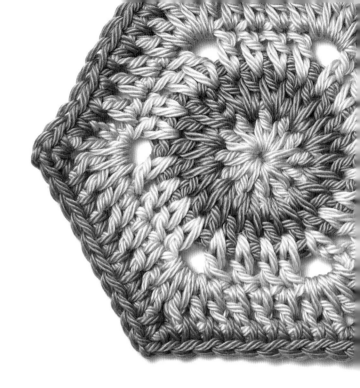

Color Picking Tools

There are numerous digital tools to use in assisting with the color choosing task. Some of my favorites include the Pantone and Adobe Capture CC apps, which allow you to upload or take a photograph that appeals to you in terms of its color composition, and to isolate some of the component colors. Color-centric websites, such as Design Seeds, also offer endless pre-made palettes, to which you can then match yarn colors. See the Resources section at the back of this book for more info on these tools.

Color Choice "Hacks"

Still feeling uncertain about how to artfully choose colors for your project? There are a number of what I like to call color choice "hacks" to help you out.

VARIEGATED YARN

You can start by picking up a skein of variegated yarn. Chances are the combination of colors in the skein complement each other in a pleasing way. You can do your best to find matching single colors of yarn. Don't be afraid to mix different yarn brands of the same fiber type and weight to achieve the color combination you're seeking.

INSPIRATION ALL AROUND

It's often said that imitation is the sincerest form of flattery. When it comes to color choice, I'm not shy about replicating others' tastes. I find inspiration not only in other crochet and knit designers' color choices, but in the world at large. I save images with color combinations I like on social media sites such as Instagram and Pinterest. I also snap photos of palettes found in shop displays, product designs, and nature. When you begin honing your eye for color, you will find that inspiration is present almost everywhere.

MIX BY HAND

If you're more of the hands-on type, there are also numerous ways to experiment with choosing colors for a project based on the yarn colors you have on hand. I mix and match solid granny square swatches made in a spectrum of my favorite yarns, such as the Cascade Ultra Pima Cotton used in the motif designs in this book, until I find a desirable palette. Other crocheters use yarn wrapped around clothespins or chipboard tags to compose the color deck they shuffle to compile combinations that speak to them.

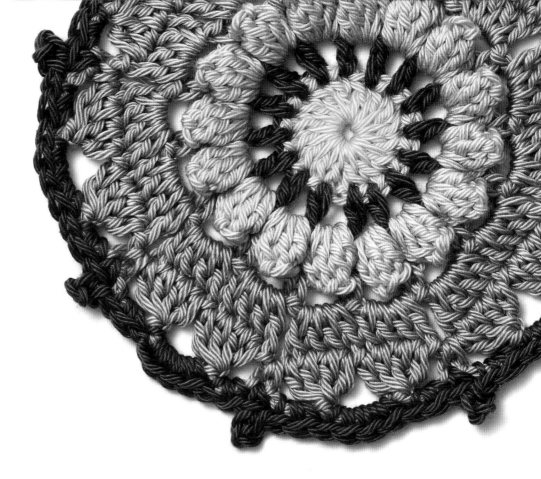

How Many Colors?

When it comes to color choice, is it true that less is more, or more is more? The answer depends somewhat on the attributes of the project you are working on. These include the size of the finished piece, the intricacy of the design, and the effect you're trying to achieve. Let me explain.

When working on a larger-scale piece, such as a blanket, made of individual motifs, incorporating fewer colors will lend to a more minimalist design, and call attention to the texture of the motifs. Using more colors draws your eye to the mix of hues, and often creates a bolder finished piece.

Small projects, such as cushion covers, can similarly be made with just a few or many colors. However, keep in mind that trying to use too many colors on a small project can become distracting and result in a somewhat "busy" look.

The ideal relationship between motif intricacy and the number of colors you choose similarly depends on what kind of result you would like. Working up motifs that are simpler in terms of their level of detail in a limited palette will result in cleaner lines, and less "noise." By contrast, using fewer colors in more complex motifs results in an emphasis on stitches and texture, rather than the interplay of colors on different rounds. If you instead want to focus on highlighting a broad palette of color choices, consider doing so with less detailed motifs for a stronger effect. I try to avoid using too many colors for more intricate motifs, because I can find the effect overwhelming. But depending on your taste, sometimes more really is more!

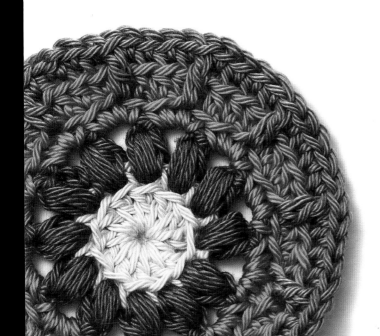

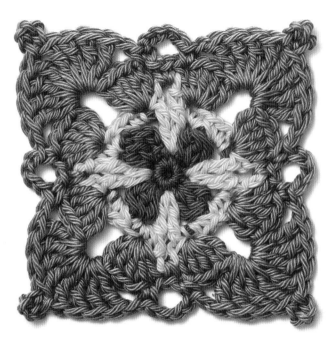
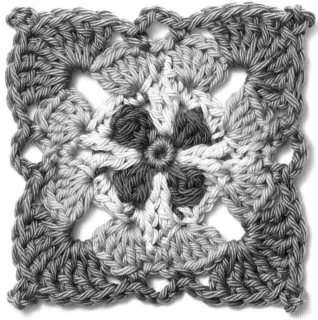

Color Order

You will see throughout this book that the relative amount of each color, and the order in which you use them within a particular motif, can significantly change the motif's appearance. You can experiment with making motifs in a single color, or in an entire rainbow of colors. Similarly, you can crochet adjacent rounds in the same color, or switch it up on every round, depending on which parts of the motif you would like to accentuate. You can use the color choice alternatives for motifs that I suggest in this book as a springboard for your own experimentation.

When choosing color order, it is important to keep in mind not only how to place colors within a single motif, but also how those colors will be distributed over the entire project. Perhaps you like the look of joined motifs that feature different colors throughout the project. Or perhaps bordering motifs in a uniform color, such that the center of the motif is highlighted when they are joined, appeals more. Several of the motifs in this book also rely on color placement to create a visual effect that

is only apparent once all of the motifs for the project are assembled. Photo collage apps can allow you to get a sense about what joined motifs will look like as a whole before you go to the trouble of making all of them. Take a closely cropped photo of an individual motif, and then input it into a collage app as many times as needed to create an approximation of what a larger piece will look like **(FIGURE 1)**.

Crochet in Color

Crochet offers the opportunity to express yourself not only through patterns and projects, but also through countless potential combinations of colors. Whether bold and bright, or soft and subdued, the palettes you choose are a unique reflection of you as a yarn artist. I hope that playing with color as you work up the motifs in this book provides you with as much joy as I experienced in designing them!

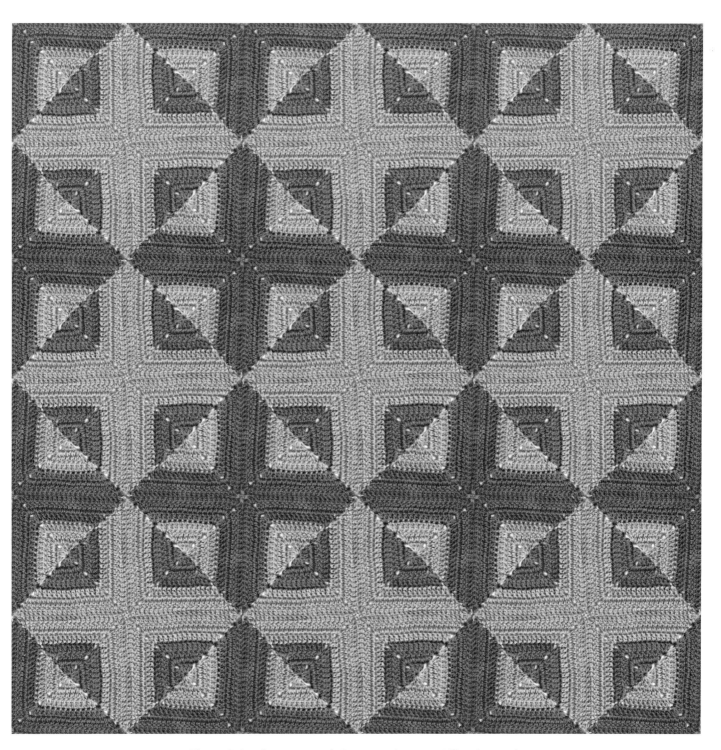

Figure 1: A collage app can help you see how a motif's colors and shape would work if many were put together in a larger piece.

THE MOTIFS:
circles

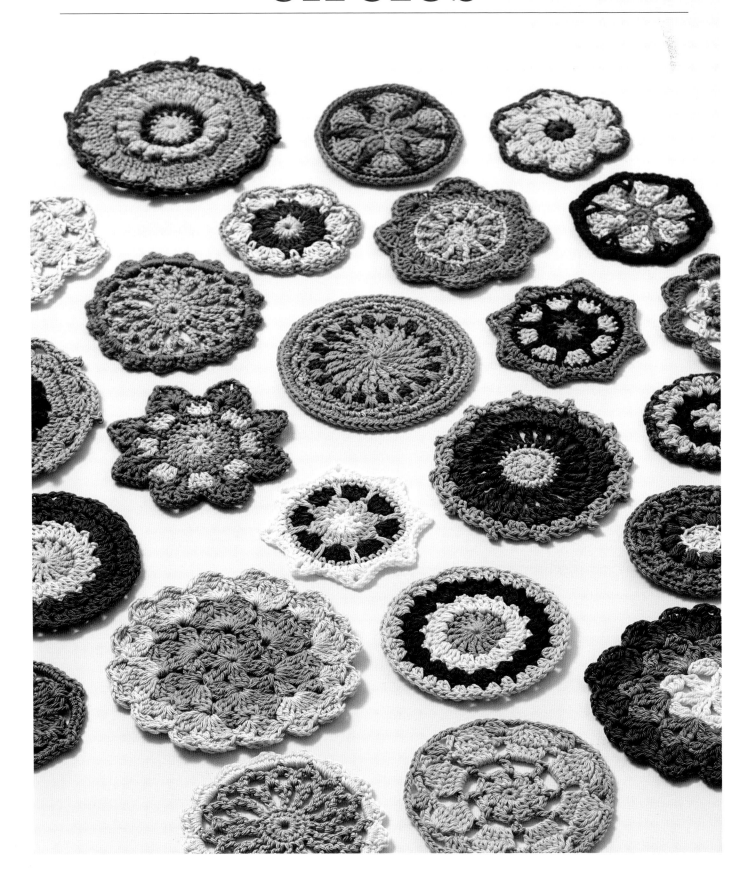

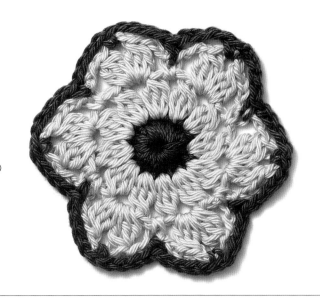

FINISHED SIZE
3½" (9 cm) in diameter before blocking.

HOOK
G-6 (4.0 mm).

GAUGE
First 3 rnds = 2¼" (5.5 cm) in diameter.

COLORS
(A) #3771 Paprika
(B) #3764 Sunshine
(C) #3793 Indigo Blue

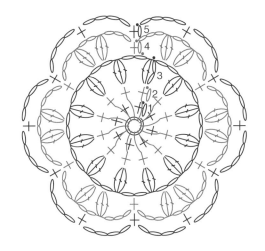

notes

- Ch 1 at the beg of rnds does not count as a st.
- Do not tighten the adjustable ring until after completing the second rnd.
- You can use the ch-4 sps on the final rnd to join these motifs as you go.
- You can change the look of this motif by changing colors on different rnds. Using the same color for Rnds 3 and 4 creates a more cohesive "flower" shape.

With A, make an adjustable ring.

Rnd 1: (RS) Ch 1, work 8 sc in ring, join with a sl st in first sc—8 sc.

Rnd 2: Ch 1, working over sts in Rnd 1, work 12 sp sc in ring, join with a sl st in first sc—12 sp sc. Fasten off A.

Rnd 3: With RS facing, join B with a sl st in any st, ch 2, 2-dc cluster in same st (counts as 3-dc cluster), ch 2, *3-dc cluster in next st, ch 2; rep from * around, join with a sl st in first cluster—12 3-dc clusters; 12 ch-2 sps.

Rnd 4: Sl st in first ch-2 sp, ch 1, *sc in ch-2 sp, ch 3, (3-dc cluster, ch 2, 3-dc cluster) in next ch-2 sp, ch 3; rep from * around, join with a sl st in first sc—6 sc; 12 ch-3 sps; 12 3-dc clusters; 6 ch-2 sps. Fasten off B.

Rnd 5: With RS facing, join C with a sl st in any sc, ch 1, *sc in sc, ch 4, sc in ch-2 sp, ch 4; rep from * around, join with a sl st in first sc—12 sc; 12 ch-4 sps. Fasten off C.

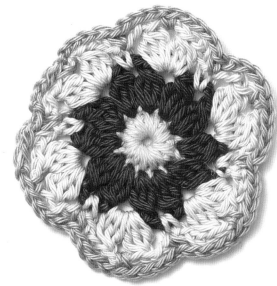

Alternate Colorway
(A) #3764 Sunshine (Rnds 1 and 2)
(B) #3793 Indigo Blue (Rnd 3)
(C) #3736 Ice (Rnd 4)
(D) #3759 Taupe (Rnd 5)

#2

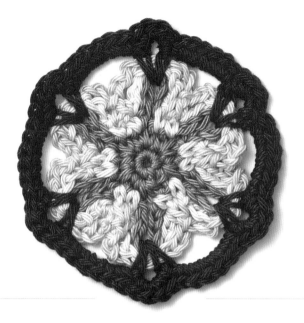

FINISHED SIZE
3½" (9 cm) in diameter
before blocking.

HOOK
G-6 (4.0 mm).

GAUGE
First 3 rnds = 2½"
(6.5 cm) in diameter.

COLORS
(A) #3729 Grey
(B) #3760 Celery
(C) #3746 Chartreuse
(D) #3704 Syrah

notes

- To make a standing spike sc, begin with a sl st on the hook and complete st as usual.
- Ch 1 at the beg of rnds does not count as a st.
- On this motif, using the same color for Rnds 2–4 creates a framed flower look, while changing colors on each of these rnds contributes to more of a stained glass look.

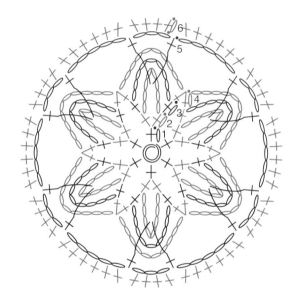

With A, make an adjustable ring.

Rnd 1: (RS) Ch 1, work 6 sc in ring, join with a sl st in first sc—6 sc.

Rnd 2: Ch 1, (sc, ch 8, sc) in each st around, join with a sl st in first sc—12 sc; 6 ch-8 sps. Fasten off A.

Rnd 3: With RS facing, join B with a sl st in same st as join, ch 1, sc in first sc, *ch 9, skip next ch-8 sp**, sc in each of next sc; rep from * around, ending last rep at **, sc in last sc, join with a sl st in first sc—12 sc; 6 ch-9 sps. Fasten off B.

Rnd 4: With RS facing, join C with a sl st in first st to the right of the join, ch 1, sc2tog over first 2 sts, ch 10, *sc2tog over next 2 sts, ch 10; rep from * around, join with a sl st in first sc2tog—6 sc2tog; 6 ch-10 sps. Fasten off C.

Rnd 5: With RS facing, join D with a standing sp sc around the center of the chains of Rnds 2, 3, and 4, ch 3, sp sc around same set of chains, *ch 5**, (sp sc, ch 3, sp sc) around the next set of chains in Rnds 2, 3, and 4, rep from * around, ending last rep at **, join with a sl st in first sp sc—12 sp sc; 6 ch-3 sp; 6 ch-5 sps.

Rnd 6: Sl st in next ch-3 sp, ch 1, *4 sc in ch-3 sp, 6 sc in next ch-5 sp; rep from * around, join with a sl st in first sc—60 sc. Fasten off D.

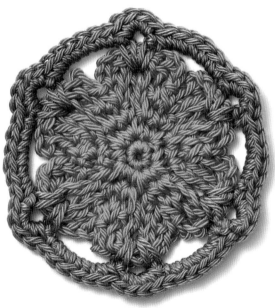

FINISHED SIZE
5½″ (14 cm) in diameter
before blocking.

HOOK
G-6 (4.0 mm).

GAUGE
First 3 rnds = 4″ (10 cm)
in diameter.

COLORS
(A)#3718 Natural
(B) #3805 Colony Blue
(C) #3725 Cobalt

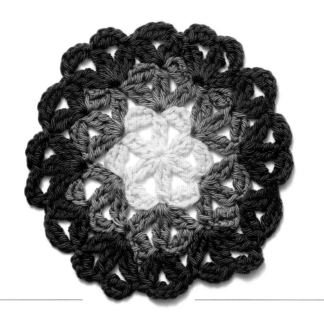

#3

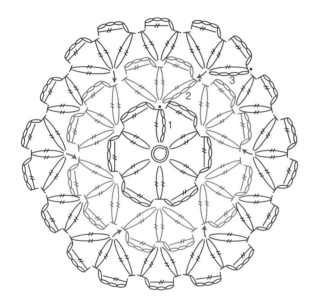

◀ *Alternate Colorway for Motif #2*
(A) #3750 Tangerine (Rnd 1)
(B) #3802 Honeysuckle (Rnds 2–4)
(C) #3729 Grey (Rnds 5 and 6)

notes
- The "back bump" referenced in this patt is the lp on the back (or bottom) of the ch st, distinct from the front and back lps of the ch.

With A, make an adjustable ring.

Rnd 1: (RS) Ch 4, tr (counts as 2-tr cluster here and throughout) in ring, ch 4, tr in "back bump" of 4th ch from hook, [2-tr cluster, ch 4, tr in "back bump" of 4th ch from hook] 5 times in ring, join with a sl st in first tr—6 2-tr clusters; 6 ch-4 sps; 6 tr. Fasten off A.

Rnd 2: With RS facing, join B with a sl st in any 2-tr cluster, (ch 4, tr, [ch 4, tr in "back bump" of 4th ch from hook, 2-tr cluster] twice) in same st, (2-tr cluster, [ch 4, tr in "back bump" of 4th ch from hook, 2-tr cluster] twice) in each 2-tr cluster around, join with a sl st in first tr—18 2-tr clusters; 12 ch-4 sps; 12 tr. Fasten off B.

Rnd 3: With RS facing, join C with a sl st in same st as join, (ch 4, tr, [ch 4, tr in "back bump" of 4th ch from hook, 2-tr cluster] twice) in same st, *sk next (ch 4, tr), (2-tr cluster, ch 4, tr in "back bump" of 4th ch from hook, 2-tr cluster) in next 2-tr cluster, sk next (ch 4, tr, 2-tr cluster)**, (2-tr cluster, [ch 4, tr in "back bump" of 4th ch from hook, 2-tr cluster] twice) in next 2-tr cluster; rep from * around, ending last rep at **, join with a sl st in first tr—30 2-tr clusters; 18 ch-4 sps; 18 tr. Fasten off C.

#4

FINISHED SIZE
4½″ (11.5 cm) in diameter
before blocking.

HOOK
G-6 (4.0 mm).

GAUGE
First 3 rnds = 3½″
(9 cm) in diameter.

COLORS
(A) #3764 Sunshine
(B) #3736 Ice
(C) #3805 Colony Blue

With A, make an adjustable ring.

Rnd 1: (RS) Ch 4 (counts as tr), work 15 tr in ring, join with a sl st in top of beg ch-4—16 tr. Fasten off A.

Rnd 2: With RS facing, join B with a sl st in any st, ch 2, 2-dc cluster in same st (counts as 3-dc cluster), ch 2, (3-dc cluster, ch 2) in each st around, join with a sl st in first 2-dc cluster—16 3-dc clusters; 16 ch-2 sps. Fasten off B.

Rnd 3: With RS facing, join C with a sl st in any 3-dc cluster, ch 2, dc in same st (counts as 2-dc cluster here and throughout), ch 2, 2-dc cluster in same st, (2-dc cluster, ch 2, 2-dc cluster) in each 3-dc cluster around, join with a sl st in first dc—32 2-dc clusters; 16 ch-2 sps.

Rnd 4: Ch 2, dc in same st (counts as 2-dc cluster), *2-dc cluster in next 2-dc cluster, ch 2**, 2-dc cluster in next 2-dc cluster; rep from * around, ending last rep at **, join with a sl st in first dc—32 2-dc clusters; 16 ch-2 sps. Fasten off C.

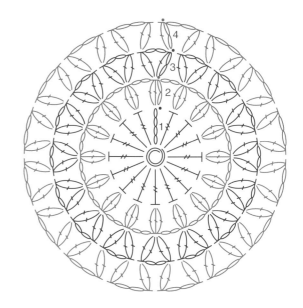

Alternate Colorway
(A) #3752 Coral (Rnd 1)
(B) #3718 Natural (Rnd 2)
(C) #3704 Syrah (Rnd 3)
(D) #3753 White Peach (Rnd 4)

FINISHED SIZE
3¼″ (8.5 cm) in diameter
before blocking.

HOOK
G-6 (4.0 mm).

GAUGE
First 3 rnds = 2″
(5 cm) in diameter.

COLORS
(A) #3764 Sunshine
(B) #3704 Syrah
(C) #3732 Aqua
(D) #3771 Paprika

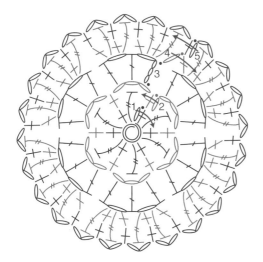

notes

- Ch 1 at the beg of rnds does not count as a st.
- Rnds in this motif with tr sts are considered to be facing the WS. After turning the motif to the RS, the tr sts are pushed to the front.

With A, make an adjustable ring.

Rnd 1: (WS) Ch 1, [sc, tr] 6 times in ring, join with a sl st in first sc, turn—6 sc; 6 tr. Fasten off A.

Rnd 2: (RS) With RS facing, join B with a sl st in any st, ch 1, sc in first sc, *ch 3, sk next tr**, sc in next sc; rep from * around, ending last rep at **, join with sl st in first sc—6 sc; 6 ch-3 sps.

Rnd 3: Sl st in next ch-3 sp, ch 4 (counts as dc, ch 1), (dc, ch 1, dc) in same sp, (dc, ch 1, dc, ch 1, dc) in each ch-3 sp around, join with sl st in 3rd ch of beg ch-4, turn—18 dc; 12 ch-1 sps. Fasten off B.

Rnd 4: (WS) With WS facing, join C with a sl st in any ch-1 sp, ch 1, (sc, tr, sc, tr) in each ch-1 sp around; join with a sl st in first sc, turn—24 sc; 24 tr. Fasten off C.

Rnd 5: (RS) With RS facing, join D with a sl st in any sc, ch 1, (sc, ch 2) in each sc around, join with a sl st in first sc—24 sc; 24 ch-2 sps. Fasten off D.

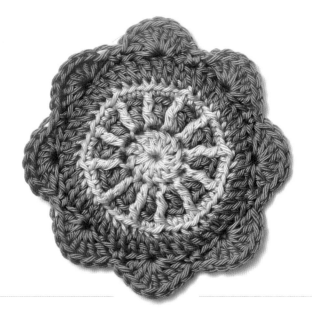

#6

FINISHED SIZE
4¼" (11 cm) in diameter
before blocking.

HOOK
G-6 (4.0 mm).

GAUGE
First 3 rnds = 2" (5 cm)
in diameter.

COLORS
(A) #3746 Chartreuse
(B) #3798 Suede
(C) #3726 Periwinkle
(D) #3767 Deep Coral

notes

- This motif is worked using some overlaid sts. Overlay crochet is worked as a series of rnds worked in the back lp, with additional sts "overlaid," or anchored in the front lp. When making overlaid sts, there are times when the st(s) in the row below (underneath the overlaid st) is skipped, and times when it is not. This is specified in the patt. Each rnd is closed with an "invisible join" (see Glossary), unless indicated otherwise.

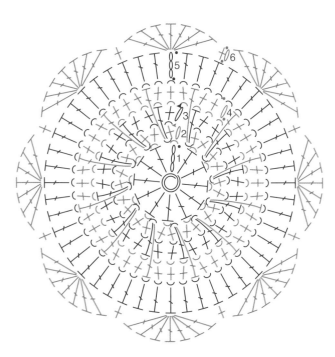

With A, make an adjustable ring.

Rnd 1: (RS) Ch 3 (counts as dc here and throughout), work 11 dc in ring; join with a sl st in top of beg ch-3— 12 dc. Fasten off A.

Rnd 2: Work this round in back lps only of sts. With RS facing, join B with a sl st in any st, ch 1 (counts as sc here and throughout), sc in same st, 2 sc in each st around, work invisible join in 2nd sc—24 sc. Fasten off B.

Rnd 3: Work this round in back lps only of sts, except as indicated otherwise. With RS facing, join C with a sl st in any ch-2 sp, ch 1, sc in next st, *dc in remaining front lp of next corresponding st in Rnd 1, do not sk a st in Rnd 3**, sc in each of next 2 sts; rep from * around, ending last rep at **, work invisible join in 2nd sc—24 sc; 12 dc. Fasten off C.

Rnd 4: Work this round in back lps only of sts, except as indicated otherwise. With RS facing, join A with a sl st in first sc of any 2-sc) group, ch 1 (counts as sc), sc in each of next 2 sts, *tr in front lp of next corresponding st in Rnd 1 (to the left of the dc from Rnd 3), do not sk a st in Rnd 4**, sc in each of next 3 sts; rep from * around, ending last rep at **, work invisible join in 2nd sc—36 sc; 12 tr. Fasten off A.

Rnd 5: Work this round in back lps only of sts. With RS facing, join B with a sl st in any st, ch 3, dc in each st around, join with a sl st in top of beg ch-3—48 dc. Fasten off B.

Rnd 6: With RS facing, join D with a sl st in any ch-2 sp, ch 1 (does not count as a st), sc in first st, *sk next 2sts, 7 dc in next st, sk next 2 sts**, sc in next st; rep from * around, ending last rep at **, join with a sl st in first sc—8 sc; 56 dc. Fasten off D.

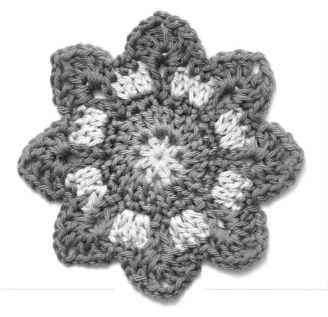

FINISHED SIZE

4¾" (12 cm) in diameter before blocking.

HOOK

G-6 (4.0 mm).

GAUGE

First 3 rnds = 3½" (9 cm) in diameter.

COLORS

(A) #3764 Sunshine
(B) #3772 Cornflower
(C) #3802 Honeysuckle
(D) #3760 Celery

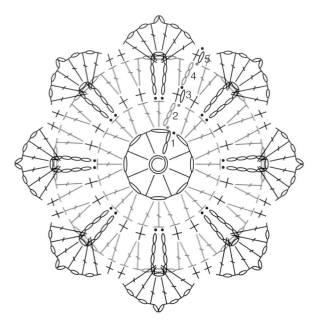

notes

- Ch 1 at the beg of rnds does not count as a st.
- Using the same color on Rnds 3 and 5 gives the appearance that they are connected.

With A, make an adjustable ring.

Rnd 1: (RS) Ch 3 (counts as hdc, ch 1), [hdc, ch 1] 7 times in ring, join with a sl st to 2nd ch of beg ch-3—8 hdc; 8 ch-1 sps. Fasten off A.

Rnd 2: With RS facing, join B with a sl st in any ch-1 sp, ch 3 (counts as dc here and throughout), 2 dc in same sp, 3 dc in each ch-1 sp around, join with a sl st in top of beg ch-3—24 dc. Fasten off B.

Rnd 3: With RS facing, join C with a sl st in the first dc of any 3-dc, ch 1, sc in first st, *(sl st, ch 9, sl st) in next st**, sc in each of next 2 sts; rep from * around, ending last rep at **, sc in next st, join with sl st in first sc—16 sc; 16 sl sts; 8 ch-9 sps. Fasten off C.

Rnd 4: With RS facing, join D with a sl st in same st as join, ch 3 (counts as dc), dc in same st, *ch 3, working behind ch-9 sp in Rnd 3**, 2 dc in each of next 2 sc; rep from * around, ending last rep at **, 2 dc in next sc, join with sl st in top of beg ch-3—32 dc; 8 ch-3 sps. Fasten off D.

Rnd 5: With RS facing, join C with a sl st in same st as join, ch 1, sc in first st, *sk next st, (dc, ch 1, dc, ch 1) around ch-9 sp of Rnd 3 and ch-3 sp of Rnd 4, (dc, ch 2, dc, ch 1) around ch-9 sp of Rnd 3 only, (dc, ch 1, dc) around ch-9 sp of Rnd 3 and ch-3 sp of Rnd 4, sk next st**, sc in each of next 2 sts; rep from * around, ending last rep at **, sc in next st, join with sl st in first sc—16 sc; 48 dc; 32 ch-1 sps; 8 ch-2 sps. Fasten off C.

#8

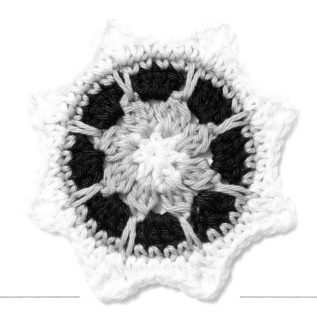

FINISHED SIZE
4" (10 cm) in diameter
before blocking.

HOOK
G-6 (4.0 mm).

GAUGE
First 3 rnds = 2½"
(6.5 cm) in diameter.

COLORS
(A) #3728 White
(B) #3775 Cool Mint
(C) #3703 Magenta

notes

- Ch 1 at the beg of rnd does not count as a st.
- Using the same color on Rnds 2 and 4 creates a more integrated look to the motif.

With A, make an adjustable ring.

Rnd 1: (RS) Ch 3 (counts as hdc, ch 1), [hdc, ch 1] 7 times in ring, join with a sl st in 2nd ch of beg ch-3—8 hdc; 8 ch-1 sps. Fasten off A.

Rnd 2: With RS facing, join B with a sl st in any ch-1 sp, ch 3, 2-dc cluster in same sp (counts as 3-dc cluster), ch 2, (3-dc cluster, ch 2) in each ch-1 sp around, join with a sl st to first 2-dc cluster—8 3-dc clusters; 8 ch-2 sps. Fasten off B.

Rnd 3: With RS facing, join C with a sl st in any ch-2 sp, ch 3 (counts as dc), 3 dc in same sp, 4 dc in each ch-2 sp around, join with a sl st in top of beg ch-3—32 dc. Fasten off C.

Rnd 4: With RS facing, join B with a sl st in same st as join, ch 1, sc in each of first 4 sts, *sp sc in next corresponding 3-dc cluster of Rnd 2, ch 1**, sc in each of next 4 sts; rep from * around, ending last rep at **, join with a sl st in first sc—32 sc; 8 sp sc; 8 ch-1 sps. Fasten off B.

Rnd 5: With RS facing, join A with a sl st in same st as join, ch 2 (counts as hdc), *sc in each of next 2 sts, hdc in next st, (dc, ch 2, dc) in next st, hdc in next ch-1 sp**, hdc in next st; rep from * around, ending last rep at **, join with a sl st in top of beg ch-2—16 dc; 24 hdc; 16 sc; 8 ch-2 sps. Fasten off A.

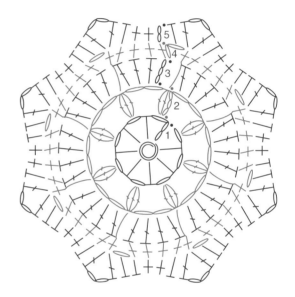

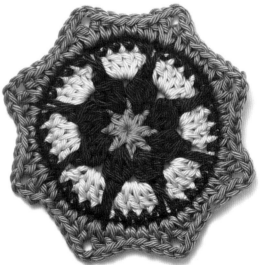

Alternate Colorway
(A) #3750 Tangerine (Rnd 1)
(B) #3704 Syrah (Rnds 2 and 4)
(C) #3764 Sunshine (Rnd 3)
(D) #3798 Suede (Rnd 5)

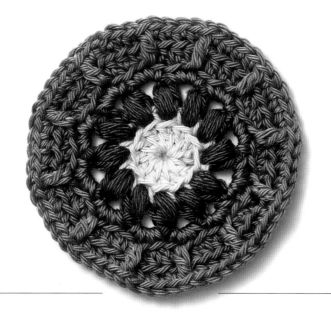

FINISHED SIZE
3½" (9 cm) in diameter before blocking.

HOOK
G-6 (4.0 mm).

GAUGE
First 3 rnds = 2¼" (5.5 cm) in diameter.

COLORS
(A) #3736 Ice
(B) #3792 Brick
(C) #3802 Honeysuckle
(D) #3729 Grey

notes

- Ch 1 at the beg of rnds does not count as a st.
- Working into the back lp on one rnd leaves open the front lp, into which sts of a subsequent rnd can be worked.
- This motif is worked using some overlaid sts. Overlay crochet is worked as a series of rnds worked in the back lp, with additional sts "overlaid," or anchored in the front lp. When making overlaid sts, there are times when the st(s) in the row below (underneath the overlaid st) is skipped, and times when it is not. This is specified in the patt. Each rnd is closed with an "invisible join" (see Glossary), unless indicated otherwise.

With A, make an adjustable ring.

Rnd 1: (RS) Ch 3 (counts as dc), work 11 dc in ring, join with a sl st in top of beg ch-3—12 dc. Fasten off A.

Rnd 2: Work this round in back lps only of sts. With RS facing, join B with a sl st in any st, beg puff st in first st, ch 2, (puff st, ch 2) in each st around, join with a sl st in beg puff st—12 puff sts; 12 ch-2 sps. Fasten off B.

Rnd 3: With RS facing, join C with a sl st in any ch-2 sp, ch 1, 3 sc in each ch-2 sp around, join with a sl st in first sc—36 sc.

Rnd 4: Work this round in back lps only of sts. Ch 2 (counts as hdc), *2 hdc in next st**, hdc in each of next 2 sts; rep from * around, ending last rep at **, hdc in last st, join with sl st in top of beg ch-2—48 hdc. Fasten off C.

Rnd 5: Work this round in back lps only of sts, except as indicated. With RS facing, join D with a sl st in same st as join, ch 1, sc in each of first 2 sts, *dc in front lp of next corresponding sc in Rnd 3 (center sc in a 3-sc group), sk no sts in Rnd 5**, sc in each of next 4 sts; rep from * around, ending last rep at **, sc in each of last 2 sts, join with sl st in first sc—48 sc; 12 dc. Fasten off D.

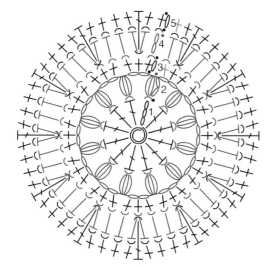

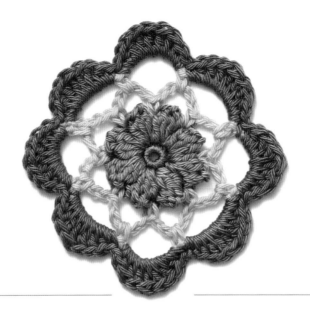

#10

FINISHED SIZE
4" (10 cm) in diameter before blocking.

HOOK
G-6 (4.0 mm).

GAUGE
First 3 rnds = 2½" (6.5 cm) in diameter.

COLORS
(A) #3778 Lavender
(B) #3760 Celery
(C) #3761 Juniper

notes

- Ch 1 at the beg of rnds does not count as a st.
- Rnd 3 is closed with (ch 2, dc), which counts as a ch-5 sp. This better positions the st for the next rnd.

With A, make an adjustable ring.

Rnd 1: (RS) Ch 1, work 8 sc in ring, join with a sl st in first sc—8 sc.

Rnd 2: Beg popcorn, ch 3, (popcorn, ch 3) in each st around, join with a sl st in beg popcorn—8 popcorns; 8 ch-3 sps. Fasten off A.

Rnd 3: With RS facing, join B with a sl st in any ch-3 sp, ch 1, sc in same sp, (ch 5, sc) in each ch-3 sp around, ch 2, join with dc in first sc instead of last ch-5 sp—8 sc; 8 ch-5 sps.

Rnd 4: Ch 1, (sc, ch 6) in each ch-5 sp around, join with a sl st in first sc—8 sc; 8 ch-6 sps. Fasten off B.

Rnd 5: With RS facing, join C with a sl st in any ch-6 sp, ch 1, (sc, hdc, 2 dc, tr, 2 dc, hdc, sc) in each ch-6 sp around, join with a sl st in first sc—16 sc; 16 hdc; 32 dc; 8 tr. Fasten off C.

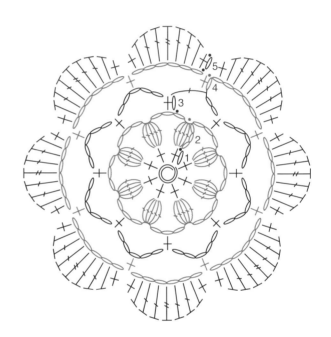

Alternate Colorway for Motif #11 ▶

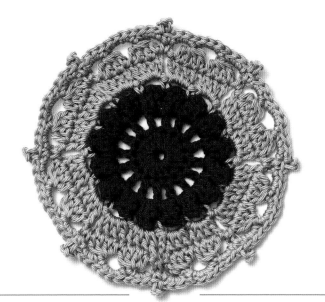

FINISHED SIZE
5½″ (14 cm) in diameter before blocking.

HOOK
G-6 (4.0 mm).

GAUGE
First 3 rnds = 3″ (7.5 cm) in diameter.

COLORS
(A) #3704 Syrah
(B) #3710 Orchid

#11

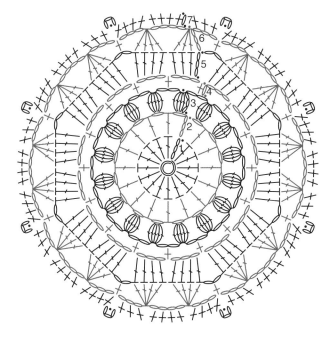

notes

- Ch 1 at the beg of rnds does not count as a st.

With A, make an adjustable ring.

Rnd 1: (RS) Ch 3 (counts as dc here and throughout), work 15 dc in ring, join with a sl st in top of beg ch-3—16 dc.

Rnd 2: Ch 4 (counts as dc, ch1). (dc, ch 1) in each st around, join with a sl st in top of beg ch-3—16 dc; 16 ch-1 sps.

Rnd 3: Sl st in next ch-1 sp, beg popcorn, ch 2, (popcorn, ch 2) in each ch-1 sp around, join with a sl st in beg popcorn—16 popcorns; 16 ch-2 sps. Fasten off A.

Rnd 4: With RS facing, join B with a sl st in any ch-2 sp, ch 1, (sc, ch 3) in each ch-2 sp around, join with a sl st in first sc—16 sc; 16 ch-3 sps.

Rnd 5: Sl st in next ch-3 sp, ch 3 (counts as dc), 3 dc in same sp, *4 dc in next ch-3 sp, ch 2**, 4 dc in next ch-3 sp; rep from * around, ending last rep at **, join with a sl st in top of beg ch-3—64 dc; 8 ch-2 sps.

Rnd 6: Ch 3, dc3tog over next 3 sts (counts as dc4tog), *ch 4, dc4tog over next 4 sts, ch 3, sc in next ch-2 sp, ch 3**, dc4tog over next 4 sts; rep from * around, ending last rep at **, join with a sl st in first dc3tog—16 dc4tog; 8 ch-4 sps; 16 ch-3 sps; 8 sc.

Rnd 7: Sl st in next ch-4 sp, ch 1, *4 sc in ch-4 sp, 3 sc in next ch-3 sp, (sc, picot) in next sc, 3 sc in next ch-3 sp; rep from * around, join with a sl st in first sc—88 sc; 8 picots. Fasten off B.

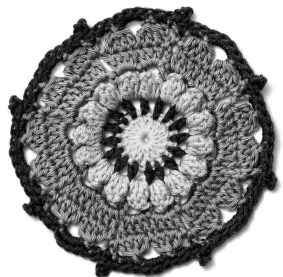

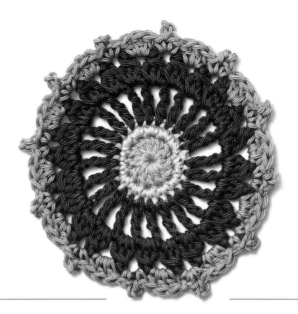

FINISHED SIZE

5″ (12.5 cm) in diameter before blocking.

HOOK

G-6 (4.0 mm).

GAUGE

First 3 rnds = 3″ (7.5 cm) in diameter.

COLORS

(A)3732 Aqua
(B) #3764 Sunshine
(C) #3701 Cranberry
(D) #3725 Cobalt
(E) #3738 Spearmint

notes

- Ch 1 at the beg of rnds does not count as a st.

With A, make an adjustable ring.

Rnd 1: (RS) Ch 3 (counts as dc), work 11 dc in ring, join with a sl st in top of beg ch-3—12 dc. Fasten off A.

Rnd 2: With RS facing, join B with a sl st in any st, ch 1, 2 sc in each st around, join with a sl st in first sc—24 sc. Fasten off B.

Rnd 3: With RS facing, join C with a sl st in any st, ch 6 (counts as tr, ch 2), (tr, ch 2) in each st around, join with a sl st in 4th ch of beg ch-6—24 tr; 24 ch-2 sps. Fasten off C.

Rnd 4: With RS facing, join D with a sl st in any ch-2 sp, ch 2, 2-dc cluster in same sp (counts as 3-dc cluster), ch 3, (3-dc cluster, ch 3) in each ch-2 sp around, join with sl st to first 2-dc cluster—24 3-dc clusters; 24 ch-3 sps. Fasten off D.

Rnd 5: With RS facing, join E with a sl st in any ch-3 sp, ch 1, *(sc, picot, sc) in ch-3 sp, 3 dc in next ch-3 sp; rep from * around, join with a sl st in first sc—24 sc; 12 picots; 36 dc. Fasten off E.

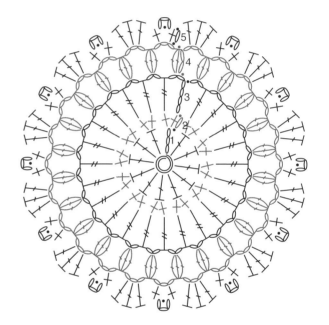

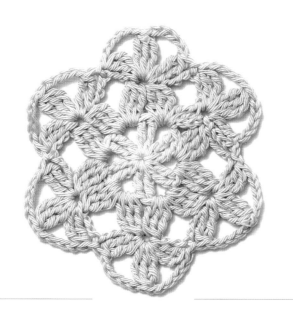

FINISHED SIZE
4½" (11.5 cm) in diameter before blocking.

HOOK
G-6 (4.0 mm).

GAUGE
First 3 rnds = 2¾" (7 cm) in diameter from picot to picot.

COLORS
(A) #3743 Yellow Rose
(B) #3736 Ice

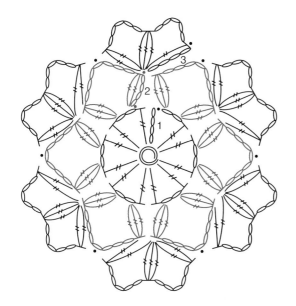

notes

- Using the same color for Rnds 2 and 3 creates the outer "flowers" on this motif.

With A, make an adjustable ring.

Rnd 1: (RS) Ch 4 (counts as tr), tr in ring, ch 2, [2 tr, ch 2] 5 times in ring, join with a sl st in top of beg ch-4—12 tr; 6 ch-2 sps. Fasten off A.

Rnd 2: With RS facing, join B with a sl st in any ch-2 sp, ch 4, 2-tr cluster in same sp (counts as 3-tr cluster), ch 7, 3-tr cluster in same sp, (3-tr cluster, ch 7, 3-tr cluster) in each ch-2 sp around, join with a sl st in first 2-tr cluster—12 3-tr clusters; 6 ch-7 sps.

Rnd 3: Ch 4, tr in same st (counts as tr2tog), (ch 5, 3-tr cluster, ch 5, 2-tr cluster) in same st, *sl st in center ch of next ch-7 sp**, tr2tog over next 2 3-tr clusters, ch 5, (3-tr cluster, ch 5, 2-tr cluster) in same st as last leg of tr2tog; rep from * around, ending last rep at **, join with a sl st in first tr—6 tr2tog; 6 2-tr clusters; 6 3-tr clusters; 12 ch-5 sps; 6 sl sts. Fasten off B.

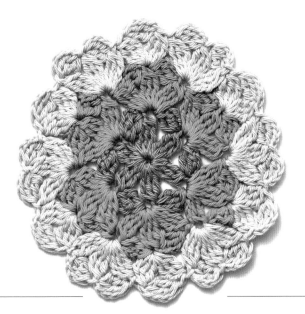

FINISHED SIZE
5½" (14 cm) in diameter
before blocking.

HOOK
G-6 (4.0 mm).

GAUGE
First 2 rnds = 4"
(10 cm) in diameter.

COLORS
(A) #3717 Sand
(B) #3752 Coral
(C) #3760 Celery

notes

- The "back bump" referenced in this patt is the lp on the back (or bottom) of the ch st, distinct from the front and back lps of the ch.
- Blocking this motif can create more definition between the "petals."

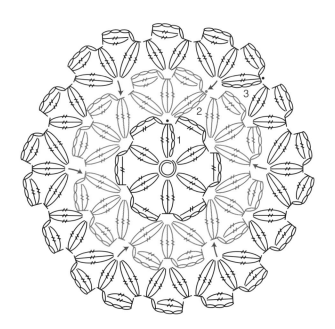

With A, make an adjustable ring.

Rnd 1: (RS) Ch 4, 2-tr cluster in ring (counts as 3-tr cluster here and throughout), ch 4, 2-tr cluster in "back bump" of 4th ch from hook, [3-tr cluster, ch 4, 2-tr cluster in "back bump" of 4th ch from hook] 5 times in ring, join with a sl st in first 2-tr cluster—6 3-tr clusters; 6 ch-4 sps; 6 2-tr clusters. Fasten off A.

Rnd 2: With RS facing, join B with a sl st in any 3-tr cluster, (ch 4, 2-tr cluster, [ch 4, 2-tr cluster in "back bump" of 4th ch from hook, 3-tr cluster] twice) in same st, (3-tr cluster, [ch 4, 2-tr cluster in "back bump" of 4th ch from hook, 3-tr cluster] twice) in each 3-tr cluster around, join with a sl st in first 2-tr cluster—18 3-tr clusters; 12 ch-4 sps; 12 2-tr clusters. Fasten off B.

Rnd 3: With RS facing, join C with a sl st in same st as join, (ch 4, 2-tr cluster, [ch 4, 2-tr cluster in "back bump" of 4th ch from hook, 3-tr cluster] twice) in same st, *sk next (ch 4, 2-tr cluster), (3-tr cluster, ch 4, 2-tr cluster in "back bump" of 4th ch from hook, 3-tr cluster) in next 3-tr cluster, sk next (ch 4, 2-tr cluster, 3-tr cluster)**, (3-tr cluster, [ch 4, 2-tr cluster in "back bump" of 4th ch from hook, 3-tr cluster] twice) in next 3-tr cluster; rep from * around, ending last rep at **, join with a sl st in first 2-tr cluster—30 3-tr clusters; 18 ch-4 sps; 18 2-tr clusters. Fasten off C.

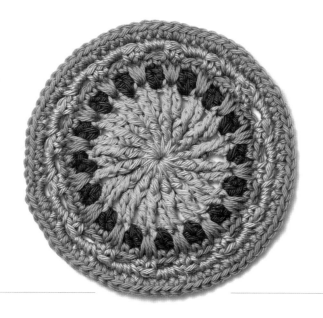

FINISHED SIZE
5" (12.5 cm) in diameter before blocking.

HOOK
G-6 (4.0 mm).

GAUGE
First 3 rnds = 3" (7.5 cm) in diameter.

COLORS
(A) #3798 Suede
(B) #3752 Coral
(C) #3793 Indigo Blue
(D) #3735 Jade

notes

• Ch 1 at the beg of rnds does not count as a st.

With A, make an adjustable ring.

Rnd 1: (RS) Ch 4 (counts as tr here and throughout), work 15 tr in ring, join with a sl st in top of beg ch-4—16 tr. Fasten off A.

Rnd 2: With RS facing, join B with a sl st in any st, ch 4, fptr around the post of same st, (tr, fptr) in each st around, join with a sl st in top of beg ch-4—16 tr; 16 fptr. Fasten off B.

Rnd 3: With RS facing, join C with a sl st in any tr, ch 3 (counts as dc), dc in same st, ch 1, sk next fptr, *2 dc in next tr, ch 1, sk next fptr; rep from * around, join with a sl st in top of beg ch-3—32 dc; 16 ch-1 sps. Fasten off C.

Rnd 4: With RS facing, join D with a sl st in same st as join, ch 1, sc in each of first 2 sts, *working over ch-1 sp, 2 sp sc in next corresponding st in Rnd 2; rep from * around, join with a sl st in first sc—32 sc; 32 sp sc. Fasten off D.

Rnd 5: With RS facing, join A with a sl st in the first of any 2 sp sc worked in the same st, ch 1, sc in each of first 2 sts, *ch 2, sk next 2 sts**, sc in each of next 2 sts; rep from * around, ending last rep at **, join with a sl st in first sc—32 sc; 16 ch-2 sps.

Rnd 6: Sl st to next ch-2 sp, ch 1, (3 sc, ch 2) in each ch-2 sp around, join with a sl st in first sc—48 sc; 16 ch-2 sps. Fasten off A.

Rnd 7: With RS facing, join D with a sl st in any ch-2 sp, ch 1, *2 sc in ch-2 sp, sc in each of next 3 sts; rep from * around, join with a sl st in first sc—80 sc. Fasten off D.

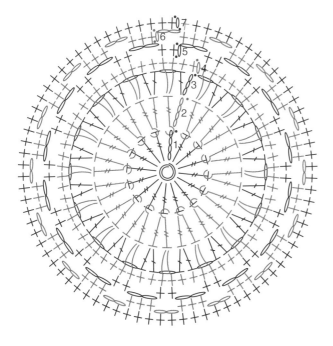

#16

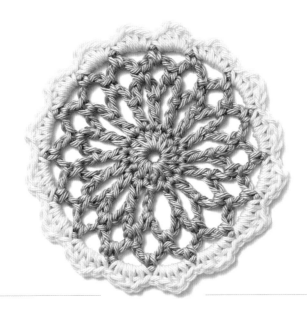

FINISHED SIZE
4½" (11.5 cm) in diameter
before blocking.

HOOK
G-6 (4.0 mm).

GAUGE
First 3 rnds = 3½"
(9 cm) in diameter.

COLORS
(A) #3727 Sky Blue
(B) #3718 Natural

notes

- Ch 1 at the beg of rnds does not count as a st.
- Rnd 2 is closed with (ch 2, dc), which counts as a ch-5 sp, and Rnd 3 is joined with (ch 1, dc), which counts as a ch-4 sp. This better positions the st for the beg of the next rnd.

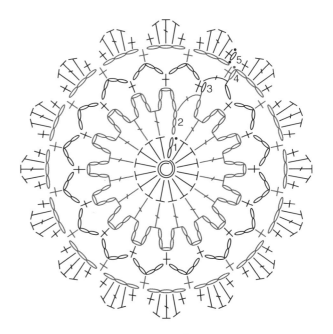

With A, make an adjustable ring.

Rnd 1: (RS) Ch 2 (counts as hdc), work 15 hdc in ring, join with a sl st top of beg ch-2—16 hdc.

Rnd 2: Ch 8 (counts as dc, ch 5), dc in next st. (Ch 5, dc) in each st around, ch 2, join with dc in 3rd ch of beg ch-8 instead of last ch-5 sp—16 dc; 16 ch-5 sps.

Rnd 3: Ch 1, sc in same sp, (ch 4, sc) in each ch-5 sp around, ch 1, join with dc in first sc instead of last ch-4 sp—16 sc; 16 ch-4 sps.

Rnd 4: Ch 1, sc in same sp, ch 3, (sc, ch 3) in each ch-4 sp around, join with a sl st in first sc—16 sc; 16 ch-3 sps. Fasten off A.

Rnd 5: With RS facing, join B with a sl st in any ch-3 sp, ch 1, (sc, hdc, dc, hdc, sc) in each ch-3 sp around, join with a sl st in first sc—32 sc; 32 hdc; 16 dc. Fasten off B.

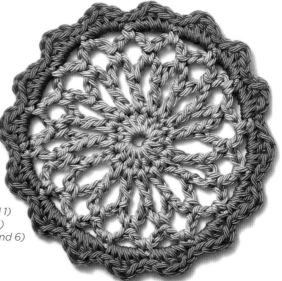

Alternate Colorway
(A) #3762 Spring Green (Rnd 1)
(B) #3710 Orchid (Rnds 2–4)
(C) #3767 Deep Coral (Rnds 5 and 6)

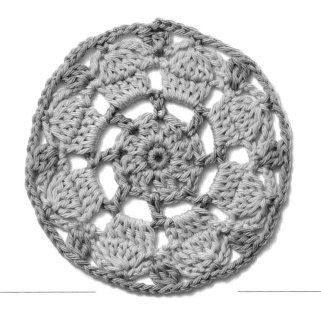

FINISHED SIZE
4½″ (11.5 cm) in diameter
before blocking.

HOOK
G-6 (4.0 mm).

GAUGE
First 3 rnds = 2¼″
(5.5 cm) in diameter.

COLORS
(A) #3738 Spearmint
(B) #3732 Aqua
(C) #3767 Deep Coral
(D) #3775 Cool Mint

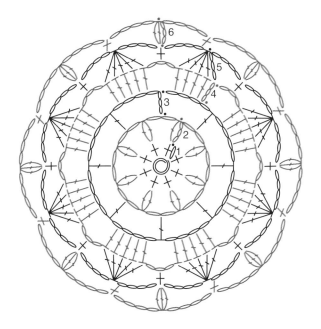

With A, make an adjustable ring.

Rnd 1: (RS) Ch 1, work 8 sc in ring, join with a sl st in first sc—8 sc. Fasten off A.

Rnd 2: With RS facing, join B with a sl st in any st, ch 3, dc in same st (counts as 2-dc cluster), ch 2, (2-dc cluster, ch 2) in each st around, join with a sl st in top of beg ch-3—8 2-dc clusters; 8 ch-2 sps. Fasten off B.

Rnd 3: With RS facing, join C with a sl st in any ch-2 sp, ch 7 (counts as dc, ch 4), (dc, ch 4) in each ch-2 sp around, join with a sl st in 3rd ch of beg ch-7—8 dc; 8ch-4 sps. Fasten off C.

Rnd 4: With RS facing, join D with a sl st in any ch-4 sp, ch 3 (counts as dc), 4 dc in same sp, ch 3, (5 dc, ch 3) in each ch-4 sp around, join with a sl st in top of beg ch-3—40 dc; 8 ch-3 sps.

Rnd 5: Ch 3, dc4tog over next 4 sts (counts as dc5tog), *ch 4, sc in next ch-3 sp, ch 4**, dc5tog over next 5 sts; rep from * around, ending last rep at **, join with a sl st in first dc4tog—8 dc5tog; 16 ch-4 sps; 8 sc. Fasten off D.

Rnd 6: With RS facing, join A with a sl st in any sc, ch 3, 2-dc cluster in same st (counts as 3-dc cluster), *ch 4, sk dc5tog, sc in first ch of next ch-4 sp, ch 4**, 3-dc cluster in next sc; rep from * around, ending last rep at **, join with a sl st in first 2-dc cluster—8 3-dc clusters; 16 ch-4 sps; 8 sc. Fasten off A.

THE MOTIFS: CIRCLES 31

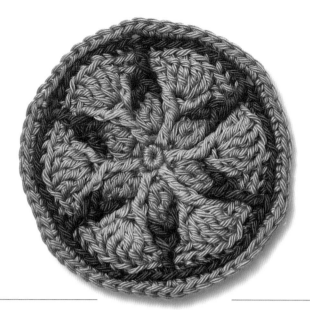

FINISHED SIZE

3¾" (9.5 cm) in diameter
before blocking.

HOOK

G-6 (4.0 mm).

GAUGE

First 4 rnds = 1½"
(3.8 cm) in diameter.

COLORS

(A) #3797 Dark Sea Foam
(B) #3776 Pink Rose
(C) #3798 Suede
(D) #3793 Indigo Blue

notes

- All rnds are worked in the blo except as indicated.
- Ch 1 at the beg of rnds counts as a st on some, but not all rnds, as written in the patt.
- You may need to push the tr2tog to the left to access the st of Rnd 4 to the right of the tr2tog.
- This motif is worked using some overlaid sts. Overlay crochet is worked as a series of rnds worked in the back lp, with additional sts "overlaid," or anchored in the front lp. When making overlaid sts, there are times when the st(s) in the row below (underneath the overlaid st) is skipped, and times when it is not. This is specified in the patt. Each rnd is closed with an "invisible join" (see Glossary), unless indicated otherwise.

With A, make an adjustable ring.

Rnd 1: (RS) Ch 1 (does not count as a st), work 6 sc in ring, join with a sl st in first sc—6 sc.

Rnd 2: Ch 1 (does not count as a st), 2 sc in each st around, join with a sl st in back lp of first sc—12 sc.

Rnd 3: Ch 1 (does not count as a st), 2 sc in same st, *sc in next st**, 2 sc in next st; rep from * around, ending last rep at **, join with a sl st in back lp of first sc—18 sc. Fasten off A.

Rnd 4: With RS facing, join B with a sl st in first st after join, ch 1 (counts as sc), *tr in front lp only of next corresponding st in Rnd 1**, sc in each of next 3 sts; rep from * around, ending last rep at **, work invisible join to first tr—6 tr; 18 sc. Fasten off B.

Rnd 5: With RS facing, join C with a sl st in any tr, ch 1 (counts as sc), sc in next st, *2-tr cluster in front lp of next corresponding st of Rnd 2**, sc in each of next 4 sts; rep from * around, ending last rep at **, sc in each of last 2 sts, work invisible join in 2nd sc—6 2-tr clusters; 24 sc. Fasten off C.

Rnd 6: With RS facing, join D with a sl st in any tr2tog, ch 1 (counts as sc), *dc2tog in front lps of 2 sts of Rnd 4 on either side of the 2-tr cluster of Rnd 5 (see Notes)**, sc in each of the next 5 sts; rep from * around, ending last rep at **, sc in each of last 4 sts, work invisible join in first dc2tog—6 dc2tog; 30 sc. Fasten off D.

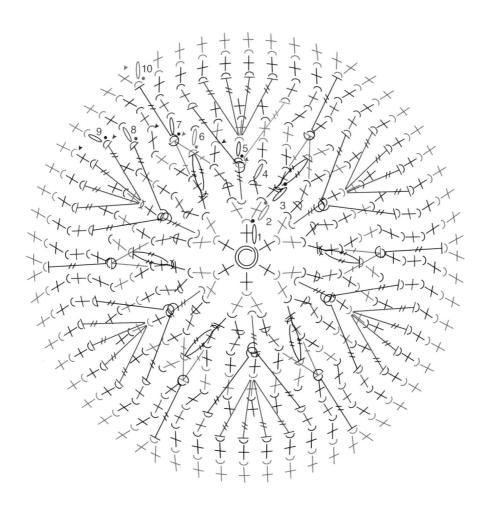

Rnd 7: With RS facing, join B with a sl st in any dc2tog, ch 1 (counts as sc), sc in next st, *fptr around the post of next corresponding tr in Rnd 4, sc in each of next 3 sts, fptr around same tr of Rnd 4, sk next st**, sc in next 2 sts; rep from * around, ending last rep at **, work invisible join in 2nd sc—12 fptr; 30 sc. Fasten off B.

Rnd 8: With RS facing, join A with a sl st in fptr to the left of the join, ch 1 (counts as sc), *4 tr in front lp of next corresponding st in Rnd 5 that lies between the 2 fptr of Rnd 7, sk next 3 sts**, sc in each of next 4 sts; rep from * around, ending last rep at **, sc in each of last 3 sts, work invisible join in 2nd sc—24 tr; 24 sc. Fasten off A.

Rnd 9: With RS facing, join D with a sl st in same st as join, ch 1 (counts as sc), *sc in each of next 5 sts, fptr around the post of next corresponding dc2tog in Rnd 6**, sc in each of next 3 sts; rep from * around, ending last rep at **, sc in each of last 2 sts, work invisible join in 2nd sc—6 fptr; 48 sc. Fasten off D.

Rnd 10: With RS facing, join C with a sl st in any fptr, ch 1 (counts as sc), sc in same st, *sc in each of next 8 sts**, 2 sc in next st; rep from * around, ending last rep at **, work invisible join in 2nd sc—60 sc. Fasten off C.

#19

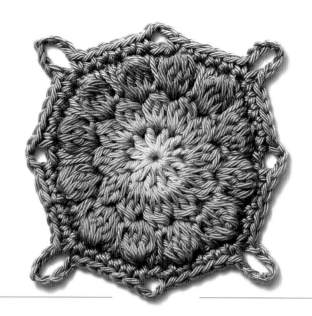

FINISHED SIZE
3½" (9 cm) in diameter
before blocking.

HOOK
G-6 (4.0 mm).

GAUGE
First 3 rnds = 2¾"
(7 cm) in diameter.

COLORS
(A)#3764 Sunshine
(B) #3710 Orchid
(C) #3779 Pansy
(D) #3759 Taupe

notes

- Ch 1 at the beg of rnds does not count as a st.
- This motif is designed to be joined as you go. When ready to join, use ch-3 sps to join adjacent sides, and ch-6 sps to join on the diagonal.
- Use colors similar in shade to create an ombré-effect flower in the center of the motif, or use contrasting colors to more clearly highlight the clusters of stitches on Rnd 3.

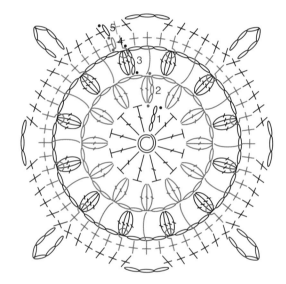

With A, make an adjustable ring.

Rnd 1: (RS) Ch 3 (counts as dc), work 11 dc in ring, join with a sl st in top of beg ch-3—12 dc. Fasten off A.

Rnd 2: With RS facing, join B with a sl st between any 2 sts, ch 3, 2-dc cluster in same sp (counts as 3-dc cluster), ch 2, *3-dc cluster between next 2 sts, ch 2; rep from * around, join with a sl st in first 2-dc cluster—12 3-dc clusters; 12 ch-2 sps. Fasten off B.

Rnd 3: With RS facing, join C with a sl st in any ch-2 sp, ch 3, 3-dc cluster in same sp (counts as 4-dc cluster), ch 3, (4-dc cluster, ch 3) in each ch-2 sp around, join with a sl st in first 3-dc cluster—12 4-dc clusters; 12 ch-3 sps. Fasten off C.

Rnd 4: With RS facing, join D with a sl st in any ch-3 sp, ch 1, *(sc, working over ch-3 sp, sp sc in next corresponding 3-dc cluster in Rnd 2, sc) in next ch-3 sp, fpsc around the post of next 4-dc cluster; rep from * around, join with a sl st in first sc—24 sc; 12 sp sc; 12 fpsc.

Rnd 5: Ch 1, sc in same st, sc in each of next 2 sts, *(sc, ch 6, sc) in next st, sc in each of next 5 sts, ch 3, sk next st**, sc in each of next 5 sts; rep from * around, ending last rep at **, sc in each of last 2 sts, join with sl st in first sc—48 sc; 4 ch-6 sps; 4 ch-3 sps. Fasten off D.

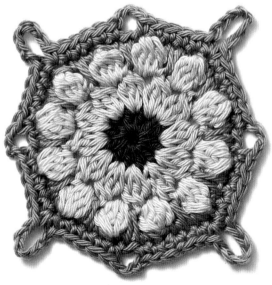

Alternate Colorway
(A) #3701 Cranberry
(B) #3746 Chartreuse
(C) #3753 White Peach
(D) #3797 Dark Sea Foam

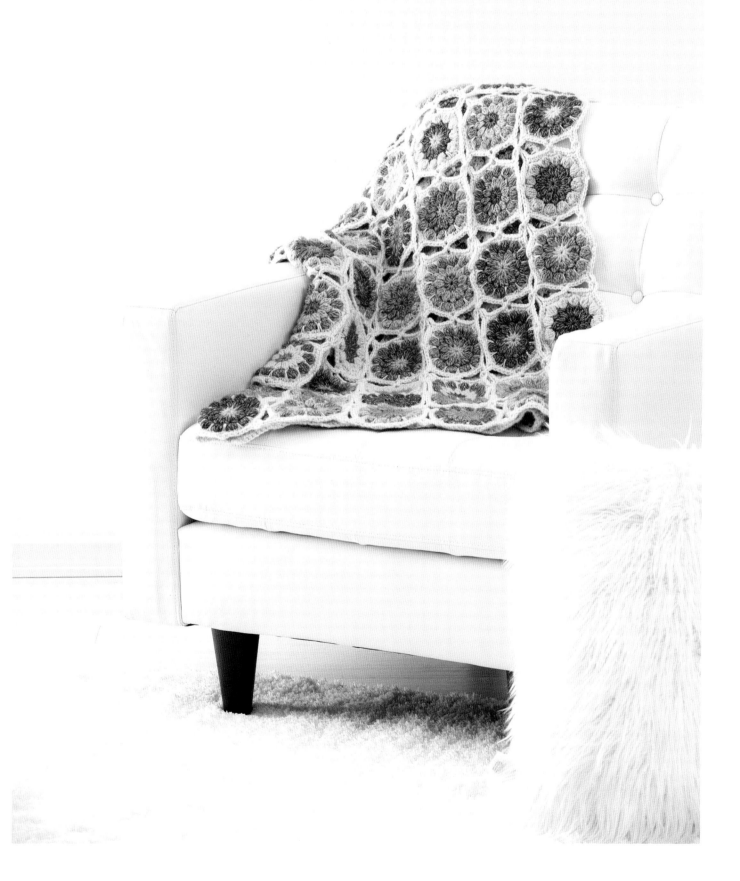

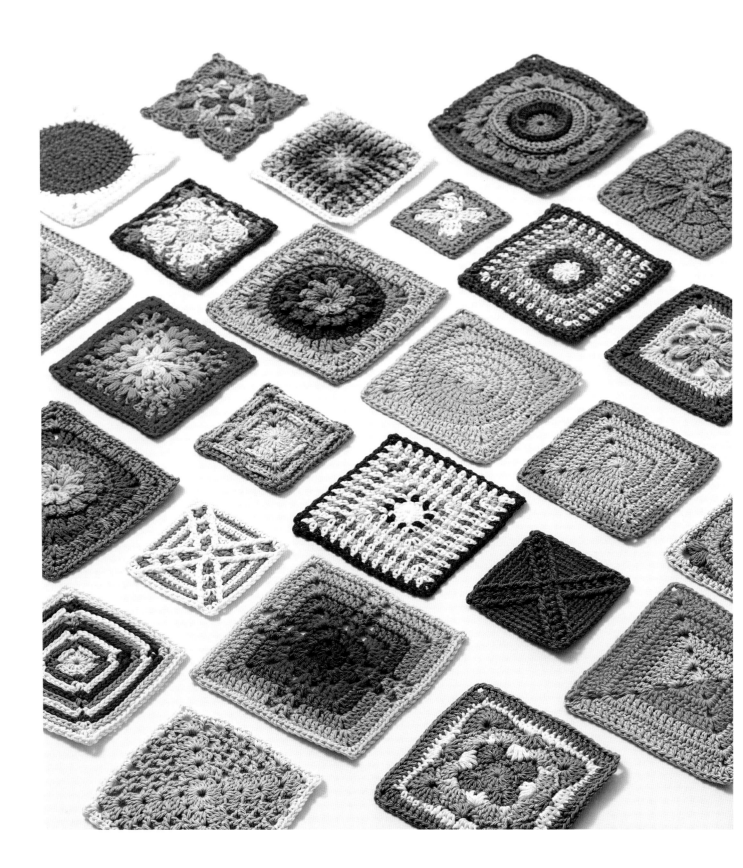

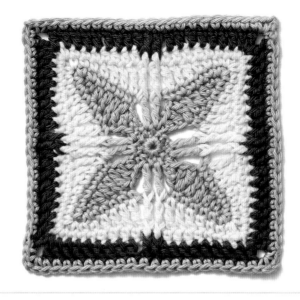

FINISHED SIZE
5″ (12.5 cm) across
before blocking.

HOOK
G-6 (4.0 mm).

GAUGE
First 3 rnds = 4½″
(11.5 cm) across.

COLORS
(A) #3747 Gold
(B) #3775 Cool Mint
(C) #3718 Natural
(D) #3793 Indigo Blue

notes

- Ch 1 at the beg of rnds does not count as a st.
- When working into ch sts, it helps to work into the back "bump" of the st to leave open the front and back lps of the ch for the next rnd.
- Blocking will help this square to lie flat.

With A, make an adjustable ring.

Rnd 1: (RS) Ch 1, work 8 sc in ring, join with a sl st in first sc—8 sc.

Rnd 2: *Ch 10, sl st in 2nd ch from hook, sc in next ch, hdc in next ch, dc in each of next 2 ch, tr in next ch, dc in next ch, hdc in next ch, sc in next ch, sl st in each of next 2 sts in Rnd 1; rep from * around, join with sl st in same st as the join for Rnd 1—4 ch-10 foundation chains; 12 sl sts; 8 sc; 8 hdc; 12 dc; 4 tr. Fasten off A.

Rnd 3: With RS facing, join B with a sl st in the sl st to the left of any "petal," ch 4 (counts as tr), tr in next st, *working into the opposite side of the chain from Rnd 2, sk next 3 ch sts, sc in each of the next 5 ch sts, (sc, ch 2, sc) in tip of petal, sc in each of next 5 sts, sk next 3 sts on petal**, tr in each of next 2 sl sts; rep from * around, ending last rep at **, join with a sl st in top of beg ch-4—8 tr; 48 sc; 4 ch-2 sps. Fasten off B.

Rnd 4: With RS facing, join C with a sl st in any ch-2 sp, ch 1, *(sc, ch 2, sc) in ch-2 sp, sc in each of next 2 sts, hdc in next st, dc in each of next 2 sts, tr in next st, fptr around the post of each of next 2 tr, tr in next st, dc in each of next 2 sts, hdc in next st, sc in each of next 2 sts; rep from * around, join with a sl st in first sc—24 sc; 8 hdc; 16 dc; 8 tr; 8 fptr; 4 ch-2 sps.

Rnd 5: Sl st in next ch-2 sp, ch 1, *(sc, ch 2, sc) in ch-2 sp, sc in each of next 3 sts, hdc in each of next 4 sts, fpdc around the post of each of next 2 fptr, hdc in each of next 4 sts, sc in each of next 3 sts; rep from * around, join with a sl st in first sc—32 sc; 32 hdc; 8 fpdc; 4 ch-2 sps. Fasten off C.

Rnd 6: With RS facing, join D with a sl st in any ch-2 sp, ch 5 (counts as dc, ch 2), dc in same sp, *dc in each of next 8 sts, fpdc around the post of each of next 2 fpdc, dc in each of next 8 sts**, (dc, ch 2, dc) in ch-2 sp; rep from * around, ending last rep at **, join with a sl st in 3rd ch of beg ch-5—72 dc; 8 fpdc; 4 ch-2 sps. Fasten off D.

Rnd 7: With RS facing, join A with a sl st in any ch-2 sp, ch 1, *(sc, ch 2, sc) in ch-2 sp, sc in each of next 20 sts; rep from * around, join with sl st in first sc—88 sc; 4 ch-2 sps. Fasten off A.

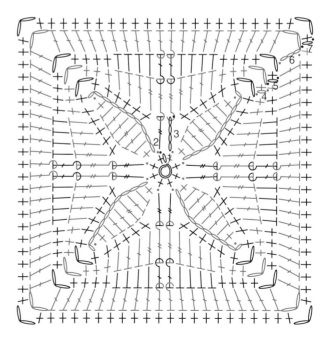

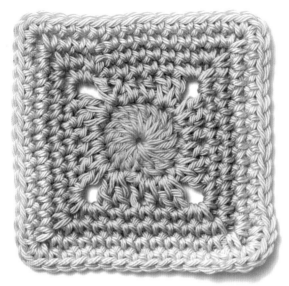

#21

FINISHED SIZE
3½" (9 cm) across
before blocking.

HOOK
G-6 (4.0 mm).

GAUGE
First 3 rnds = 2"
(5 cm) across.

COLORS
(A) #3732 Aqua
(B) #3807 Jasmine Green
(C) #3764 Sunshine

notes

- Ch 1 at the beg of rnds does not count as a st.
- Play around with changing colors on different rnds to create stripes of varying widths.

With A, make an adjustable ring.

Rnd 1: (RS) Ch 3 (counts as dc), work 15 dc in ring, join with a sl st in top of beg ch 3—16 dc. Fasten off A.

Rnd 2: With RS facing, join B with a sl st in any st, ch 3 (counts as dc), dc in same st, *ch 2, 2 dc in next st, hdc in each of next 2 sts**, 2 dc in next st; rep from * around, ending last rep at **, join with sl st top of beg ch-3—16 dc; 8 hdc; 4 ch-2 sps.

Rnd 3: Sl st to next ch-2 sp, ch 1, *(2 sc, ch 2, 2 sc) in ch-2 sp, sk next st, sc in each of next 5 sts; rep from * around, join with a sl st in first sc—36 sc; 4 ch-2 sps.

Rnd 4: Ch 1, sc in each of first 2 sts, *(sc, ch 2, sc) in next ch-2 sp**, sc in each of next 9 sts; rep from * around, ending last rep at **, sc in each of last 7 sts, join with sl st in first sc—44 sc; 4 ch-2 sps. Fasten off B.

Rnd 5: With RS facing, join C with a sl st in any ch-2 sp, ch 1, *(sc, ch 2, sc) in ch-2 sp, sc in each of next 11 sts; rep from * around, join with a sl st in first sc—52 sc; 4 ch-2 sps.

Rnd 6: Ch 1, sc in same st, *3 sc in next ch-2 sp**, sc in each of next 13 sts; rep from * around, ending last rep at **, sc in each of last 12 sts, join with sl st in first sc—64 sc. Fasten off C.

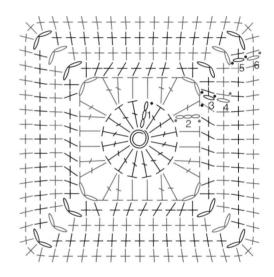

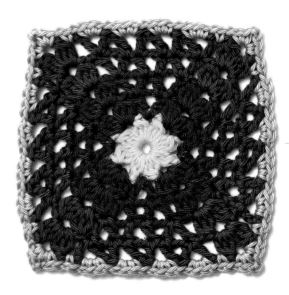

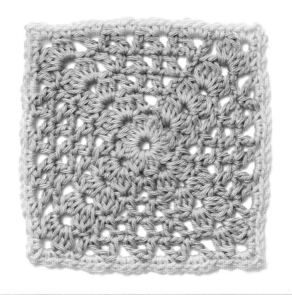

FINISHED SIZE
5" (12.5 cm) across before blocking.

HOOK
G-6 (4.0 mm).

GAUGE
First 3 rnds = 3" (7.5 cm) across.

COLORS
(A) #3807 Jasmine Green
(B) #3718 Natural

notes

- Working this motif in one main and one contrasting color allows the "X" pattern in the square to stand out, while using a number of different colors calls more attention to the color pattern rather than the stitch pattern.

With A, make an adjustable ring.

Rnd 1: (RS) Ch 2, 2-dc cluster in ring (counts as 3-dc cluster), ch 2, (3-dc cluster, ch 2) 7 times in ring, join with a sl st in first 2-dc cluster—8 3-dc clusters; 8 ch-2 sps.

Rnd 2: Sl st in next ch-2 sp, ch 5 (counts as dc, ch 2 here and throughout), dc in same sp, *(3-dc cluster, ch 2, 3-dc cluster) in next ch-2 sp**, (dc, ch 2, dc) in next ch-2 sp; rep from * around, ending last rep at **, join with a sl st in 3rd ch of beg ch-5—8 dc; 8 ch-2 sps; 8 3-dc clusters.

Rnd 3: Ch 5, dc in same st, *(dc, ch 2, dc) in next dc, (3-dc cluster, ch 2, 3-dc cluster) in next ch-2 sp**, (dc, ch 2, dc) in next dc; rep from * around, ending last rep at **, join with a sl st in 3rd ch of beg ch-5—16 dc; 12 ch-2 sps; 8 3-dc clusters.

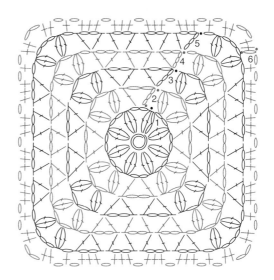

Rnd 4: Ch 5, dc in same st. *dc in next dc, ch 2, dc in next dc, (dc, ch 2, dc) in next dc, ch 1, (3-dc cluster, ch 3, 3-dc cluster) in next ch-2 sp, ch 1**, (dc, ch 2, dc) in next dc; rep from * around, ending last rep at **, join with a sl st in 3rd ch of beg ch-5—24 dc; 12 ch-2 sps; 4 ch-3 sps; 8 ch-1 sps; 8 3-dc clusters.

Rnd 5: Ch 5, dc in same st, *dc in next dc, ch 2, dc in each of next 2 dc, ch 2, dc in next dc, (dc, ch 2, dc) in next dc, ch 1, (3-dc cluster, ch 3, 3-dc cluster) in next ch-2 sp, ch 1**, (dc, ch 2, dc) in next dc; rep from * around, ending last rep at **, join with a sl st in 3rd ch of beg ch-5—32 dc; 16 ch-2 sps; 4 ch-3 sps; 8 ch-1 sps; 8 3-dc clusters. Fasten off A.

Rnd 6: With RS facing, join B with a sl st in any ch-3 sp, ch 1, *(2 sc, ch 2, 2 sc) in ch-3 sp, ch 1, sc in next ch-1 sp, ch 1, (3 sc, ch 1) in each of next 4 ch-2 sps, sc in next ch-1 sp, ch 1; rep from * around, join with sl st in first sc—72 sc; 4 ch-2 sps; 28 ch-1 sps. Fasten off B.

#23

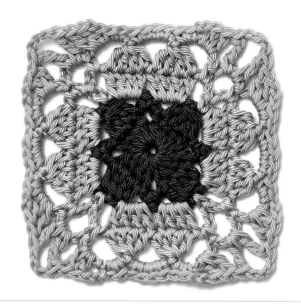

FINISHED SIZE
4¼" (11 cm) across
before blocking.

HOOK
G-6 (4.0 mm).

GAUGE
First 3 rnds = 2¾"
(7 cm) across.

COLORS
(A) #3779 Pansy
(B) #3710 Orchid
(C) #3747 Gold

notes

- Ch 1 at the beg of rnds does not count as a st.

With A, make an adjustable ring.

Rnd 1: (RS) Ch 3 (counts as dc), 3 dc in ring, ch 3, (4 dc, ch 3) 3 times in ring, join with a sl st in top of beg ch-3—16 dc, 4 ch-3 sps.

Rnd 2: Ch 3, dc3tog over next 3 sts (counts as dc4tog), *ch 3, sc in next ch-3 sp, ch 3**, dc4tog over next 4 sts: rep from * around, ending last rep at **, join with a sl st in first dc3tog—4 dc4tog; 8 ch-3 sps; 4 sc. Fasten off A.

Rnd 3: With RS facing, join B with a sl st in any dc4tog, ch 1, sc in first st, *ch 3, 4 dc in each of next 2 ch-3 sps, ch 3**, sc in next dc3tog; rep from * around, ending last rep at **, join with a sl st in first sc—4 sc; 8 ch-3 sps; 32 dc.

Rnd 4: Sl st in next ch-3 sp, ch 1, *sc in ch-3 sp, ch 5, dc4tog over next 4 sts, ch 4, dc4tog over next 4 sts, ch 5, sc in next ch-3 sp, ch 4; rep from * around, join with sl st in first sc—8 sc; 8 ch-5 sps; 8 ch-4 sps; 8 dc4tog. Fasten off B.

Rnd 5: With RS facing, join C with a sl st in ch-4 sp between any 2 dc4tog, ch 1, *4 sc in ch-4 sp, (2 sc, ch 2, 2 dc) in next ch-5 sp, (tr, ch 3, tr) in next ch-4 sp, (2 dc, ch 2, 2 sc) in next ch-5 sp; rep from * around, join with sl st in first sc—32 sc; 8 ch-2 sps; 16 dc; 8 tr; 4 ch-3 sps. Fasten off C.

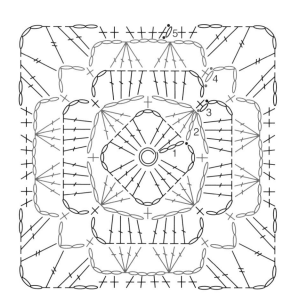

Alternate Colorway for Motif #24 ▶
(A) #3703 Magenta (Rnd 1)
(B) #3747 Gold (Rnd 2)
(C) #3718 Natural (Rnds 3–5)

FINISHED SIZE
3¼" (8.5 cm) across before blocking.

HOOK
G-6 (4.0 mm).

GAUGE
First 3 rnds = 2¼" (5.5 cm) across.

COLORS
(A) #3792 Brick
(B) #3752 Coral
(C) #3747 Gold
(D) #3764 Sunshine
(E) #3743 Yellow Rose

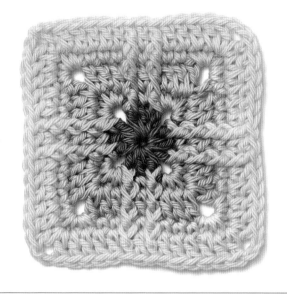

#24

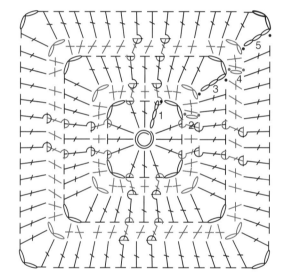

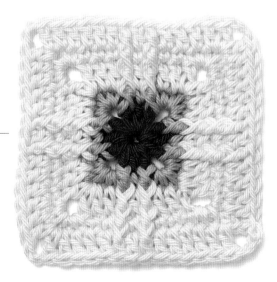

notes

- Ch 1 at the beg of rnds does not count as a st.

With A, make an adjustable ring.

Rnd 1: (RS) Ch 3 (counts as dc), 2 dc in ring, ch 2, (3 dc, ch 2) 3 times in ring, join with a sl st in top of beg ch-3—12 dc; 4 ch-2 sps. Fasten off A.

Rnd 2: With RS facing, join B with a sl st in any ch-2 sp, ch 1, *(2 sc, ch 2, 2 sc) in ch-2 sp, fpdc around the post of next dc, sc in next dc, fpdc around the post of next dc; rep from * around, join with a sl st in first sc—20 sc; 4 ch-2 sps; 8 fpdc. Fasten off B.

Rnd 3: With RS facing, join C with a sl st in any ch-2 sp, ch 5 (counts as dc, ch 2 here and throughout), dc in same sp, *dc in each of next 2 sts, fpdc around the post of next fpdc, dc in next st, fpdc around the post of next fpdc, dc in each of next 2 sts**, (dc, ch 2, dc) in next ch-2 sp; rep from * around, ending last rep at **, join with a sl st in 3rd ch of beg ch-5—28 dc; 4 ch-2 sps; 8 fpdc. Fasten off C.

Rnd 4: With RS facing, join D with a sl st in any ch-2 sp, ch 1, *(2 sc, ch 2, 2 sc) in ch-2 sp, sk next st, sc in each of next 2 sts, fpdc around the post of next fpdc, sc in next st, fpdc around the post of next fpdc, sc in each of next 3 sts; rep from * around, join with sl st in first sc—40 sc; 4 ch-2 sps; 8 fpdc. Fasten off D.

Rnd 5: With RS facing, join E with a sl st in any ch-2 sp, ch 5, dc in same sp, *dc in each of next 4 sts, fpdc around the post of next fpdc, dc in next st, fpdc around the post of next fpdc, dc in each of next 5 sts**, (dc, ch 2, dc) in next ch-2 sp; rep from * around, ending last rep at **, join with a sl st in 3rd ch of beg ch-5—48 dc; 4 ch-2 sps; 8 fpdc. Fasten off E.

#25

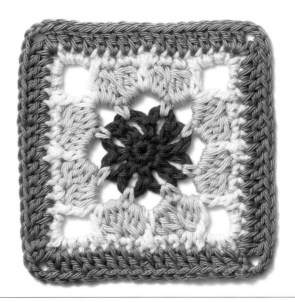

FINISHED SIZE
4" (10 cm) across
before blocking.

HOOK
G-6 (4.0 mm).

GAUGE
First 3 rnds = 2¼"
(5.5 cm) across.

COLORS
(A) #3755 Lipstick Red
(B) #3711 China Pink
(C) #3718 Natural
(D) #3733 Turquoise

notes

- Ch 1 at the beg of rnds does not count as a st.
- Ch 1, dc at the end of Rnd 3 counts as a ch-4 sp.

With A, make an adjustable ring.

Rnd 1: (RS) Ch 1, work 8 sc in ring, join with a sl st in first sc—8 sc.

Rnd 2: Ch 1, (sc, ch 3) in each st around, join with a sl st in first sc—8 sc; 8 ch-3 sps. Fasten off A.

Rnd 3: With RS facing, join B with a sl st in any ch-3 sp, ch 1, sc in same sp, (ch 4, sc) in each ch-3 sp around, ch 1, dc in first sc instead of last ch-4 sp—8 sc; 8 ch-4 sps.

Rnd 4: Ch 2, 2-dc cluster in ch-4 sp (counts as 3-dc cluster), *(3-dc cluster, ch 7, 3-dc cluster) in next ch-4 sp, (3-dc cluster, ch 2**, 3-dc cluster) in next ch-4 sp; rep from * around, ending last rep at **, join with a sl st in first 2-dc cluster—16 3-dc cluster, 4 ch-7 sps; 4 ch-2 sps. Fasten off B.

Rnd 5: With RS facing, join C with a sl st in any ch-7 sp, ch 1, *(3 sc, ch 2, 3 sc) in ch-7 sp, working over ch-7 sp, tr in next ch-4 sp of Rnd 3 between 2 3-dc cluster of Rnd 4, sc in each of next 2 3-dc clusters, sc in next ch-2 sp, working over ch-2 sp, tr in next ch-4 sp of Rnd 3 between 2 3-dc clusters of Rnd 4, sc in same ch-2 sp in Rnd 3, sc in each of next 2 3-dc clusters, tr in next ch-4 sp of Rnd 3 between 2 3-dc clusters of Rnd 4; rep from * around, join with a sl st in first sc—48 sc; 12 tr; 4 ch-2 sps. Fasten off C.

Rnd 6: With RS facing, join D with a sl st in any ch-2 sp, ch 5 (counts as dc, ch 2), dc in same sp, *dc in each of next 15 sts**, (dc, ch 2, dc) in next ch-2 sp; rep from * around, ending last rep at **, join with sl st in 3rd ch of beg ch-5—68 dc; 4 ch-2 sps. Fasten off D.

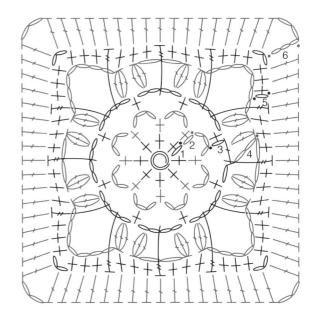

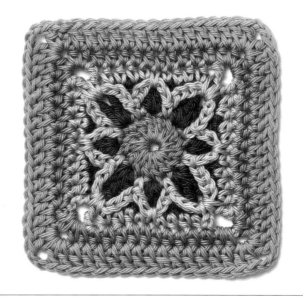

FINISHED SIZE
4¼" (11 cm) across
before blocking.

HOOK
G-6 (4.0 mm).

GAUGE
First 3 rnds = 2½"
(6.5 cm) across.

COLORS
(A)#3797 Dark Sea
(B) #3808 Light Grey
(C) #3793 Indigo Blue
(D) #3738 Spearmint

notes

- Ch sts worked in front of a rnd of a contrasting color create a textured flower in the center of this motif.

With A, make an adjustable ring.

Rnd 1: (RS) Ch 3 (counts as dc here and throughout), work 15 dc in ring, join with a sl st in top of beg ch-3—16 dc. Fasten off A.

Rnd 2: With RS facing, join B with a sl st in any st, ch 1, sc in first st, *ch 8, sk next st, sc in next st, ch 5, sk next st**, sc in next st; rep from * around, ending last rep at **, join with a sl st in first sc—8 sc; 4 ch-8 sps; 4 ch-5 sps. Fasten off B.

Rnd 3: With RS facing, with lps of Rnd 2 held in front, join C with a sl st in a skipped st of Rnd 1 that lies centered under any ch-8 sp, ch 4 (counts as tr), (tr, ch 2, 2 tr) in same st, *(2 dc, ch 1, 2 dc) in next skipped st of Rnd 1**, (2 tr, ch 2, 2 tr) in next skipped st of Rnd 1; rep from * around, ending last rep at **, join with a sl st in top of beg ch-4—16 tr, 4 ch-2 sp, 16 dc, 4 ch-1 sps. Fasten off C.

Rnd 4: With RS facing, working over ch-8 sp in Rnd 2, join B with a sl st in any ch-2 sp, ch 6 (counts as tr, ch 2), tr in same sp, *hdc in each of next 3 sts, sc in next st, working over ch-5 sp in Rnd 2, sc in next ch-1 sp, sc in next st, hdc in each of next 3 sts**, working over ch-8 sp in Rnd 2, (tr, ch 2, tr) in next ch-2 sp; rep from * around, ending last rep at **, join with sl st in 4th ch of beg ch-6—8 tr; 4 ch-2 sps; 24 hdc; 12 sc. Fasten off B.

Rnd 5: With RS facing, join A with a sl st in any ch-2 sp, ch 2 (counts as hdc), (hdc, ch 2, 2 hdc) in same sp, *sk next tr, hdc in each of next 10 sts**, (2 hdc, ch 2, 2 hdc) in next ch-2 sp; rep from * around, ending last rep at **, join with a sl st in top of beg ch-4—56 hdc; 4 ch-2 sps. Fasten off A.

Rnd 6: With RS facing, join D with a sl st in any ch-2 sp, ch 3, (dc, ch 2, 2 dc) in same sp, *sk next st, dc in each of next 13 sts**, (2 dc, ch 2, 2 dc) in next ch-2 sp; rep from * around, ending last rep at **, join with a sl st in top of beg ch-3—68 dc; 4 ch-2 sps. Fasten off D.

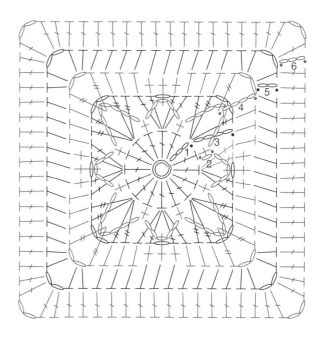

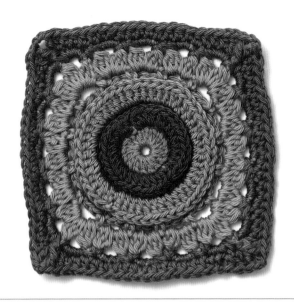

FINISHED SIZE
5¼" (13.5 cm) across
before blocking.

HOOK
G-6 (4.0 mm).

GAUGE
First 3 rnds = 2"
(5 cm) across.

COLORS
(A) #3798 Suede
(B) #3779 Pansy
(C) #3778 Lavender
(D) #3738 Jade
(E) #3774 Major Teal

#27

notes

- Working into first the front, and then the back lps on adjacent rnds creates a three-dimensional texture on this motif.

With A, make an adjustable ring.

Rnd 1: (RS) Ch 3 (counts as dc here and throughout), work 15 dc in ring, join with a sl st in top of beg ch-3—16 dc. Fasten off A.

Rnd 2: With RS facing, working in front lps of sts, join B with a sl st in any st, ch 2 (counts as hdc), hdc in same st, 2 hdc in each st around, join with a sl st in top of beg ch-2—32 hdc. Fasten off B.

Rnd 3: With RS facing, working in back lps of sts in Rnd 1, rejoin B with a sl st in any st in Rnd 1, ch 3, dc in same st, 2 dc in each st around, join with a sl st in top of beg ch-3—32 dc. Fasten off B.

Rnd 4: With RS facing, working in front lps of sts, join C with a sl st in any st, ch 3, dc in same st, *dc in next st**, 2 dc in next st; rep from * around, ending last rep at **, join with a sl st in top of beg ch-3—48 dc. Fasten off C.

Rnd 5: With RS facing, working in back lps of sts in Rnd 3, rejoin C with a sl st in any st in Rnd 3, ch 3, dc in same st, *dc in next st**, 2 dc in next st; rep from * around, ending last rep at **, join with a sl st in top of beg ch-3—48 dc. Fasten off C.

Rnd 6: With RS facing, join D with a sl st in any st, ch 1, sc in first st, *ch 3, sk next 2 sts**, sc in next st; rep from * around, ending last rep at **, join with a sl st in first sc—16 sc; 16 ch-3 sps.

Rnd 7: Sl st in next ch-3 sp, ch 2, 2-dc cluster (counts as 3-dc cluster), [ch 3, 3-dc cluster] twice in same sp, *(3-dc cluster, ch 3, 3-dc cluster) in each of next 3 ch-3 sps**, ([3-dc cluster, ch 3] twice, 3-dc cluster) in next ch-3 sp; rep from * around, ending last rep at **, join with a sl st in first 2-dc cluster—36 3-dc clusters, 20 ch-3 sps. Fasten off D.

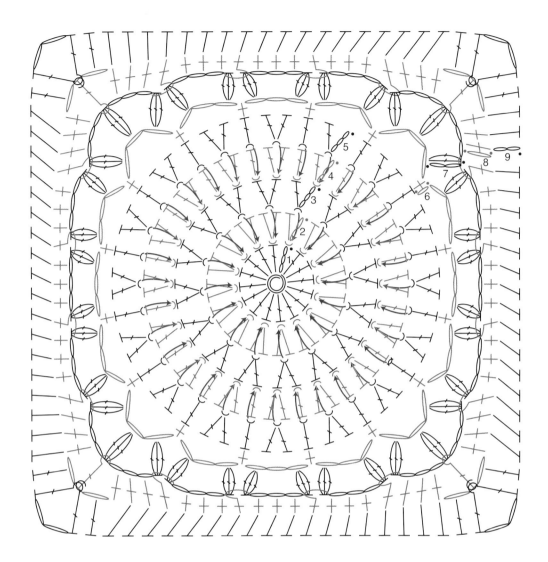

Rnd 8: With RS facing, join E with a sl st in ch-3 sp following join, ch 1, *3 sc in ch-3 sp, ch 1, fpdc around the post of next 3-dc cluster, ch 1, [3 sc in next ch-3 sp, fpsc around the post of next 3-dc cluster] 4 times; rep from * around, join with a sl st in first sc—45 sc; 8 ch-1 sps; 4fpdc; 16 fpsc.

Rnd 9: Ch 2 (counts as hdc), hdc in each of next 2 sts, *dc in next ch-1 sp, (fpdc, ch 2, fpdc) around the post of next fpdc, dc in next ch-1 sp, sk next st**, hdc in each of next 18 sts; rep from * around, ending last rep at **. hdc in each of next 15 sts, join with a sl st in top of beg ch-2—72 hdc; 8 dc; 8 fpdc; 4 ch-2 sps. Fasten off E.

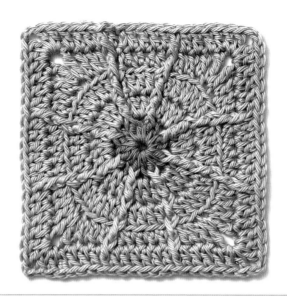

#28

FINISHED SIZE
4¼" (11 cm) across
before blocking.

HOOK
G-6 (4.0 mm).

GAUGE
First 3 rnds = 2¾"
(7 cm) across.

COLORS
(A) #3778 Lavender
(B) #3808 Light Grey

notes

- Ch 2 at the beg of the rnd counts as dc unless otherwise stated.
- If the post stitches are causing the motif to buckle inward, try replacing the fpdc sts with fptr sts. Blocking the motif will also help it to lie flat.
- You can use tapestry crochet, carrying along the second color to make the post stitches stand out more.

With A, make an adjustable ring.

Rnd 1: (RS) Ch 2 (counts as dc), work 15 dc in ring, join with a sl st in top of beg ch-2—16 dc. Fasten off A.

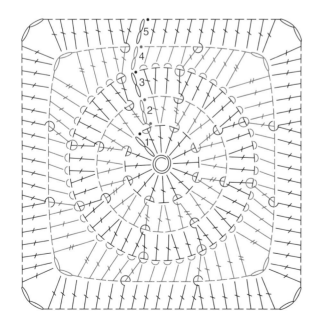

Rnd 2: With RS facing, join B with a sl st in the st to the right of the join, ch 2, fptr around the post of same st, *2 dc in the next st**, dc in the next st, fptr around the post of same st; rep from * around, ending last rep at **, join with a sl st in ch-2 sp—24 dc; 8 fptr.

Rnd 3: Ch 2, *fpdc around the post of next fptr, dc in same st, dc in next st, 2 dc in next st, dc in each of next 2 sts, fpdc around the post of same fptr, dc in next st, 2 dc in next st**, dc in next st; rep from * around, ending last rep at **, join with a sl st in top of beg ch-2—32 dc; 8 fpdc.

Rnd 4: Working in the back lps of sts, ch 2 (counts as hdc), *fpdc around the post of next fpdc, dc in same st, dc in each of the next 2 sts, (tr, ch 2, tr) in next st, dc in each of next 3 sts, fpdc around the post of next fpdc, hdc in same st**, hdc in each of the next 4 sts; rep from * around, ending last rep at **, hdc in each of last 3 sts, join with a sl st in top of beg ch-2—24 dc; 8 tr; 8 fpdc; 20 hdc; 4 ch-2 sps.

Rnd 5: Ch 2, *dc in next fpdc, fpdc around the post of same fpdc, dc in each of next 4 sts, (2 dc, ch 2, 2 dc) in next ch-2 sp, dc in each of next 4 sts, fpdc around the post of next fpdc**, dc in each of next 5 sts; rep from * around, ending last rep at **, dc in each of last 4 sts, join with sl st in ch-2 sp—72 dc; 8 fpdc; 4 ch-2 sps. Fasten off B.

Alternate Colorway for Motif #28 ▶
*(A) #3802 Honeysuckle
(Rnd 1 and all post stitches),
(B) #3729 Grey (Rnds 4 and 5)*

FINISHED SIZE
4¾" (12 cm) across
before blocking.

HOOK
G-6 (4.0 mm).

GAUGE
First 3 rnds = 3" (7.5 cm)
across.

COLORS
(A) #3736 Ice
(B) #3750 Tangerine
(C) #3767 Deep Coral

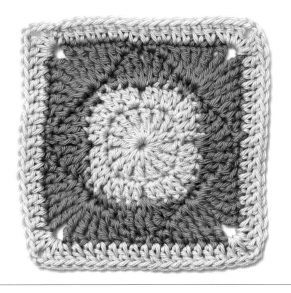

#29

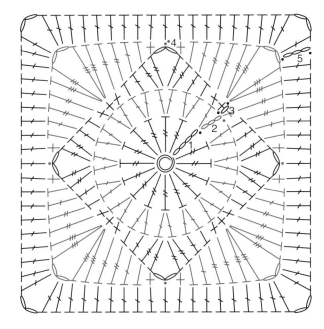

notes

- Ch 1 at the beg of rnds does not count as a st.
- Use colors of varying contrast to change how much the central squares "pop."

With A, make an adjustable ring.

Rnd 1: (RS) Ch 4 (counts as tr), work 15 tr in ring, join with a sl st in top of beg ch-4—16 tr.

Rnd 2: Ch 3 (counts as dc), dc in same st, 2 dc in each st around, join with sl st in top of beg ch-3—32 dc. Fasten off A.

Rnd 3: With RS facing, join B with a sl st between any 2 sts, ch 1, *sc between 2 sts, sc in next st, hdc in next st, dc in next st, tr in next st, (tr, ch 2, tr) between next 2 sts, tr in next st, dc in next st, hdc in next st, sc in next st; rep from * around, join with a sl st in first sc—16 tr; 8 dc; 8 hdc; 12 sc; 4 ch-2 sps. Fasten off B.

Rnd 4: With RS facing, join C with a sl st in any ch-2 sp, *sc in next st, hdc in next st, dc in next st, tr in each of next 2 sts, (2 dtr, ch 2, 2 dtr) in next st, tr in each of next 2 sts, dc in next st, hdc in next st, sc in next st**, sl st in next ch-2 sp; rep from * around, ending last rep at **, join with a sl st in first sl st—16 dtr; 16 tr; 8 dc; 8 hdc; 8 sc; 4 sl sts; 4 ch-2 sps. Fasten off C.

Rnd 5: With RS facing, join A with a sl st in any ch-2 sp, ch 3 (counts as dc), (dc, ch 2, 2 dc) in same sp, *dc in each of next 15 sts**, (2 dc, ch 2, 2 dc) in next ch-2 sp; rep from * around, ending last rep at **, join with a sl st in top of beg ch-3—76 dc; 4 ch-2 sps. Fasten off A

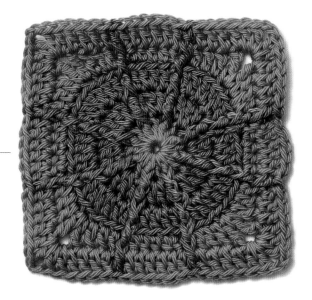

#30

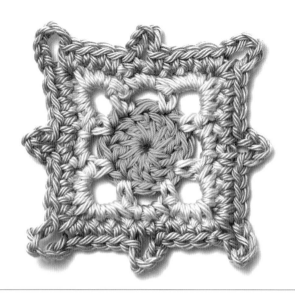

FINISHED SIZE
3" (7.5 cm)across
before blocking.

HOOK
G-6 (4.0 mm).

GAUGE
First 3 rnds = 2"
(5 cm) across.

COLORS
(A) #3752 Coral
(B) #3763 Water Lily
(C) #3808 Light Grey

notes

• Ch 1 at the beg of rnds does not count as a st.

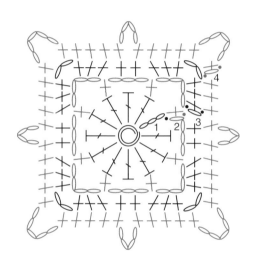

With A, make an adjustable ring.

Rnd 1: (RS) Ch 3 (counts as dc), work 11 dc in ring, join with a sl st in top of beg ch-3—12 dc. Fasten off A.

Rnd 2: With RS facing, join B with a sl st in any st, ch 1, sc in same st, *ch 4, sc in next st, ch 3, sk next st**, sc in next st; rep from * around, ending last rep at **, join with a sl st in first sc—8 sc; 4 ch-4 sps; 4 ch-3 sps.

Rnd 3: Sl st in next ch-4 sp, ch 1, *(3 sc, ch 2, 3 sc) in ch-4 sp, 2 sc in next ch-3 sp; rep from * around, join with sl st in first sc—32 sc; 4 ch-2 sps. Fasten off B.

Rnd 4: With RS facing, join C with a sl st in any ch-2 sp, ch 1, *(sc, ch 5, sc) in ch-2 sp, sc in each of next 4 sts, ch 4, sc in each of next 4 sts; rep from * around, join with a sl st in first sc—40 sc; 4 ch-5 sps: 4 ch-4 sps. Fasten off C.

Alternate Colorway for Motif #31 ▶
(A) #3775 Cool Mint, (Rnds 1 and 2)
(B) #3735 Jade (Rnd 3)
(C) #3733 Turquoise (Rnd 4)
(D) #3774 Major Teal (Rnd 5)
(E) #3798 Suede (Rnds 6–8)

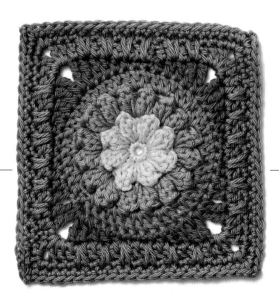

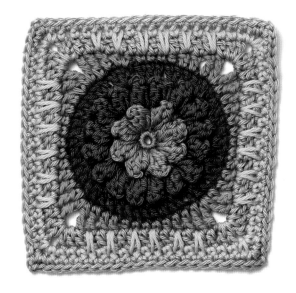

#31

notes

- Ch 1 at the beg of rnds does not count as a st.
- Using an accent color for Rnd 7 allows that color to pop, while using the same color for Rnds 6–8 places the focus on texture.

With A, make an adjustable ring.

Rnd 1: (RS) Ch 1, work 8 sc in ring, join with a sl st in first sc—8 sc.

Rnd 2: Beg popcorn in first st, ch 2, (popcorn, ch 2) in each st around, join with a sl st to beg popcorn—8 popcorns; 8 ch-2 sps. Fasten off A.

Rnd 3: With RS facing, join B with a sl st in any ch-2, beg popcorn in same sp, ch 2, *popcorn in next popcorn, ch 2**, popcorn in next ch-2 sp, ch 2; rep from * around, ending last rep at **, join with a sl st in beg popcorn—16 popcorns; 16 ch-2 sps. Fasten off B.

Rnd 4: With RS facing, join C with a sl st in any ch-2 sp, ch 3 (counts as dc here and throughout), 2 dc in same sp, 3 dc in each ch-2 sp around, join with a sl st in top of beg ch-3—48 dc. Fasten off C.

Rnd 5: With RS facing, join D with a sl st in same st as join, ch 1, sc in each of first 3 sts, *hdc in next st, dc in each of next 2 sts, tr in next st, (tr, ch 2, tr) in next st, tr in next st, dc in each of next 2 sts, hdc in next st**, sc in each of next 3 sts; rep from * around, ending last rep at **, join with a sl st in first sc—12 sc; 8 hdc; 16 dc; 16 tr; 4 ch-2 sps. Fasten off D.

Rnd 6: With RS facing, join E with a sl st in any ch-2 sp, ch 3 (counts as dc), (dc, ch 2, 2 dc) in same sp, *dc in each of next 13 sts**, (2 dc, ch 2, 2 dc) in next ch-2 sp; rep from * around, ending last rep at **, join with a sl st in top of beg ch-3—68 dc; 4 ch-2 sps. Fasten off E.

Rnd 7: With RS facing, join F with a sl st in any ch-2 sp, ch 1, *(sc, ch 2, sc) in ch-2 sp, sc in each of next 3 sts, [working over sts in Rnd 6, sp sc in next corresponding dc in Rnd 5, sk st behind sp sc, sc in next st] 6 times, sc in each of next 2 sts; rep from * around, join with a sl st in first sc—52 sc; 24 sp sc; 4 ch-2 sps. Fasten off F.

Rnd 8: With RS facing, join E with a sl st in any ch-2 sp, ch 1, *(sc, ch 2, sc) in ch-2 sp, sc in each of next 19 sts; rep from * around, join with a sl st in first sc—84 sc; 4 ch-2 sps. Fasten off E.

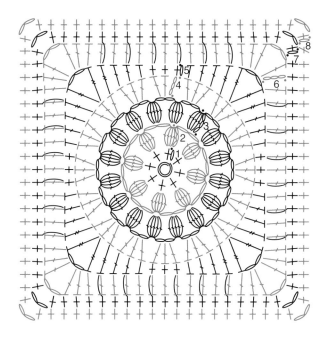

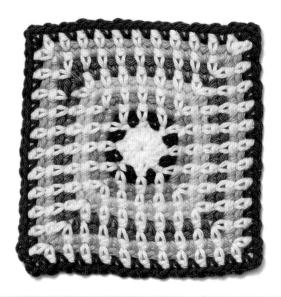

#32

FINISHED SIZE
4¾" (12 cm) across
before blocking.

HOOK
G-6 (4.0 mm).

GAUGE
First 3 rnds = 1¾"
(4.5 cm) across.

COLORS
(A) #3728 White
(B) #3714 Burgundy
(C) #3750 Tangerine
(D) #3748 Buttercup
(E) #3761 Juniper
(F) #3732 Aqua
(G) #3704 Syrah

notes

- Ch 1 at the beg of rnds does not count as a st.
- Achieve different effects by using the same color on every other round, or different colors on each round.

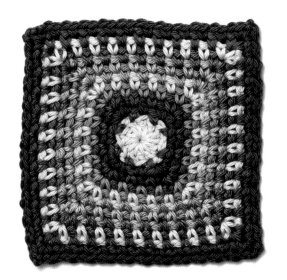

Alternate Colorway
(A) #3736 Ice (Rnds 1 and 10)
(B) #3725 Cobalt (Rnds 2 and 11)
(C) #3793 Indigo Blue (Rnds 3 and 12)
(D) #3734 Teal (Rnd 4)
(E) #3735 Jade (Rnd 5)
(F) #3763 Water Lily (Rnd 6)
(G) #3797 Dark Sea Foam (Rnd 7)
(H) #3762 Spring Green (Rnd 8)
(I) #3761 Juniper (Rnd 9)

With A, make an adjustable ring.

Rnd 1: (RS) Ch 3 (counts as dc), work 11 dc in ring, join with a sl st in top of beg ch-3—12 dc. Fasten off A.

Rnd 2: With RS facing, join B with a sl st in any st, ch 1, sc in same st, *ch 2, sc in next st, ch 1, sk next st**, sc in next st; rep from * around, ending last rep at **, join with a sl st in first sc—8 sc; 4 ch-2 sps; 4 ch-1 sps. Fasten off B.

Rnd 3: With RS facing, join A with a sl st in any ch-2 sp, ch 1, *(sc, ch 2, sc) in ch-2 sp, ch 1, sk next st, sc in next ch-1 sp, ch 1, sk next st; rep from * around, join with a sl st in first sc—12 sc; 4 ch-2 sps; 8 ch-1 sps. Fasten off A.

Rnd 4: With RS facing, join C with a sl st in any ch-2 sp, ch 1, *(sc, ch 2, sc) in ch-2 sp, ch 1, sk next st, (sc, ch 1) in each of next 2 ch-1 sps; rep from * around, join with sl st in first sc—16 sc; 4 ch-2 sps; 12 ch-1 sps. Fasten off C.

Rnd 5: With RS facing, join A with a sl st in any ch-2 sp, ch 1, *(sc, ch 2, sc) in ch-2 sp, ch 1, sk next st, (sc, ch 1) in each of next 3 ch-1 sps; rep from * around, join with sl st in first sc—20 sc; 4 ch-2 sps; 16 ch-1 sps. Fasten off A.

Rnd 6: With RS facing, join D with a sl st in any ch-2 sp, ch 1, *(sc, ch 2, sc) in ch-2 sp, ch 1, sk next st, (sc, ch 1) in each of next 4 ch-1 sps; rep from * around, join with sl st in first sc—24 sc; 4 ch-2 sps; 20 ch-1 sps. Fasten off D.

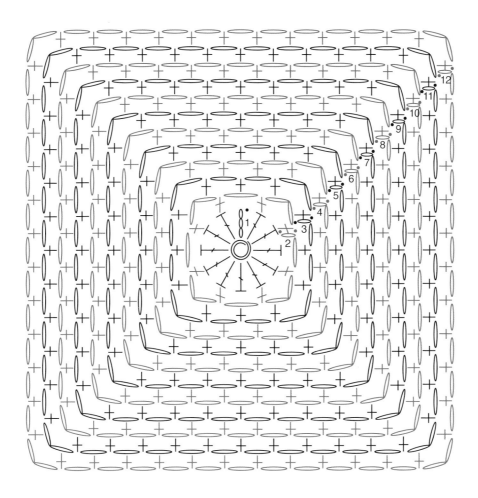

Rnd 7: With RS facing, join A with a sl st in any ch-2 sp, ch 1, *(sc, ch 2, sc) in ch-2 sp, ch 1, sk next st, (sc, ch 1) in each of next 5 ch-1 sps; rep from * around, join with sl st in first sc—28 sc; 4 ch-2 sps; 24 ch-1 sps. Fasten off A.

Rnd 8: With RS facing, join E with a sl st in any ch-2 sp, ch 1, *(sc, ch 2, sc) in ch-2 sp, ch 1, sk next st, (sc, ch 1) in each of next 6 ch-1 sps; rep from * around, join with sl st in first sc—32 sc; 4 ch-2 sps; 28 ch-1 sps. Fasten off E.

Rnd 9: With RS facing, join A with a sl st in any ch-2 sp, ch 1, *(sc, ch 2, sc) in ch-2 sp, ch 1, sk next st, (sc, ch 1) in each of next 7 ch-1 sps; rep from * around, join with sl st in first sc—36 sc; 4 ch-2 sps; 32 ch-1 sps. Fasten off A.

Rnd 10: With RS facing, join F with a sl st in any ch-2 sp, ch 1, *(sc, ch 2, sc) in ch-2 sp, ch 1, sk next st, (sc, ch 1) in each of next 8 ch-1 sps; rep from * around, join with sl st in first sc—40 sc; 4 ch-2 sps; 36 ch-1 sps. Fasten off F.

Rnd 11: With RS facing, join A with a sl st in any ch-2 sp, ch 1, *(sc, ch 2, sc) in ch-2 sp, ch 1, sk next st, (sc, ch 1) in each of next 9 ch-1 sps; rep from * around, join with sl st in first sc—44 sc; 4 ch-2 sps; 40 ch-1 sps. Fasten off A.

Rnd 12: With RS facing, join G with a sl st in any ch-2 sp, ch 1, *(sc, ch 2, sc) in ch-2 sp, ch 1, sk next st, (sc, ch 1) in each of next 10 ch-1 sps; rep from * around, join with sl st in first sc—48 sc; 4 ch-2 sps; 44 ch-1 sps. Fasten off G.

#33

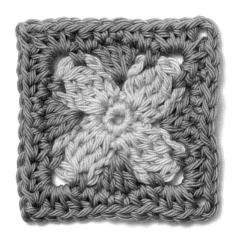

FINISHED SIZE
2½″ (6.5 cm) across
before blocking.

HOOK
G-6 (4.0 mm).

GAUGE
First 3 rnds = 2″
(5 cm) in diameter.

COLORS
(A) #3753 White Peach
(B) #3736 Ice
(C) #3735 Jade

notes

- Ch 1 at the beg of rnds does not count as a st.
- Using the same color for Rnds 1 and 2 gives the motif the appearance of having an "X" in the center.

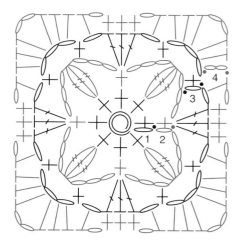

With A, make an adjustable ring.

Rnd 1: (RS) Ch 1, work 8 sc in ring, join with a sl st in first sc—8 sc. Fasten off A.

Rnd 2: With RS facing, join B with a sl st in any st, ch 1, sc in first st, *ch 3, 3-tr cluster in next st, ch 3**, sc in next st; rep from * around, ending last rep at **, join with sl st in first sc—4 sc; 8 ch-3 sps; 4 3-tr clusters. Fasten off B.

Rnd 3: With RS facing, join C with a sl st in ch-3 sp following the join, ch 1, sc in same sp, *ch 3, sc in next ch-3 sp, ch 1, 3 dc in next sc, ch 1**, sc in next ch-3 sp; rep from * around, ending last rep at **, join with a sl st in first sc—8 sc; 4 ch-3 sps; 8 ch-1 sps; 12 dc.

Rnd 4: Sl st in next ch-3 sp, ch 2 (counts as hdc), (2 hdc, ch 2, 3 hdc) in same sp, *hdc in next ch-1 sp, sc in each of next 3 sts, ch 1, hdc in next ch-1 sp**, (3 hdc, ch 2, 3 hdc) in next ch-3 sp; rep from * around, ending last rep at **, join with sl st in top of beg ch-2—32 hdc; 12 sc; 4 ch-2 sps. Fasten off C.

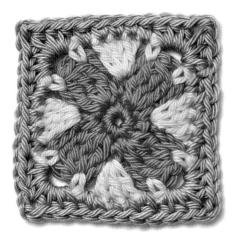

Alternate Colorway
(A) #3767 Deep Coral (Rnds 1 and 2)
(B) #3718 Natural (Rnd 3)
(C) #3759 Taupe (Rnd 4)

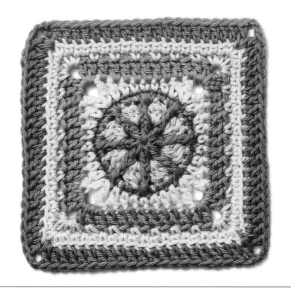

FINISHED SIZE
5" (12.5 cm) across before blocking.

HOOK
G-6 (4.0 mm).

GAUGE
First 3 rnds = 2" (5 cm) in diameter.

COLORS
(A) #3750 Tangerine
(B) #3764 Sunshine
(C) #3718 Natural
(D) #3712 Primrose

notes

- Ch 1 at the beg of rnds does not count as a st.

With A, make an adjustable ring.

Rnd 1: (RS) Ch 4 (counts as dc, ch 1), (dc, ch 1) 7 times in ring, join with a sl st in 3rd ch of beg ch-4—8 dc, 8 ch-1 sps. Fasten off A.

Rnd 2: With RS facing, join B with a sl st in any ch-1 sp, ch 2, 2-dc cluster in same sp (counts as 3-dc cluster), ch 3, (3-dc cluster, ch 3) in each ch-1 sp around, join with a sl st in first 2-dc cluster—8 3-dc clusters; 8 ch-3 sps. Fasten off B.

Rnd 3: With RS facing, join A with a sl st in any ch-3 sp, ch 1, *(sc, working over ch-3 sp in Rnd 2, fptr around the post of next dc in Rnd 1, sc) in next ch-3 sp, sc in next 3-dc cluster; rep from * around, join with sl st in first sc—24 sc; 8 fptr. Fasten off A.

Rnd 4: With RS facing, join C with a sl st in any fptr, ch 6 (counts as tr, ch 2), tr in same st. *dc in next st, hdc in next st, sc in each of next 3 sts, hdc in next st, dc in next st**, (tr, ch 2, tr) in next st; rep from * around, ending last rep at **, join with sl st in 4th ch of beg ch-6—8 tr; 8 dc; 8 hdc; 12 sc; 4 ch-2 sps. Fasten off C.

Rnd 5: With RS facing, join D with a sl st in any ch-2 sp, ch 3 (counts as dc), (dc, ch 2, 2 dc) in same sp, *dc in each of next 9 sts**, (2 dc, ch 2, 2 dc) in next ch-2 sp; rep from * around, ending last rep from **, join with a sl st in top of beg ch-3—52 dc; 4 ch-2 sps. Fasten off D.

Rnd 6: With RS facing, join B with a sl st in any ch-2 sp, ch 1, *(2 sc, ch 2, 2 sc) in ch-2 sp, (ch 1, sk next st, sc in next st) 6 times, ch 1, sk next st; rep from * around, join with a sl st in first sc—40 sc; 4 ch-2 sps; 28 ch-1 sps. Fasten off B.

Rnd 7: With RS facing, join C with a sl st in any ch-2 sp, ch 1, *(sc, ch 2, sc) in ch-2 sp, sc in next st, [sc in next st, sc in next ch-1 sp] 7 times, sc in each of next 2 sts; rep from * around, join with sl st in first sc—76 sc; 4 ch-2 sps. Fasten off C.

Rnd 8: Work this round in back lps only, except in corner spaces. With RS facing, join A with a sl st in any ch-2 sp, ch 5 (counts as dc, ch 2), dc in same sp, *dc in each of next 19 sts**, (dc, ch 2, dc) in next ch-2 sp; rep from * around, ending last rep at **, join with a sl st in 3rd ch of beg ch-5—84 dc; 4 ch-2 sps. Fasten off A.

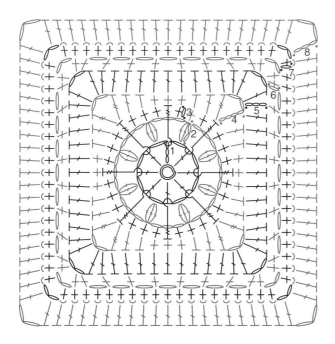

#35

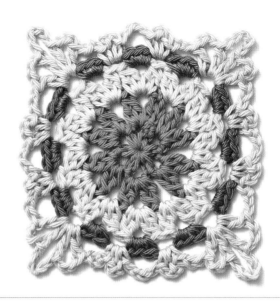

FINISHED SIZE
4″ (10 cm) across before blocking.

HOOK
G-6 (4.0 mm).

GAUGE
First 3 rnds = 3″ (7.5 cm) across.

COLORS
(A) #3712 Primrose
(B) #3739 Lime
(C) #3800 Blueberry
(D) #3736 Ice

notes

- Ch 1 at the beg of rnds does not count as a st.

With A, make an adjustable ring.

Rnd 1: (RS) Ch 1, (sc, ch 3) 6 times in ring, join with sl st in first sc—6 sc; 6 ch-3 sps.

Rnd 2: Sl st in next ch-3 sp, ch 2, dc in same sp (counts as 2-dc cluster here and throughout), ch 2, 2-dc cluster in same sp, ch 2, (2-dc cluster, ch 2, 2-dc cluster, ch 2) in each ch-3 sp around, join with sl st in first dc—12 2-dc clusters; 12 ch-2 sps. Fasten off A.

Rnd 3: With RS facing, join B with a sl st in any ch-2 sp, ch 2, dc in same sp, ch 2, 2-dc cluster in same sp, (2-dc cluster, ch 2, 2-dc cluster) in each ch-2 sp around, join with a sl st in first dc—24 2-dc clusters, 12 ch-2 sps. Fasten off B.

Rnd 4: With RS facing, join C with a sl st in any ch-2 sp, ch 1, (3 sc, ch 2) in each ch-2 sp around, join with a sl st in first sc—36 sc; 12 ch-2 sps. Fasten off C.

Rnd 5: With RS facing, join D with a sl st in any ch-2 sp, ch 1, *(sc, ch 3, sc) in ch-2 sp, ch 4, (sc, ch 3, sc) in next ch-2 sp, ch 3, (dc, ch 3, dc, ch 5, dc, ch 3, dc) in next ch-2 sp, ch 3; rep from * around, join with sl st in first sc—16 dc; 24 ch-3 sps; 4 ch-5 sps; 4 ch-4 sps; 16 sc. Fasten off D.

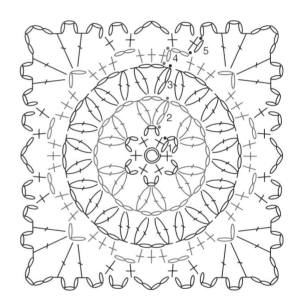

Alternate Colorway for Motif #36 ▶
(A) #3704 Syrah (Rnd 1)
(B) #3778 Lavender (Rnd 2)
(C) #3760 Celery (Rnd 3)
(D) #3808 Light Grey (Rnd 4)
(E) #3736 Ice (Rnd 5)

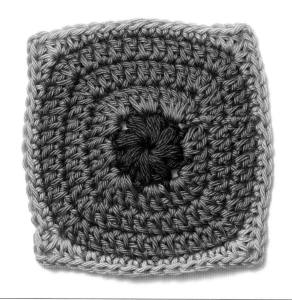

FINISHED SIZE
4" (10 cm) across
before blocking.

HOOK
G-6 (4.0 mm).

GAUGE
First 3 rnds = 2¾"
(7 cm) across.

COLORS
(A) #3771 Paprika
(B) #3805 Colony Blue
(C) #3747 Gold

#36

notes

- Work Rnds 2–4 in a single color for a clean look, or change colors on every rnd to create cheerful stripes.

With A, make an adjustable ring.

Rnd 1: (RS) Work beg puff st in ring, ch 2, (puff st, ch 2) 7 times in ring, join with sl st in beg puff st—8 puff sts; 8 ch-2 sps. Fasten off A.

Rnd 2: With RS facing, join B with a sl st in any ch-2 sp, ch 3 (counts as dc), 4 dc in same sp, *3 dc in next ch-2 sp**, 5 dc in next ch-2 sp; rep from * around, ending last rep at **, join with a sl st in top of beg ch-3—32 dc.

Rnd 3: Ch 2 (does not count as st), dc in same st, dc in next st, *3 dc in next st**, dc in each of next 7 sts; rep from * around, ending last rep at **, dc in each of last 5 sts, join with a sl st in first dc—40 dc.

Rnd 4: Ch 2 (does not count as st), dc in same st, dc in each of next 2 sts, *3 dc in next st**, dc in each of next 9 sts; rep from * around, ending last rep at **, dc in each of last 6 sts, join with a sl st in first dc—48 dc. Fasten off B.

Rnd 5: With RS facing, join C with a sl st in 2nd dc of any 3-dc group, ch 2 (counts as hdc), (hdc, ch 2, 2 hdc) in same st, *hdc in next st, sc in each of next 9 sts, hdc in next st**, (2 hdc, ch 2, 2 hdc) in next st; rep from * around, ending last rep at **, join with a sl st in top of beg ch-2—24 hdc; 4 ch-2 sps; 36 sc. Fasten off C.

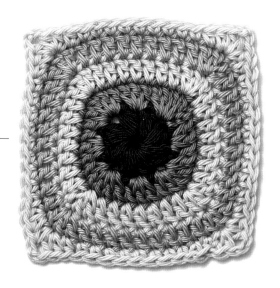

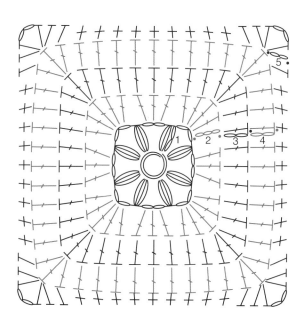

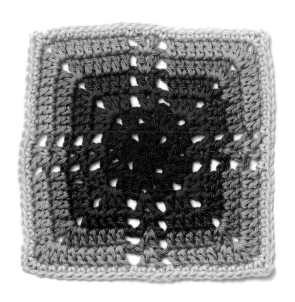

#37

FINISHED SIZE
5¾" (14.5 cm) across
before blocking.

HOOK
G-6 (4.0 mm).

GAUGE
First 3 rnds = 2¾"
(7 cm) across.

COLORS
(A) #3704 Syrah
(B) #3703 Magenta
(C) #3755 Lipstick Red
(D) #3769 Ginger
(E) #3750 Tangerine
(F) #3752 Coral
(G) #3748 Buttercup

notes

- The ch 3 at the beg of rnds counts as a dc.
- Experiment with changing colors on every rnd or on just some of the rnds.

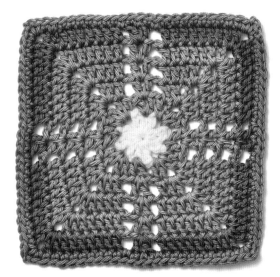

Alternate Colorway
(A) #3728 White (Rnd 1)
(B) #3797 Dark Sea Foam (Rnds 2–5)
(C) #3761 Juniper (Rnd 6)
(D) #3729 Grey (Rnd 7)

With A, make an adjustable ring.

Rnd 1: (RS) Ch 3, 2 dc in ring, ch 2, (3 dc, ch 2) 3 times in ring, join with a sl st in top of beg ch-3—12 dc; 4 ch-2 sps. Fasten off A.

Rnd 2: With RS facing, join B with a sl st in any ch-2 sp, ch 1, ch 3, (dc, ch 2, 2 dc) in same sp, *sk next st, (dc, ch 1, dc) in next st, sk next st**, (2 dc, ch 2, 2 dc) in next ch-2 sp; rep from * around, ending last rep at **, join with a sl st in top of beg ch-3—24 dc; 4 ch-2 sps; 4 ch-1 sps. Fasten off B.

Rnd 3: With RS facing, join C with a sl st in any ch-2 sp, ch 3, (dc, ch 2, 2 dc) in same sp, *dc in next st, ch 1, sk next 2 sts, (dc, ch 1, dc) in next ch-1 sp, ch 1, sk next 2 sts, dc in next st**, (2 dc, ch 2, 2 dc) in next ch-2 sp; rep from * around, ending last rep at **, join with a sl st in top of beg ch-3—32 dc; 4 ch-2 sps; 12 ch-1 sps. Fasten off C.

Rnd 4: With RS facing, join D with a sl st in any ch-2 sp, ch 3, (dc, ch 2, 2 dc) in same sp, *dc in each of next 3 sts, ch 1, sk next ch-1 sp, (dc, ch 1, dc) in next ch-1 sp, ch 1, sk next ch-1 sp, dc in each of next 3 sts**, (2 dc, ch 2, 2 dc) in next ch-2 sp; rep from * around, ending last rep at **, join with a sl st in top of beg ch-3—48 dc; 4 ch-2 sps; 12 ch-1 sps. Fasten off D.

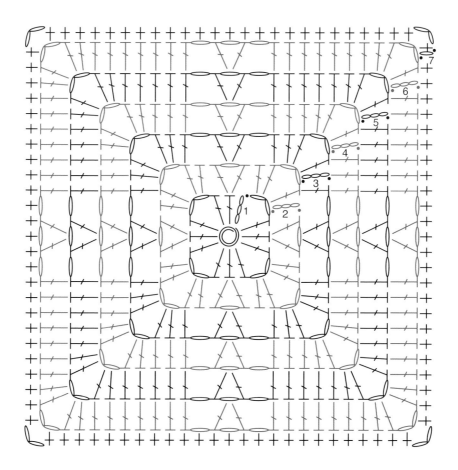

Rnd 5: With RS facing, join E with a sl st in any ch-2 sp, ch 3, (dc, ch 2, 2 dc) in same sp, *dc in each of next 5 sts, ch 1, sk next ch-1 sp, (dc, ch 1, dc) in next ch-1 sp, ch 1, sk next ch-1 sp, dc in each of next 5 sts**, (2 dc, ch 2, 2 dc) in next ch-2 sp; rep from * around, ending last rep at **, join with a sl st in top of beg ch-3—64 dc; 4 ch-2 sps; 12 ch-1 sps. Fasten off E.

Rnd 6: With RS facing, join F with a sl st in any ch-2 sp, ch 3, (dc, ch 2, 2 dc) in same sp, *dc in each of next 7 sts, ch 1, sk next ch-1 sp, (dc, ch 1, dc) in next ch-1 sp, ch 1, sk

next ch-1 sp, dc in each of next 7 sts**, (2 dc, ch 2, 2 dc) in ch-2 sp; rep from * around, ending last rep at **, join with a sl st in top of beg ch-3—80 dc; 4 ch-2 sps; 12 ch-1 sps. Fasten off F.

Rnd 7: With RS facing, join G with a sl st in any ch-2 sp, ch 1, *(sc, ch 2, sc) in ch-2 sp, sc in each of next 9 sts, [sc in next ch-1 sp, sc in next st] 3 times, sc in each of next 8 sts; rep from * around, join with sl st on first sc—100 sc; 4 ch-2 sps. Fasten off G.

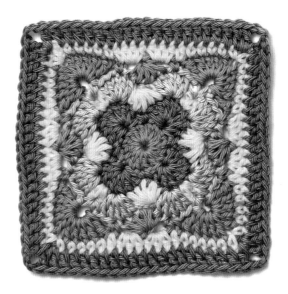

#38

FINISHED SIZE
5″ (12.5 cm) across
before blocking.

HOOK
G-6 (4.0 mm).

GAUGE
First 3 rnds = 2½″
(6.5 cm) across.

COLORS
(A) #3735 Jade
(B) #3729 Grey
(C) #3728 White
(D) #3808 Light Grey

notes

- Ch 1 at the beg of rnds does not count as a st.

With A, make an adjustable ring.

Rnd 1: (RS) Ch 3 (counts as dc), work 15 dc in ring, join with a sl st in top of beg ch-3—16 dc. Fasten off A.

Rnd 2: With RS facing, join B with a sl st in any st, ch 1, sc in first st, sk next st, 7 dc in next st, sk next st**, sc in next st, rep from * around, ending last rep at **, join with a sl st in first sc—4 sc; 28 dc. Fasten off B.

Rnd 3: With RS facing, join C with a sl st in the 4th dc of any 7-dc group, ch 1, (sc, ch 2, sc) in same st, *ch 3, sk next st, hdc5tog over next 5 sts, ch 3, sk next st**, (sc, ch 2, sc) in next st; rep from * around, ending last rep at **, join with a sl st in first sc—8 sc; 4 ch-2 sps; 8 ch-3 sps; 4 hdc5tog. Fasten off C.

Rnd 4: With RS facing, join D with a sl st in any ch-2 sp, ch 1, *(sc, ch 4, sc) in ch-2 sp, sk next st, working in front of ch-3 sp in Rnd 3, 5 dc in next skipped st in Rnd 2, sc in next hdc5tog, working in front of ch-3 sp in Rnd 3, 5 dc in next skipped st in Rnd 2, sk next st; rep from * around, join with a sl st in first sc—12 sc; 4 ch-4 sps; 40 dc. Fasten off D.

Rnd 5: With RS facing, join A with a sl st in any ch-4 sp, ch 4 (counts as tr), (4 dc, ch 2, 4 dc, tr) in same sp, *sk next 3 sts, sc in next st, ch 2, hdc5tog over next 5 sts, ch 2, sc in next st**, sk next 3 sts, (tr, 4 dc, ch 2, 4 dc, tr) in next ch-4 sp; rep from * around, ending last rep at **, join with a sl st in top of beg ch-4—8 sc; 12 ch-2 sp; 8 tr, 32 dc; 4 hdc5tog. Fasten off A.

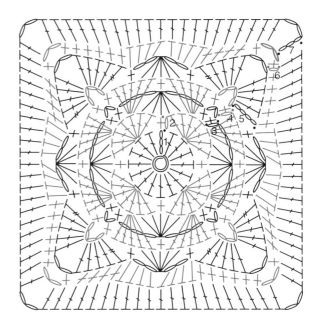

Rnd 6: With RS facing, join C with a sl st in any ch-2 corner sp, ch 1, *(sc, ch 2, sc) in ch-2 sp, sk next st, sc in each of next 4 sts, hdc in next st, 3 hdc in each of next 2 ch-2 sps, hdc in next st, sc in each of next 5 sts; rep from * around, join with a sl st in first sc—44 sc; 4 ch-2 sps; 32 hdc. Fasten off C.

Rnd 7: With RS facing, join B with a sl st in any ch-2 sp, ch 5 (counts as dc, ch 2), dc in same sp, *dc in each of next 19 sts**, (dc, ch 2, dc) in next ch-2 sp; rep from * around, ending last rep at **, join with a sl st in 3rd ch of beg ch-5—84 dc; 4 ch-2 sps. Fasten off B.

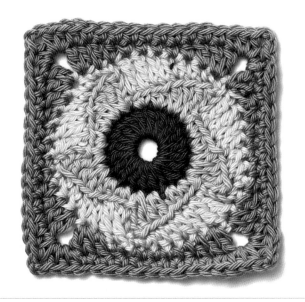

FINISHED SIZE
3¾" (9.5 cm) across before blocking.

HOOK
G-6 (4.0 mm).

GAUGE
First 3 rnds = 3" (7.5 cm) across.

COLORS
(A) #3703 Magenta
(B) #3746 Chartreuse
(C) #3753 White Peach
(D) #3797 Dark Sea Foam

#39

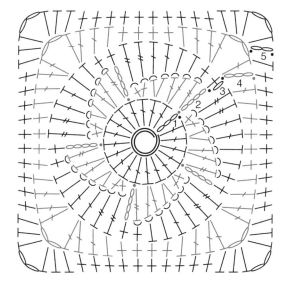

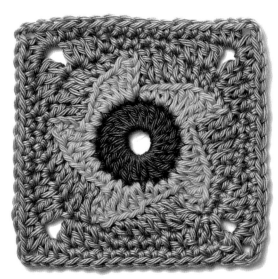

Alternate Colorway
(A) #3792 Brick (Rnd 1)
(B) #3732 Aqua (Rnd 2)
(C) #3717 Sand (Rnds 3–5)

notes

- Ch 1 at the beg of rnds does not count as a st.
- Using the same color for Rnds 3–5 accentuates the central star of the motif.

With A, make an adjustable ring.

Rnd 1: (RS) Ch 3 (counts as dc), work 19 dc in ring, join with a sl st in top of beg ch-3—20 dc. Fasten off A.

Rnd 2: With RS facing, join B with a sl st in any st, *ch 4 (counts as tr here and throughout), tr in same st, 2 dc in next st, 2 hdc in next st, 2 sc in next st, sl st in next st; rep from * around—10 tr; 10 dc; 10 hdc; 10 sc; 5 sl sts. Fasten off B.

Rnd 3: Work this round in back lps only of sts. With RS facing, join C with a sl st in top of first ch-4 "tr," ch 1, *sc in top of ch-4, sc in next st, hdc in each of next 2 sts, dc in each of next 2 sts, tr in each of next 2 sts; rep from * around, join with a sl st in first sc—10 sc; 10 hdc; 10 dc; 10 tr. Fasten off C.

Rnd 4: With RS facing, join D with a sl st in same st as join, ch 3 (counts as dc), dc in same st, *ch 2, 2 dc in next st, dc in next st, hdc in next st, sc in each of next 4 sts, hdc in next st, dc in next st**, 2 dc in next st; rep from * around, ending last rep at **, join with a sl st in top of first ch-3—16 sc; 8 hdc; 24 dc; 4 ch-2 sp.

Rnd 5: Sl st to next ch-2 sp, ch 2 (counts as hdc), (hdc, ch 2, 2 hdc) in same sp, *hdc in next st, sc in each of next 10 sts, hdc in next st**, (2 hdc, ch 2, 2 hdc) in ch-2 sp; rep from * around, ending last rep at **, join with sl st in top of beg ch-2—24 hdc; 40 sc; 4 ch-2 sps. Fasten off D.

#40

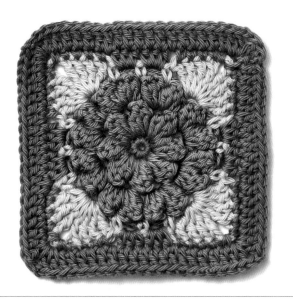

FINISHED SIZE
4½" (11.5 cm) across
before blocking.

HOOK
G-6 (4.0 mm).

GAUGE
First 3 rnds = 2¾"
(7 cm) in diameter.

COLORS
(A) #3800 Blueberry
(B) #3778 Lavender
(C) #3763 Water Lily

notes

- Ch 1 at the beg of rnds does not count as a st.
- Using the same neutral color for Rnds 5 and 6 allows the central "flower and leaf" portion of the patt to stand out.

With A, make an adjustable ring.

Rnd 1: (RS) Ch 1, work 8 sc in ring, join with a sl st in first sc—8 sc. Fasten off A.

Rnd 2: With RS facing, join B with a sl st in any st, beg popcorn in first st, ch 3, (popcorn, ch 3) in each st around, join with a sl st in beg popcorn—8 popcorns; 8 ch-3 sps.

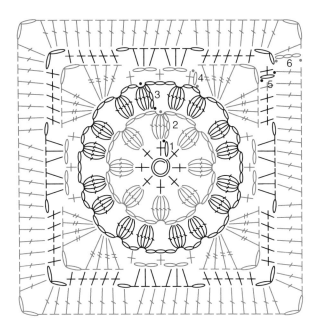

Rnd 3: Sl st in next ch-3 sp, (beg popcorn, ch 2, popcorn) in same sp, ch 3, *(popcorn, ch 2, popcorn) in next ch-3 sp, ch 3; rep from * around, join with a sl st in beg popcorn—16 popcorns; 8 ch-2 sps; 8 ch-3 sps. Fasten off B.

Rnd 4: With RS facing, join C with a sl st in any ch-2 sp, ch 1, *sc in ch-2 sp, ch 2, sc in next ch-3 sp, ch 2, sc in next ch-2 sp, (4 tr, ch 2, 4 tr) in next ch-3 sp; rep from * around, join with a sl st in first sc—12 sc; 12 ch-2 sps; 32 tr. Fasten off C.

Rnd 5: With RS facing, join A with a sl st in any ch-2 sp, ch 1, *(sc, ch 2, sc) in ch-2 sp, sc in each of next 4 sts, ch 1, 3 hdc in each of next 2 ch-2 sps, ch 1, sc in each of next 4 sts; rep from * around, join with a sl st in first sc—40 sc; 4 ch-2 sps; 8 ch-1 sps; 24 hdc.

Rnd 6: Sl st in next ch-2 sp, ch 3 (counts as dc), (dc, ch 2, 2 dc) in same sp, *dc in each of next 5 sts, dc in next ch-1 sp, sk next st, dc in each of next 5 sts, dc in next ch-1 sp, dc in each of next 5 sts**, (2 dc, ch 2, 2 dc) in next ch-2 sp; rep from * around, ending last rep at **, join with a sl st in top of beg ch-3—84 dc; 4 ch-2 sps. Fasten off A.

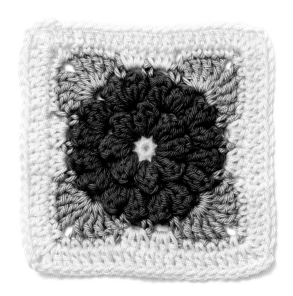

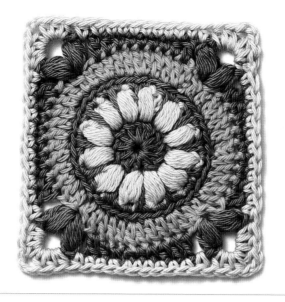

FINISHED SIZE
4″ (10 cm) across before blocking.

HOOK
G-6 (4.0 mm).

GAUGE
First 3 rnds = 2¼″ (5.5 cm) in diameter.

COLORS
(A) #3729 Grey
(B) #3736 Ice
(C) #3732 Aqua

notes

- Ch 1 at the beg of rnds does not count as a st.
- Rnd 5 is closed with hdc, which counts as ch-2 space. This better positions the hook to begin the next rnd.

With A, make an adjustable ring.

Rnd 1: (RS) Ch 3 (counts as dc here and throughout), work 11 dc in ring, join with a sl st in top of beg ch-3—12 dc. Fasten off A.

Rnd 2: With RS facing, join B with a sl st in any st, work beg puff st in same st, ch 2, (puff st, ch 2) in each st around, join with a sl st in beg puff st—12 puff sts; 12 ch-2 sps. Fasten off B.

Rnd 3: With RS facing, join A with a sl st in any ch-2 sp, ch 1, *sc in ch-2 sp, working over st in Rnd 2, sp sc in last dc in Rnd 1 (to the left of the puff st), sc in same ch-2 sp; rep from * around, join with a sl st in first sc—24 sc; 12 sp sc. Fasten off A.

Rnd 4: With RS facing, working in back lps only, join C with a sl st in any sp sc, ch 3, dc in same st, *dc in each of next 2 sts**, 2 dc in next st; rep from * around, ending last rep at **, join with a sl st in top of beg ch-3—48 dc. Fasten off C.

Rnd 5: With RS facing, join A with a sl st in same st as join, ch 1, sc in each of first 4 sts, *hdc in next st, dc in next st, ch 1, sk next st, (puff st, ch 4, puff st) in next st, ch 2, sk next st, dc in next st, hdc in next st**, sc in each of next 5 sts; rep from * around, ending last rep at **, join with a sl st in first sc—20 sc; 8 hdc; 8 dc; 8 puff sts, 4 ch-4 sps; 4 ch-1 sps; 4 ch-2 sps. Fasten off A.

Rnd 6: With RS facing, join B with a sl st in any ch-4 sp, ch 2 (counts as hdc), (2 hdc, ch 2, 3 hdc) in same sp, *hdc in next ch-2 sp, sc in each of next 9 sts, hdc in next ch-1 sp**, (3 hdc, ch 2, 3 hdc) in next ch-4 sp; rep from * around, ending last rep at **, join with a sl st in top of beg ch-2—32 hdc; 36 sc; 4 ch-2 sps. Fasten off B.

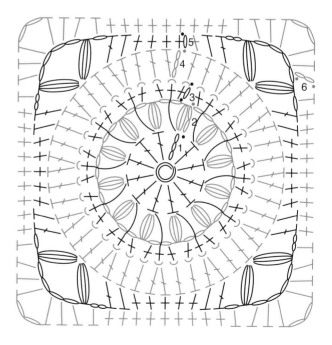

◂ *Alternate Colorway for Motif #40*
 (A) #3718 Natural
 (B) #3701 Cranberry
 (C) #3762 Spring Green

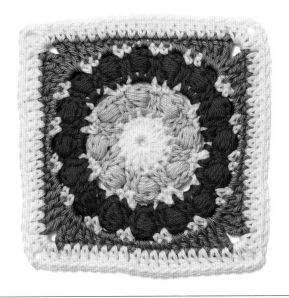

#42

FINISHED SIZE
5¼" (13.5 cm) across
before blocking.

HOOK
G-6 (4.0 mm).

GAUGE
First 3 rnds = 2½"
(6.5 cm) across.

COLORS
(A) #3728 White
(B) #3736 Ice
(C) #3755 Lipstick Red
(D) #3733 Turquoise

notes

- Ch 1 at the beg of rnds does not count as a st.
- Try this motif in contrasting colors for the "rings," or with colors close in shade for more of an ombré effect.

Alternate Colorway
(A) #3798 Suede
(B) #3792 Brick
(C) #3767 Deep Coral
(D) #3752 Coral

With A, make an adjustable ring.

Rnd 1: (RS) Ch 3 (counts as dc here and throughout), work 15 dc in ring, join with a sl st in top of beg ch-3— 16 dc. Fasten off A.

Rnd 2: With RS facing, join B with a sl st in any st, ch 3, dc in same st, *sl puff st around the post of the previous dc, dc in next st**, 2 dc in next st; rep from * around, ending last rep at **, join with a sl st in top of beg ch-3—24 dc; 8 sl puff sts. Fasten off B.

Rnd 3: With RS facing, join A with a sl st in same st as join, ch 1, sc in same st, *ch 4, sk next 2 sts**, sc in each of next 2 sts; rep from * around, ending last rep at **, sc in next st, join with sl st in first sc—16 sc; 8 ch-4 sps. Fasten off A.

Rnd 4: With RS facing, join C with a sl st in any ch-4 sp, ch 3, dc in same sp, sl puff st around the post of previous dc, dc in same sp, *2 dc in next st, sl puff st around the post of previous dc, dc in next st**, (2 dc, sl puff st around the post of previous dc, dc) in next ch-4 sp; rep from * around, ending last rep at **, join with a sl st in top of beg ch-3—16 sl puff st; 48 dc. Fasten off C.

Rnd 5: With RS facing, join A with a sl st in same st as join, ch 1, sc in same st, *ch 2, sk next 2 sts**, sc in each of next 2 sts; rep from * around, ending last rep at **, sc in last st, join with a sl st in first sc—32 sc; 16 ch-2 sps. Fasten off A.

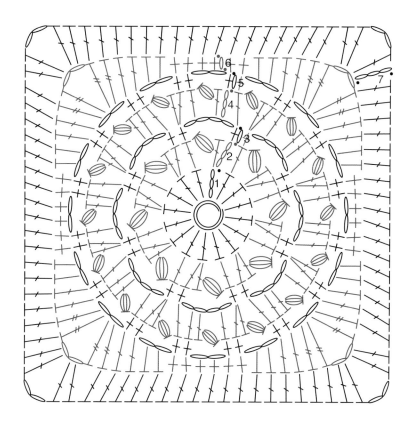

Rnd 6: With RS facing, join D with a sl st in any ch-2 sp, ch 1, *2 sc in ch-2 sp, sc in each of next 2 sts, 2 hdc in next ch-2 sp, dc in each of next 2 sts, (2 tr, ch 2, 2 tr) in next ch-2 sp, dc in each of next 2 sts, 2 hdc in next ch-2 sp, sc in each of next 2 sts; rep from * around, join with a sl st in first sc—24 sc; 16 hdc; 16 dc; 16 tr; 4 ch-2 sps. Fasten off D.

Rnd 7: With RS facing, join A with a sl st in any ch-2 sp, ch 3, (dc, ch 2, 2 dc) in same sp, *sk next st, dc in each of next 17 dc**, (2 dc, ch 2, 2 dc) in next ch-2 sp; rep from * around, ending last rep at **, join with a sl st in top of beg ch-3—84 dc; 4 ch-2 sps. Fasten off A.

#43

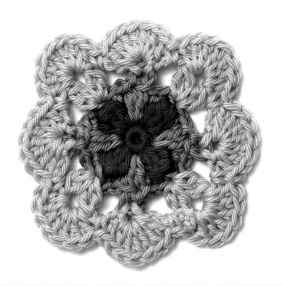

FINISHED SIZE
3½" (9 cm) across
before blocking.

HOOK
G-6 (4.0 mm).

GAUGE
First 3 rnds = 2" (5 cm)
from picot to picot.

COLORS
(A) #3755 Lipstick Red
(B) #3733 Turquoise
(C) #3732 Aqua

notes

- Changing colors on the final rnd gives the motif the appearance of being framed by shells, instead of the "petals" formed by using the same color on the final two rnds.

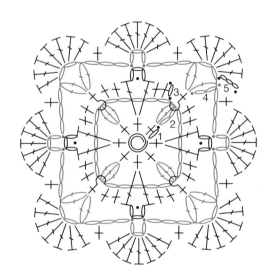

With A, make an adjustable ring.

Rnd 1: (RS) Ch 1, work 8 sc in ring, join with a sl st in first sc—8 sc.

Rnd 2: Ch 2, 2-dc cluster in same st (counts as 3-dc cluster), ch 5, sk next st, *3-dc cluster in next st, ch 5, sk next st; rep from * around, join with a sl st in first 2-dc cluster—4 3-dc clusters; 4 ch-5 sps. Fasten off A.

Rnd 3: With RS facing, join B with a sl st in any ch-5 sp, ch 1, *(2 sc, working in front of ch-5 sp, [dc, picot, dc] in next skipped st in Rnd 1, 2 sc) in same ch-5 sp in Rnd 2, fpsc around the post of next 3-dc cluster, rep from * around, join with a sl st in first sc—8 dc; 4 picots; 16 sc; 4 fpsc. Fasten off B.

Rnd 4: With RS facing, join C with a sl st in any fpsc, ch 2, dc (counts as 2-dc cluster), ch 2, 2-dc cluster in same st, *ch 3, sk next 3 sts, (sl st, ch 3, sl st) in next picot, ch 3, sk next 3 sts**, (2-dc cluster, ch 2, 2-dc cluster) in next fpsc; rep from * around, ending last rep at **, join with sl st in first dc—8 2-dc clusters; 4 ch-2 sps; 8 sl sts; 12 ch-3 sps.

Rnd 5: Sl st in next ch-2 sp, ch 3 (counts as dc), 6 dc in same sp, *sc in next ch-3 sp, 7 dc in next ch-3 sp, sc in next ch-3 sp**, 7 dc in next ch-2 sp; rep from * around, ending last rep at **, join with sl st in top of beg ch-3—56 dc; 8 sc. Fasten off C.

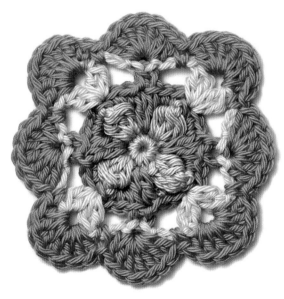

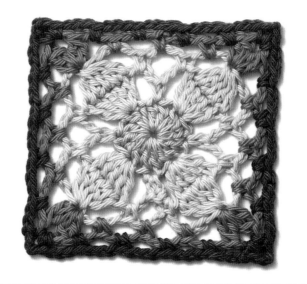

FINISHED SIZE
3¾" (9.5 cm) across before blocking.

HOOK
G-6 (4.0 mm).

GAUGE
First 3 rnds = 2½" (6.5 cm) across.

COLORS
(A) #3746 Chartreuse
(B) #3736 Ice
(C) #3733 Turquoise
(D) #3703 Magenta

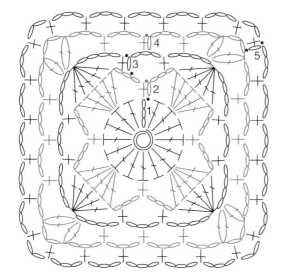

◀ *Alternate Colorway for Motif #43*
(A) #3727 Sky Blue (Rnds 1 and 2)
(B) #3750 Tangerine (Rnd 3)
(C) #3753 White Peach (Rnd 4)
(D) #3767 Deep Coral (Rnd 5)

notes

- Ch 1 at the beg of rnds does not count as a st.

With A, make an adjustable ring.

Rnd 1: (RS) Ch 3 (counts as dc), work 15 dc in ring, join with a sl st in top of beg ch-3—16 dc. Fasten off A.

Rnd 2: With RS facing, join B with a sl st in any st, ch 1, sc in first st, *ch 3, sk next st, 5 dc in next st, ch 3, sk next st**, sc in next st; rep from * around, ending last rep at **, join with sl st in first sc—4 sc; 8 ch-3 sps; 20 dc.

Rnd 3: Sl st in next ch-3 sp, ch 1, *sc in ch-3 sp, ch 4, dc5tog over next 5 dc, ch 4, sc in next ch-3 sp, ch 3; rep from * around, join with sl st in first sc—8 sc; 8 ch-4 sps; 4 ch-3 sps; 4 dc5tog. Fasten off B.

Rnd 4: With RS facing, join C with a sl st in any ch-3 sp, ch 1, *sc in ch-3 sp, ch 3, sc in next ch-4 sp, ch 3, sk next dc5tog, (dc2tog, ch 2, dc2tog) in first ch of next ch-4 sp, ch 3, sc in same ch-4 sp, ch 3; rep from * around, join with sl st in first sc—12 sc; 16 ch-3 sps; 4 ch-2 sps; 8 dc2tog. Fasten off C.

Rnd 5: With RS facing, join D with a sl st in any ch-2 sp, ch 1, *(sc, ch 2, sc) in ch-2 sp, (ch 3, sc) in each of next 4 ch-3 sps, ch 3; rep from * around, join with sl st in first sc—24 sc; 20 ch-3 sps; 4 ch-2 sps. Fasten off D.

#45

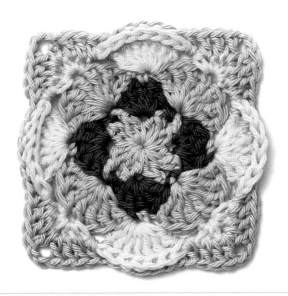

FINISHED SIZE
3¾" (9.5 cm) across
before blocking

HOOK
G-6 (4.0 mm).

GAUGE
First 3 rnds = 2½"
(6.5 cm) across.

COLORS
(A) #3807 Jasmine Green
(B) #3793 Indigo Blue
(C) #3732 Aqua
(D) #3718 Natural

notes

- Ch 1 at the beg of rnds does not count as a st.

With A, make an adjustable ring.

Rnd 1: (RS) Ch 2, dc in ring (counts as 2-dc cluster), ch 2, [2-dc cluster, ch 2] 7 times in ring, join with a sl st in first dc—8 2-dc clusters; 8 ch-2 sps. Fasten off A.

Rnd 2: With RS facing, join B with a sl st in any ch-2 sp, ch 1, *sc in ch-2 sp, 5 dc in next ch-2 sp; rep from * around, join with a sl st in first sc—4 sc; 20 dc. Fasten off B.

Rnd 3: With RS facing, join C with a sl st in any sc, ch 4 (counts as tr), 6 tr in same st, *sk next 2 sts, sc in next sc**, sk next 2 sts, 7 tr in next st; rep from * around, ending last rep at **, join with a sl st in top of beg ch-4—4 sc; 28 tr. Fasten off C.

Rnd 4: With RS facing, join D with a sl st in 4th tr of any 7-tr group, ch 1, (2 sc, ch 2, 2 sc) in first tr, *ch 1, sk next 3 sts, 7 tr in next sc, ch 1, sk next 3 sts**, (2 sc, ch 2, 2 sc) in next tr; rep from * around, ending last rep at **, join with a sl st in first sc—16 sc; 4 ch-2 sps; 8 ch-1 sps; 28 tr. Fasten off D.

Rnd 5: With RS facing, join A with a sl st in any ch-2 sp, ch 5 (counts as dc, ch 2), dc in same sp, *dc in each of next 2 sts, hdc in next ch-1 sp, bpsc around the post of each of next 7 sts, hdc in next ch-1 sp, dc in each of next 2 sts**, (dc, ch 2, dc) in next ch-2 sp; rep from * around, ending last rep at **, join with a sl st in 3rd ch of beg ch-5—24 dc; 8 hdc; 28 bpsc; 4 ch-2 sps. Fasten off A.

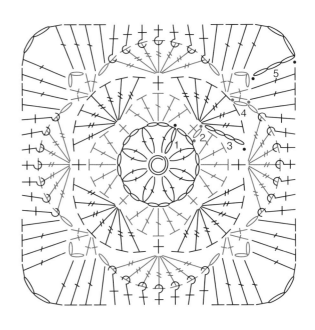

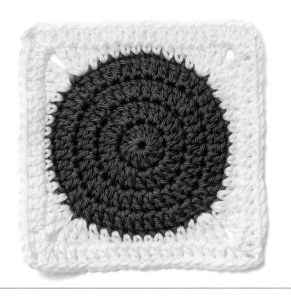

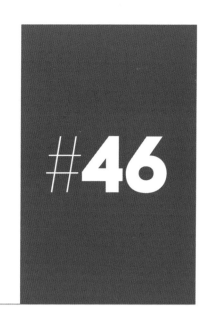

FINISHED SIZE
4½" (11.5 cm) across before blocking.

HOOK
G-6 (4.0 mm).

GAUGE
First 3 rnds = 2¼" (5.5 cm) across.

COLORS
(A) #3774 Major Teal
(B) #3728 White

#46

notes

- The increases in the center circle of this motif are alternated between rows to keep the seam straight.

- Rnd 5 is closed with a hdc, which better positions the st to beg the next rnd.

- Use the same color for the center circular rounds to create a polka dot effect, or change colors on each rnd to showcase unique color combinations.

With A, make an adjustable ring.

Rnd 1: (RS) Ch 3 (counts as dc), work 11 dc in ring, join with a sl st in top of beg ch-3—12 dc.

Rnd 2: Ch 2 (does not count as st here and throughout), 2 dc in same st, 2 dc in each st around, join with a sl st in first dc—24 dc.

Rnd 3: Ch 2, dc in same st, *2 dc in next st**, dc in next st; rep from * around, ending last rep at **, join with sl st in first dc—36 dc.

Rnd 4: Ch 2, 2 dc in same st, *dc in each of next 2 sts**, 2 dc in next st; rep from * around, ending last rep at **, join with sl st in first dc—48 dc. Fasten off A.

Rnd 5: With RS facing, join B with a sl st in any st, ch 4 (counts as tr), (tr, dc) in same st, *dc in next st, hdc in each of next 2 sts, sc in each of next 4 sts, hdc in each of next 2 sts, dc in next st, (dc, 2 tr) in next st**, ch 2, (2 tr, dc) in next st; rep from * around, ending last rep at **, join with hdc in top of beg ch-4 instead of last ch-2 sp—16 tr; 16 dc; 16 hdc; 16 sc; 4 ch-2 sps.

Rnd 6: Ch 3 (counts as dc), dc in same sp, *dc in each of next 16 sts**, (2 dc, ch 2, 2 dc) in next ch-2 sp; rep from * around, ending last rep at **, 2 dc in first sp formed by joining hdc, join with a sl st in top of beg ch-3—80 dc; 4 ch-2 sps. Fasten off B.

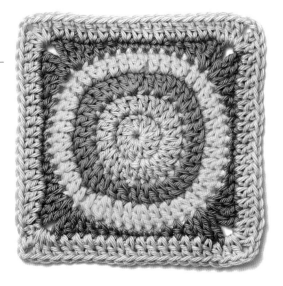

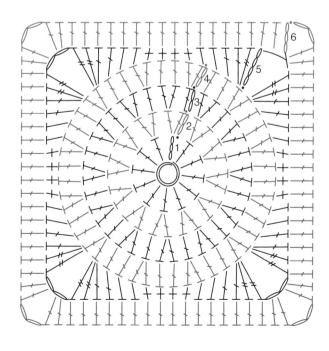

#47

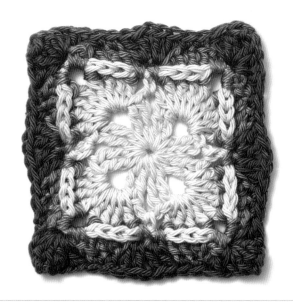

FINISHED SIZE
3½" (9 cm) across
before blocking.

HOOK
G-6 (4.0 mm).

GAUGE
First 3 rnds = 3"
(7.5 cm) across.

COLORS
(A) #3753 White Peach
(B) #3736 Ice
(C) #3798 Suede
(D) #3701 Cranberry

notes

- Ch 1 at the beg of rnds does not count as a st.

With A, make an adjustable ring.

Rnd 1: (RS) Ch 4 (counts as tr), tr in ring, ch 2, [2 tr, ch 2] 7 times in ring, join with a sl st to top of beg ch-4—16 tr; 8 ch-2 sps. Fasten off A.

Rnd 2: With RS facing, join B with a sl st in any ch-2 sp, ch 1, *sc in ch-2 sp, sk next 2 sts, (4 tr, ch 3, 4 tr) in next ch-2 sp, sk next 2 sts; rep from * around, join with a sl st in first sc—4 sc; 32 tr; 4 ch-3 sps. Fasten off B.

Rnd 3: With RS facing, join C with a sl st in any ch-3 sp, ch 1, *(2 sc, ch 2, 2 sc) in ch-3 sp, bpdc around the post of each of next 4 sts, sc between tr and sc, sc between sc and next tr, bpdc around the post of each of next 4 sts; rep from * around, join with a sl st in first sc—24 sc; 32 bpdc; 4 ch-2 sps. Fasten off C.

Rnd 4: With RS facing, join A with a sl st in any ch-2 sp, ch 5 (counts as dc, ch 2), (popcorn, ch 2, dc) in same sp, *sk next 3 sts, sc in each of next 2 sts, sk next st, 2 dc in next st, ch 1, 2 dc in next st, sk next st, sc in each of next 2 sts, sk next 3 sts**, (dc, ch 2, popcorn, ch 2, dc) in next ch-2 sp; rep from * around, ending last rep at **, join with a sl st in 3rd ch of beg ch-5—24 dc; 4 popcorn; 16 sc; 8 ch-2 sp; 4 ch-1 sps. Fasten off A.

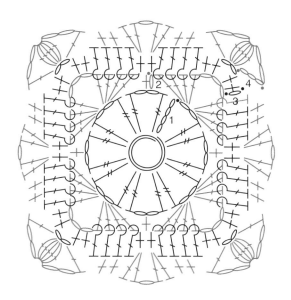

Alternate Colorway for Motif #48 ▶
(A) #3718 Natural (Rnds 1–3)
(B) #3763 Water Lily (Rnds 4–6)
(C) #3738 Spearmint (Rnds 4–6)

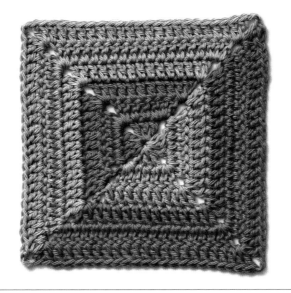

FINISHED SIZE
5" (12.5 cm) across
before blocking.

HOOK
G-6 (4.0 mm).

GAUGE
First 3 rnds = 3"
(7.5 cm) across.

COLORS
(A) #3808 Light Grey
(B) #3767 Deep Coral

#48

notes

- Do not fasten off yarn when switching colors. You do not need to carry unused colors behind the working color.
- Rnds 1–5 are closed with a hdc, which counts as a ch-2 sp. This better positions the hook to beg the next rnd.
- If working the motif in the alternate colorway, do not change colors or turn at the end of Rnds 1–3. Join color B in any ch-2 sp of Rnd 3 and cont the patt as written.

With A, make an adjustable ring.

Rnd 1: (RS) Ch 3, (2 dc, ch 2, 3 dc, ch 1) in ring, drop A, join B, with B, ch 1, (3 dc, ch 2, 3 dc) in ring, join with hdc in top of beg ch-3, turn—12 dc; 4 ch-2 sps.

Rnd 2: (WS) With B, ch 3, dc in same corner sp, dc in each of next 3 sts, (2 dc, ch 2, 2 dc) in next ch-2 sp, dc in each of next 3 sts, (2 dc, ch 1) in next ch-2 sp, drop B, pick up A, with A, (ch 1, 2 dc) in same ch-2 sp, dc in each of next 3 sts, (2 dc, ch 2, 2 dc) in next ch-2 sp, dc in each of next 3 sts, 2 dc in first corner sp, join with hdc in top of beg ch-3, turn—28 dc; 4 ch-2 sps.

Rnd 3: (RS) With A, ch 3, dc in same corner sp, dc in each of next 7 sts, (2 dc, ch 2, 2 dc) in next ch-2 sp, dc in each of next 7 sts, (2 dc, ch 1) in next ch-2 sp, drop A, pick up B, with B, (ch 1, 2 dc) in same ch-2 sp, dc in each of next 7 sts, (2 dc, ch 2, 2 dc) in next ch-2 sp, dc in each of next 7 sts, 2 dc in first corner sp, join with hdc in top of beg ch-3, do not turn—44 dc; 4 ch-2 sps.

Rnd 4: (RS) With B, ch 3, dc in same corner sp, dc in each of next 11 sts, (2 dc, ch 2, 2 dc) in next ch-2 sp, dc in each of next 11 sts, (2 dc, ch 1) in next ch-2 sp, drop B, pick up A, with A, (ch 1, 2 dc) in same ch-2 sp, dc in each of next 11 sts, (2 dc, ch 2, 2 dc) in next ch-2 sp, dc in each of next

11 sts, 2 dc in first corner sp, join with hdc in top of beg ch-3, turn—60 dc; 4 ch-2 sps.

Rnd 5: (WS) With A, ch 3, dc in same corner sp, dc in each of next 15 sts, (2 dc, ch 2, 2 dc) in next ch-2 sp, dc in each of next 15 sts, (2 dc, ch 1) in next ch-2 sp, drop A, pick up B, with B, (ch 1, 2 dc) in same ch-2 sp, dc in each of next 15 sts, (2 dc, ch 2, 2 dc) in next ch-2 sp, dc in each of next 15 sts, 2 dc in first corner sp, join with hdc in top of beg ch-3, turn—76 dc; 4 ch-2 sps.

Rnd 6: (RS) With B, ch 3, dc in same corner sp, dc in each of next 19 sts, (2 dc, ch 2, 2 dc) in next ch-2 sp, dc in each of next 19 sts, (2 dc, ch 1) in next ch-2 sp, drop B, pick up A, with A, (ch 1, 2 dc) in same ch-2 sp, dc in each of next 19 sts, (2 dc, ch 2, 2 dc) in next ch-2 sp, dc in each of next 19 sts, 2 dc in first corner sp, ch 2, join with a sl st in top of beg ch-3, turn—92 dc; 4 ch-2 sps. Fasten off A and B.

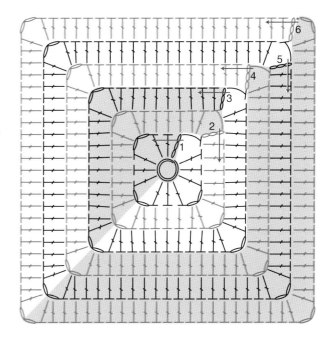

#49

FINISHED SIZE
4½" (11.5 cm) across
before blocking.

HOOK
G-6 (4.0 mm).

GAUGE
First 3 rnds = 2½"
(6.5 cm) across.

COLORS
(A) #3764 Sunshine
(B) #3747 Gold
(C) #3711 China Pink
(D) #3762 Spring Green

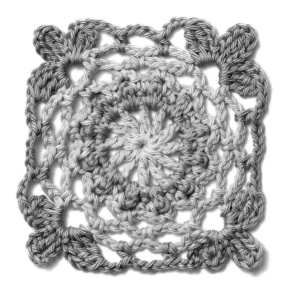

notes

- Ch 1 at the beg of rnds does not count as a st.
- Rnd 4 is closed with (ch 1, dc), which counts as a ch-4 space. This better positions the hook to begin the next round.

With A, make an adjustable ring.

Rnd 1: (RS) Ch 5 (counts as tr, ch 1), [tr, ch 1] 11 times in ring, join with a sl st to 4th ch of beg ch-5, turn—12 tr; 12 ch-1 sps. Fasten off A.

Rnd 2: (WS) With WS facing, join B with a sl st in any ch-1 sp, ch 1, (sc, tr, sc) in each ch-1 sp around, join with a sl st in first sc, turn—24 sc; 12 tr. Fasten off B.

Rnd 3: (RS) With RS facing, join C with a sl st in same st as join, ch 1, sc in first 2 sts, *ch 3, sk next tr**, sc in each of next 2 sc; rep from * around, ending last rep at **, join with a sl st in first sc—24 sc; 12 ch-3 sps.

Rnd 4: Sl st to next ch-3 sp, ch 1, sc in same sp, (ch 4, sc) in each ch-3 sp around, ending with ch 1, dc in first sc instead of last ch-4 sp—12 sc; 12 ch-4 sps.

Rnd 5: Ch 1, (sc, ch 5) in each ch-4 sp around, join with a sl st in first sc—12 sc; 12 ch-5 sps. Fasten off C.

Rnd 6: With RS facing, join D with a sl st in any ch-5 sp, ch 5 (counts as hdc, ch 3), *(2-tr cluster, ch 4, sl st, ch 4, tr, ch 4, sl st, ch 4, 2-tr cluster) in next ch-5 sp, ch 3, hdc in next ch-5 sp, ch 4**, hdc in next ch-5 sp, ch 3; rep from * around, ending last rep at **, join with a sl st in 2nd ch of beg ch-5—8 hdc; 4 ch-4 sps; 8 ch-3 sps; 8 2-tr clusters; 4 tr, 16 ch-4 sps; 8 sl sts. Fasten off D.

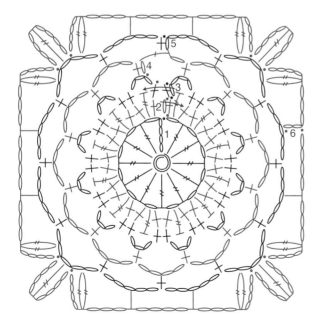

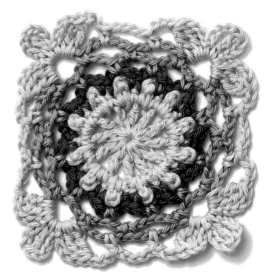

Alternate Colorway
(A) #3753 White Peach (Rnd 1)
(B) #3736 Ice (Rnds 2 and 6)
(C) #3774 Major Teal (Rnd 3)
(D) #3767 Deep Coral (Rnds 4 and 5)

FINISHED SIZE
3¼″ (8.5 cm) across before blocking.

HOOK
G-6 (4.0 mm).

GAUGE
First 3 rnds = 2¼″ (5.5 cm) across.

COLORS
(A) #3778 Lavender
(B) #3743 Yellow Rose
(C) #3747 Gold
(D) #3718 Natural

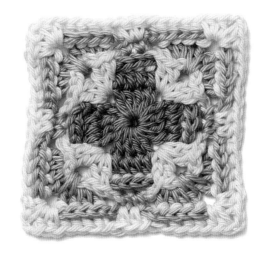

#50

notes

- Ch 1 at the beg of rnds does not count as a st.
- Working Rnds 1 and 2 of this motif in the same color creates the central "plus sign" shape. Try using different colors for a different look.

With A, make an adjustable ring.

Rnd 1: (RS) Ch 3 (counts as dc here and throughout), 3 dc in ring, ch 2, [4 dc, ch 2] 3 times in ring, join with a sl st in top of beg ch-3—16 dc; 4 ch-2 sps.

Rnd 2: Ch 3, dc in each of next 3 sts, ch 6, sk next ch-2 sp, *dc in each of next 4 sts, ch 6, sk next ch-2 sp; rep from * around, join with a sl st in top of beg ch-3—16 dc; 4 ch-6 sps. Fasten off A.

Rnd 3: With RS facing, join B with a sl st in any ch-2 sp of Rnd 1, working in front of ch-6 sp of Rnd 2, ch 3, (dc, ch 3, 2 dc) in ch-2 sp, *bpsc around the post of each of next 4 sts**, working in front of ch-6 sp of Rnd 2, (2 dc, ch 3, 2 dc) in next ch-2 sp of Rnd 1; rep from * around, ending last rep at **, join with a sl st in top of beg ch-3—16 dc; 4 ch-3 sps; 16 bpsc. Fasten off B.

Rnd 4: With RS facing, join C with a sl st in 2nd bpsc of any 4-bpsc group, ch 1, sc in each of first 2 sts, *ch 2, sk next 3 sts, 3 dc in next ch-6 sp of Rnd 2, (tr, ch 1, tr) around ch-3 sp of Rnd 3 and ch-6 sp of Rnd 2, 3 dc in same ch-6 sp of Rnd 2, ch 2, sk next 3 sts**, sc in each of next 2 sts; rep from * around, ending last rep at **, join with a sl st in first sc—8 sc; 8 ch-2 sps; 24 dc; 8 tr; 4 ch-1 sps. Fasten off C.

Rnd 5: With RS facing, join D with a sl st in any ch-1 sp, ch 2 (counts as hdc), (hdc, ch 2, 2 hdc) in same sp, *bphdc around the post of each of next 4 sts, ch 1, sk next ch-2 sp, hdc in each of next 2 sts, ch 1, sk next ch-2 sp, bphdc around each of next 4 sts**, (2 hdc, ch 2, 2 hdc) in next ch-2 sp; rep from * around, ending last rep at **, join with a sl st in top of beg ch-2—24 hdc; 32 bphdc; 4 ch-2 sps; 8 ch-1 sps. Fasten off D.

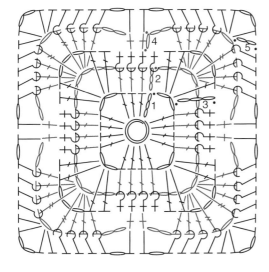

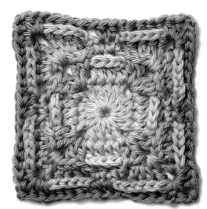

Alternate Colorway
(A) #3711 China Pink
(B) #3762 Spring Green
(C) #3807 Jasmine Green
(D)#3776 Pink Rose

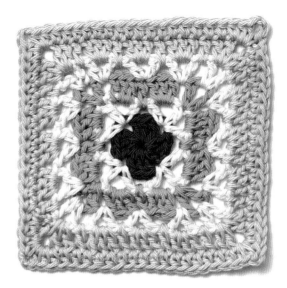

#51

FINISHED SIZE
4¾" (12 cm) across
before blocking.

HOOK
G-6 (4.0 mm).

GAUGE
First 3 rnds = 2¾"
(7 cm) across.

COLORS
(A) #3755 Lipstick Red
(B) #3718 Natural
(C) #3752 Coral
(D) #3764 Sunshine
(E) #3711 China Pink

notes

- Ch 3 at the beg of rnds counts as as dc throughout.
- Working rnds 2 and 4 in a neutral color allows the web-like nature of these sts to stand out. Y
- You will likely need to block this motif to obtain the correct shape.

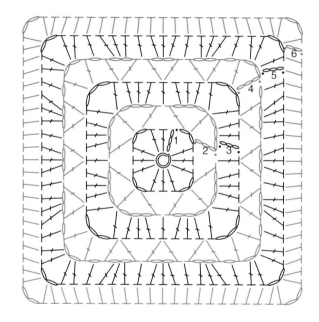

With A, make an adjustable ring.

Rnd 1: (RS) Ch 3, 2 dc in ring, ch 2, (3 dc, ch 2) 3 times in ring, join with a sl st in top of beg ch-3—12 dc; 4 ch-2 sps. Fasten off A.

Rnd 2: With RS facing, join B with a sl st in any ch-2 sp, ch 6 (counts as dc, ch 3), (dc, ch 3, dc) in same sp, (dc, ch 3, dc, ch 3, dc) in each ch-2 sp around, join with a sl st in 3rd ch of beg ch-6—12 dc; 8 ch-3 sps. Fasten off B.

Rnd 3: With RS facing, join C with a sl st in first ch-3 sp, ch 3, 2 dc in same sp, *(dc, ch 3, dc) in next dc, 3 dc in next ch-3 sp, dc between next 2 sts**, 3 dc in next ch-3 sp; rep from * around, ending last rep at **, join with a sl st in top of beg ch-3—36 dc; 4 ch-3 sps. Fasten off C.

Rnd 4: With RS facing, join B with a sl st in any ch-3 sp, ch 5 (counts as dc, ch 2), dc in same sp, *ch 1, (dc, ch 2, dc) between next 2 sts, sk next 3 dc, (dc, ch 2, dc) in next dc, sk next 3 dc, (dc, ch 2, dc) between next 2 sts, ch 1, sk next dc**, (dc, ch 2, dc) in next ch-3 sp; rep from * around, ending last rep at **, join with a sl st in 3rd ch of beg ch-5—32 dc; 16 ch-2 sps; 8 ch-1 sps. Fasten off B.

Rnd 5: With RS facing, join D with a sl st in first ch-2 (corner) sp, ch 3, (dc, ch 2, 2 dc) in same sp, *dc in next ch-1 sp, [3 dc in next ch-2 sp, dc between next 2 sts] twice, 3 dc in next ch-2 sp, dc in next ch-1 sp**, (2 dc, ch 2, 2 dc) in next ch-2 sp; rep from * around, ending last rep at **, join with a sl st in top of beg ch-3—68 dc; 4 ch-2 sps. Fasten off D.

Rnd 6: With RS facing, join E with a sl st in any ch-2 sp, ch 2 (counts as hdc), (hdc, ch 2, 2 hdc) in same sp, *hdc in each of next 17 sts**, (2 hdc, ch 2, 2 hdc) in next ch-2 sp; rep from * around, ending last rep at **, join with a sl st in top of beg ch-2—84 hdc; 4 ch-2 sps. Fasten off E.

Alternate Colorway for Motif #51 ▶
(A) #3747 Gold (Rnd 1)
(B) #3750 Tangerine (Rnds 2 and 4)
(C) #3771 Paprika (Rnd 3)
(D) #3724 Armada (Rnds 5 and 6)

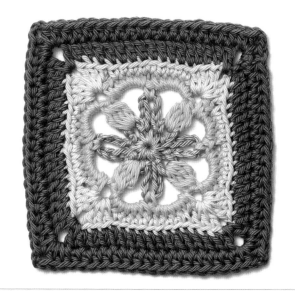

FINISHED SIZE
4½" (11.5 cm) across
before blocking.

HOOK
G-6 (4.0 mm).

GAUGE
First 3 rnds = 2½"
(6.5 cm) across.

COLORS
(A) #3717 Sand
(B) #3775 Cool Mint
(C) #3764 Sunshine
(D) #3774 Major Teal

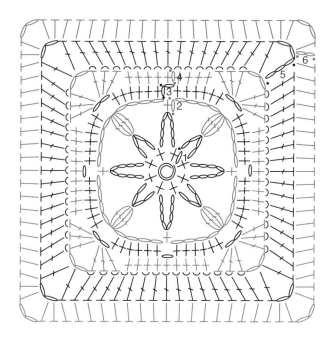

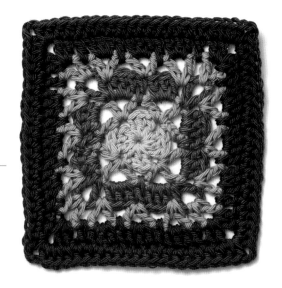

notes

- Ch 1 at the beg of rnds does not count as a st.

With A, make an adjustable ring.

Rnd 1: (RS) Ch 1, [sc, ch 8, sc, ch 4] 4 times in ring, join with a sl st in first sc—8 sc; 4 ch-8 sps; 4 ch-4 sps. Fasten off A.

Rnd 2: With RS facing, join B with a sl st in any ch-8 sp, ch 1, *sc in ch-8 sp, ch 4, 4-dc cluster in next ch-4 sp, ch 4; rep from * around, join with a sl st in first sc—4 sc; 8 ch-4 sps; 4 4-dc clusters.

Rnd 3: Sl st in next ch-4 sp, ch 1, *6 sc in ch-4 sp, ch 2, sk next 4-dc cluster, 6 sc in next ch-4 sp, ch 1, sk next sc; rep from * around, join with a sl st in first sc—48 sc; 4 ch-2 sps; 4 ch-1 sps. Fasten off B.

Rnd 4: With RS facing, join C with a sl st in any ch-1 sp, ch 1, *sc in ch-1 sp, sc in each of next 4 sts, sk next 2 sts, (3 dc, ch 2, 3 dc) in next ch-2 sp, sk next 2 sts, sc in each of next 4 sts; rep from * around, join with a sl st in first sc—36 sc; 24 dc; 4 ch-2 sps. Fasten off C.

Rnd 5: With RS facing, working in back lps only, join D with a sl st in any ch-2 sp, ch 5 (counts as dc, ch 2), dc in same sp, *dc in each of next 15 sts**, (dc, ch 2, dc) in next ch-2 sp; rep from * around, ending last rep at **, join with a sl st in top of beg ch-3—68 dc; 4 ch-2 sps.

Rnd 6: Sl st in next ch-2 sp, ch 2 (counts as hdc), (hdc, ch 2, 2 hdc) in same sp, *hdc in each of next 17 sts**, (2 hdc, ch 2, 2 hdc) in next ch-2 sp; rep from * around, ending last rep at **, join with a sl st in top of beg ch-2—84 hdc; 4 ch-2 sps. Fasten off D.

#53

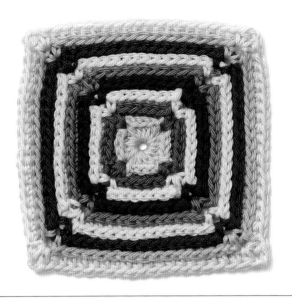

FINISHED SIZE
4½" (11.5 cm) across before blocking.

HOOK
G-6 (4.0 mm).

GAUGE
First 3 rnds = 2"
(5 cm) in diameter.

COLORS
(A) #3736 Ice
(B) #3774 Major Teal
(C) #3718 Natural
(D) #3823 Tomato
(E) #3750 Tangerine
(F) #3703 Magenta
(G) #3764 Sunshine

notes

- The "third lp" of the hdc utilized in this pattern is located on the back of the post of the st. It is distinct from the front and back lps of the st. After turning each corner, the third lp of the next stitch can be somewhat tight; be sure not to miss it!

- Ch 1 at the beg of rnds does not count as a st.

- Change colors on every round to create a notched appearance on the corners of the motif, or use the same color for consecutive rounds to show off the unique look of this stitch pattern.

With A, make an adjustable ring.

Rnd 1: (RS) Ch 1 (does not count as a st here and throughout), [4 hdc, ch 2] 4 times in ring, join with a sl st in first hdc—16 hdc; 4 ch-2 sps. Fasten off A.

Rnd 2: With RS facing, join B with a sl st in any ch-2 sp, ch 1, *(hdc, ch 2, hdc) in ch-2 sp, hdc in 3rd lp of each of next 4 sts; rep from * around, join with a sl st in first hdc—24 hdc; 4 ch-2 sps. Fasten off B.

Rnd 3: With RS facing, join C with a sl st in any ch-2 sp, ch 1, *(hdc, ch 2, hdc) in ch-2 sp, hdc in 3rd lp of each of next 6 sts; rep from * around, join with a sl st in first hdc—32 hdc; 4 ch-2 sps. Fasten off C.

Rnd 4: With RS facing, join D with a sl st in any ch-2 sp, ch 1, *(hdc, ch 2, hdc) in ch-2 sp, hdc in 3rd lp of each of next 8 sts; rep from * around, join with a sl st in first hdc—40 hdc; 4 ch-2 sps. Fasten off D.

Rnd 5: With RS facing, join E with a sl st in any ch-2 sp, ch 1, *(hdc, ch 2, hdc) in ch-2 sp, hdc in 3rd lp of each of next 10 sts; rep from * around, join with a sl st in first hdc—48 hdc; 4 ch-2 sps. Fasten off E.

Rnd 6: With RS facing, join C with a sl st in any ch-2 sp, ch 1, *(hdc, ch 2, hdc) in ch-2 sp, hdc in 3rd lp of each of next 12 sts; rep from * around, join with a sl st in first hdc—56 hdc; 4 ch-2 sps. Fasten off C.

Rnd 7: With RS facing, join F with a sl st in any ch-2 sp, ch 1, *(hdc, ch 2, hdc) in ch-2 sp, hdc in 3rd lp of each of next 14 sts; rep from * around, join with a sl st in first hdc—64 hdc; 4 ch-2 sps. Fasten off F.

Rnd 8: With RS facing, join G with a sl st in any ch-2 sp, ch 1, *(hdc, ch 2, hdc) in ch-2 sp, hdc in 3rd lp of each of next 16 sts; rep from * around, join with a sl st in first hdc—72 hdc; 4 ch-2 sps. Fasten off G.

Rnd 9: With RS facing, join C with a sl st in any ch-2 sp, ch 1, *(hdc, ch 2, hdc) in ch-2 sp, hdc in 3rd lp of each of next 18 sts; rep from * around, join with a sl st in first hdc—80 hdc; 4 ch-2 sps. Fasten off C.

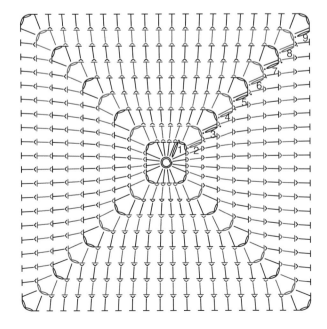

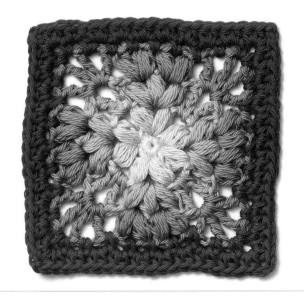

#54

FINISHED SIZE
4½" (11.5 cm) across
before blocking.

HOOK
G-6 (4.0 mm).

GAUGE
First 3 rnds = 2¼" (5.5 cm) in
diameter.

COLORS
(A) #3718 Natural
(B) #3764 Sunshine
(C) #3747 Gold
(D) #3750 Tangerine
(E) #3755 Lipstick Red

notes

- You can use a gradient of colors on subsequent rnds as shown, or experiment with your own unique pattern of changing colors to change up the look of the motif.

- Ch 1 at the beg of rnds does not count as a st.

With A, make an adjustable ring.

Rnd 1: (RS) Ch 1, work 8 sc in ring, join with a sl st in first sc—8 sc. Fasten off A.

Rnd 2: With RS facing, join B with a sl st in any st, (beg puff st, ch 2, puff st) in same st, ch 3, sk next st, *(puff st, ch 2, puff st) in next st, ch 3, sk next st; rep from * around, join with a sl st in beg puff st—8 puff sts; 4 ch-3 sps; 4 ch-2 sps. Fasten off B.

Rnd 3: With RS facing, join C with a sl st in any ch-3 sp, ch 6 (counts as tr, ch 2 here and throughout), tr in same sp, *(puff st, ch 2, puff st, ch 2, puff st) in next ch-2 sp**, (tr, ch 2, tr) in next ch-3 sp; rep from * around, ending last rep at **, join with a sl st in 3rd ch of beg ch-6—12 puff sts; 8 tr, 12 ch-2 sps. Fasten off C.

Rnd 4: With RS facing, join D with a sl st in any ch-2 sp between 2 tr, ch 6, ([tr, ch 2] twice, tr) in same sp, *ch 1, (puff st, ch 2, puff st, ch 1) in each of next 2 ch-2 sps**, ([tr, ch 2] 3 times, tr) in next corner ch-2 sp; rep from * around, ending last rep at **, join with a sl st in 3rd ch of beg ch-6—16 puff sts; 16 tr; 20 ch-2 sps; 12 ch-1 sps. Fasten off D.

Rnd 5: With RS facing, join E with a sl st in first ch-2 sp following join, ch 1, *sc in ch-2 sp, ch 2, (sc, ch 3, sc) in next ch-2 sp, [ch 2, sc] in each of next 7 sps; rep from * around, join with a sl st in first sc—36 sc; 32 ch-2 sps; 4 ch-3 sps.

Rnd 6: Sl st in next ch-2 sp, ch 2 (counts as hdc), hdc in same sp, *(2 hdc, ch 2, 2 hdc) in next ch-3 sp**, 2 hdc in each of next 8 ch-2 sps; rep from * around, ending last rep at **, 2 hdc in each of last 7 ch-2 sps, join with a sl st in top of beg ch-2—80 hdc; 4 ch-2 sps. Fasten off E.

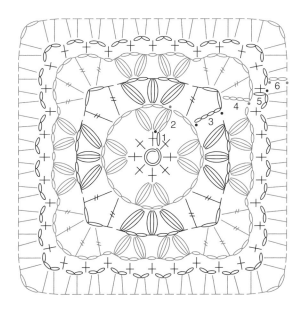

#55

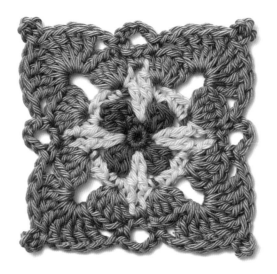

FINISHED SIZE
3½" (9 cm) across
before blocking.

HOOK
G-6 (4.0 mm).

GAUGE
First 3 rnds = 2¼"
(5.5 cm) across.

COLORS
(A) #3734 Teal
(B) #3775 Cool Mint
(C) #3729 Grey

notes

- Ch 1 at the beg of rnds does not count as a st.

With A, make an adjustable ring.

Rnd 1: (RS) Ch 1, work 8 sc in ring, join with a sl st in first sc—8 sc.

Rnd 2: Ch 3, 2-dc cluster in same st (counts as 3-dc cluster), ch 5, sk next st, *3-dc cluster in next st, ch 5, sk next st; rep from * around, join with a sl st in first 2-dc cluster—4 3-dc clusters; 4 ch-5 sps. Fasten off A.

Rnd 3: With RS facing, join B with a sl st in any ch-5 sp, ch 1, *2 sc in ch-5 sp, working in front of ch-5 sp of Rnd 2, (tr, ch 3, tr) in next skipped st in Rnd 1, 2 sc in same ch-5 sp, fpsc around the post of next 3-dc cluster; rep from * around, join with a sl st in first sc— 16 sc; 8 tr; 4 ch-3 sps; 4 fpsc. Fasten off B.

Rnd 4: With RS facing, join C with a sl st in any ch-3 sp, ch 1, *sc in ch-3 sp, sk next tr, 5 dc in next sc, ch 3, sk next 3 sts, 5 dc in next sc, sk next tr; rep from * around, join with a sl st in first sc—40 dc; 4 sc; 4 ch-3 sps.

Rnd 5: Sl st in next dc, ch 1, sc in same dc, *ch 1, sk next 4 sts, (4 tr, picot, 4 tr) in next ch-3 sp, ch 1, sk next 4 sts, sc in next dc, ch 4, sk next st**, sc in next st; rep from * around, ending last rep at **, join with a sl st in first sc—32 tr; 4 picots; 8 sc; 4 ch-4 sps; 8 ch-1 sps. Fasten off C.

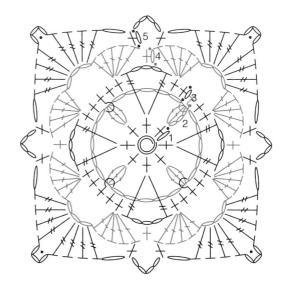

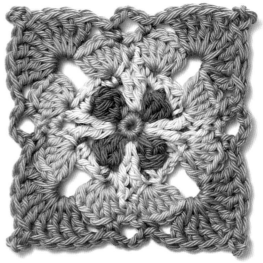

Alternate Colorway
(A) #3726 Periwinkle (Rnds 1 and 5)
(B) #3725 Cobalt (Rnd 2)
(C) #3763 Water Lily (Rnd 3)
(D) #3747 Gold (Rnd 4)

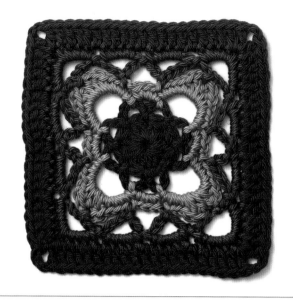

#56

FINISHED SIZE
4½″ (11.5 cm) across
before blocking.

HOOK
G-6 (4.0 mm).

GAUGE
First 3 rnds = 2″
(5 cm) across.

COLORS
(A) #3823 Tomato
(B) #3800 Blueberry
(C) #3725 Cobalt

notes

- Rnd 5 is closed with (ch 3, dc), which counts as a ch-6 sp. This better positions the hook for the beg of the next rnd.
- Ch 1 at the beg of rnds does not count as a st.

With A, make an adjustable ring.

Rnd 1: (RS) Ch 2, dc (counts as 2-dc cluster), ch 1, [2-dc cluster, ch 1] 7 times in ring, join with a sl st in first dc—8 2-dc clusters; 8 ch-1 sps.

Rnd 2: Sl st in next ch-1 sp, *ch 4, sl st in next ch-1 sp; rep from * around, join with a sl st in first sl st—8 ch-4 sps; 8 sl sts. Fasten off A.

Rnd 3: With RS facing, join B with a sl st in any ch-4 sp, *ch 7, sl st in next ch-4 sp, ch 3, sl st in next ch-4 sp; rep from * around, ending with last sl st in first sl st—4 ch-7 sps; 4 ch-3 sps; 8 sl sts.

Rnd 4: Sl st in next ch-7 sp, ch 1, *(4 sc, hdc, dc, ch 1, dc, hdc, 4 sc) in ch-7 sp, 3 sc in next ch-3 sp; rep from * around, join with a sl st in first sc— 44 sc; 8 hdc; 8 dc; 4 ch-1 sps. Fasten off B.

Rnd 5: With RS facing, join C with a sl st in any ch-1 sp, *ch 6, sk next 5 sts, sl st in next st, ch 6, sk next 3 sts, sl st in next st**, ch 6, sk next 5 sts, sl st in next ch-1 sp; rep from * around, ending last rep at **, join with ch 3, dc in first sl st instead of last ch-6 sp—12 ch-6 sps; 12 sl sts.

Rnd 6: *Ch 6, sl st in next ch-6 sp, (ch 4, sl st) in each of next 2 ch-6 sps; rep from * around, ending with last sl st in last ch-6 sp of Rnd 5—4 ch-6 sps; 8 ch-4 sps; 12 sl sts.

Rnd 7: Sl st in next ch-6 sp, ch 1, *(4 sc, ch 2, 4 sc) in ch-6 sp (corner), (ch 2, 4 sc) in each of next 2 ch-4 sps, ch 2; rep from * around, join with a sl st in first sc— 64 sc; 16 ch-2 sps. Fasten off C.

Rnd 8: With RS facing, join A with a sl st in any corner ch-2 sp, ch 5 (counts as dc, ch 2), dc in same sp, *[dc in each of next 4 sts, dc in next ch-2 sp] 3 times, dc in each of next 4 sts**, (dc, ch 2, dc) in next ch-2 sp; rep from * around, ending last rep at **, join with a sl st in 3rd ch of beg ch-5— 84 dc; 4 ch-2 sps. Fasten off A.

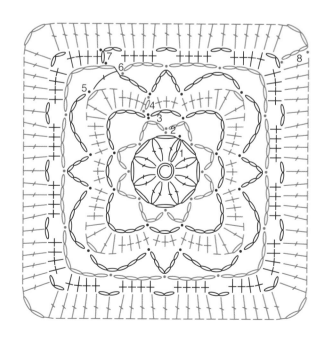

#57

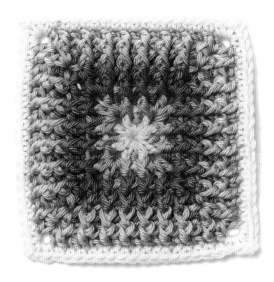

FINISHED SIZE
4¼" (11 cm) across
before blocking.

HOOK
G-6 (4.0 mm).

GAUGE
First 3 rnds = 2¼"
(5.5 cm) across.

COLORS
(A) #3775 Cool Mint
(B) #3735 Jade
(C) #3734 Teal
(D) #3761 Juniper
(E) #3738 Spearmint
(F) #3807 Jasmine Green
(G) #3728 White

notes

- Use ombré or gradient colors to lend a modern look. Or focus on one central color to put the spotlight on the ribbing created by the front and back post stitches.

Alternate Colorway
(A) #3732 Aqua (Rnds 1–6)
(B) #3728 White (Rnd 7)

With A, make an adjustable ring.

Rnd 1: (RS) Ch 3 (counts as dc here and throughout), 2 dc in ring, ch 2, (3 dc, ch 2) 3 times in ring, join with a sl st in top of beg ch-3—12 dc; 4 ch-2 sps. Fasten off A.

Rnd 2: With RS facing, join B with a sl st in any ch-2 sp, ch 3 (counts as dc), (dc, ch 2, 2 dc) in same sp, *fpdc around the post of next st, bpdc around the post of next st, fpdc around the post of next st**, (2 dc, ch 2, 2 dc) in next ch-2 sp; rep from * around, ending last rep at **, join with a sl st in top of beg ch-3—16 dc; 8 fpdc; 4 bpdc; 4 ch-2 sps. Fasten off B.

Rnd 3: With RS facing, join C with a sl st in any ch-2 sp, ch 2 (counts as hdc here and throughout), (hdc, ch 2, 2 hdc) in same sp, *(fpdc around the post of next st, bpdc around the post of next st) 3 times, fpdc around the post of next st**, (2 hdc, ch 2, 2 hdc) in next ch-2 sp; rep from * around, ending last rep at **, join with a sl st in top of beg ch-2—16 hdc; 16 fpdc; 12 bpdc; 4 ch-2 sps. Fasten off C.

Rnd 4: With RS facing, join D with a sl st in any ch-2 sp, ch 4 (counts as hdc, ch 2 here and throughout), hdc in same sp, *[fpdc around the post of next st, bpdc around the post of next st] 5 times, fpdc around the post of next st**, (hdc, ch 2, hdc) in next ch-2 sp; rep from * around, ending last rep at **, join with a sl st in 2nd ch of beg ch-4—8 hdc; 24 fpdc; 20 bpdc; 4 ch-2 sps. Fasten off D.

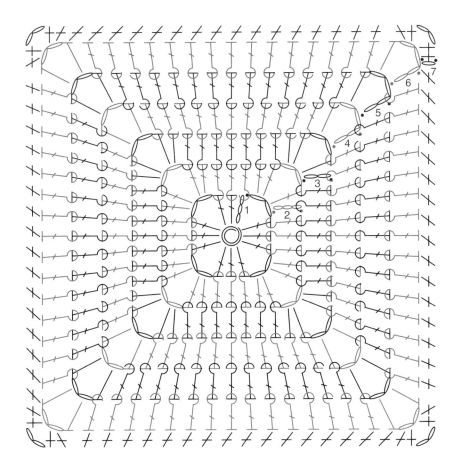

Rnd 5: With RS facing, join E with a sl st in any ch-2 sp, ch 4, hdc in same sp, *[bpdc around the post of next st, fpdc around the post of next st] 6 times, bpdc around the post of next st**, (hdc, ch 2, hdc) in next ch-2 sp; rep from * around, ending last rep at **, join with a sl st in 2nd ch of beg ch-4—8 hdc; 24 bpdc; 28 fpdc; 4 ch-2 sps. Fasten off E.

Rnd 6: With RS facing, join F with a sl st in any ch-2 sp, ch 4, hdc in same sp, *[fpdc around the post of next st, bpdc around the post of next st] 7 times, fpdc around the post of next st**, (hdc, ch 2, hdc) in next ch-2 sp; rep from * around, ending last rep at **, join with a sl st in 2nd ch of beg ch-4—8 hdc; 32 fpdc; 28 bpdc; 4 ch-2 sps. Fasten off F.

Rnd 7: With RS facing, join G with a sl st in any ch-2 sp, ch 1, *(2 sc, ch 2, 2 sc) in ch-2 sp, sk next st, sc in each of next 16 sts; rep from * around, join with a sl st in first sc—80 sc; 4 ch-2 sps. Fasten off G.

#58

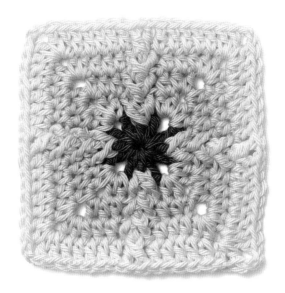

FINISHED SIZE
3¾" (9.5 cm) across
before blocking.

HOOK
G-6 (4.0 mm).

GAUGE
First 3 rnds = 2¼"
(5.5 cm) across.

COLORS
(A) #3701 Cranberry
(B) #3711 China Pink
(C) #3764 Sunshine
(D) #3743 Yellow Rose
(E) #3718 Natural

notes

- Try using the same color on subsequent rnds to better highlight the texture of the post sts.

With A, make an adjustable ring.

Rnd 1: (RS) Ch 3 (counts as dc here and throughout), 2 dc in ring, ch 2, (3 dc, ch 2) 3 times in ring, join with a sl st in top of beg ch-3—12 dc; 4 ch-2 sps. Fasten off A.

Rnd 2: With RS facing, join B with a sl st in any ch-2 sp, ch 2 (counts as hdc here and throughout), (hdc, ch 2, 2 hdc) in same sp, *sk next st, (fpdc, 1 hdc, fpdc) in next st, sk next st**, (2 hdc, ch 2, 2 hdc) in next ch-2 sp; rep from * around, ending last rep at **, join with a sl st in top of beg ch-2—20 hdc; 8 fpdc; 4 ch-2 sps. Fasten off B.

Rnd 3: With RS facing, join C with a sl st in any ch-2 sp, ch 4 (counts as hdc, ch 2), hdc in same sp, *hdc in each of next 2 sts, sk next st, (fpdc, hdc, fpdc) in next hdc, sk next st, hdc in each of next 2 sts**, (hdc, ch 2, hdc) in next ch-2 sp; rep from * around, ending last rep at **, join with a sl st in 2nd ch of beg ch-4—28 hdc; 8 fpdc; 4 ch-2 sps. Fasten off C.

Rnd 4: With RS facing, join D with a sl st in any ch-2 sp, ch 2, (hdc, ch 2, 2 hdc) in same sp, *hdc in each of next 3 sts, sk next st, (fpdc, hdc, fpdc) in next hdc, sk next st, hdc in each of next 3 sts**, (2 hdc, ch 2, 2 hdc) in next ch-2 sp; rep from * around, ending last rep at **, join with a sl st in top of beg ch-2—44 hdc; 8 fpdc; 4 ch-2 sps. Fasten off D.

Rnd 5: With RS facing, join E with a sl st in any ch-2 sp, ch 3, (dc, ch 2, 2 dc) in same sp, *dc in each of next 5 sts, sk next st, (fpdc, ch 1, fpdc) in next hdc, sk next st, dc in each of next 5 sts**, (2 dc, ch 2, 2 dc) in next ch-2 sp; rep from * around, ending last rep at **, join with a sl st in top of beg ch-3—56 dc; 8 fpdc; 4 ch-2 sps; 4 ch-1 sps. Fasten off E.

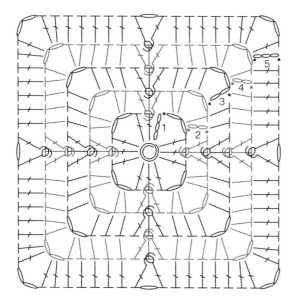

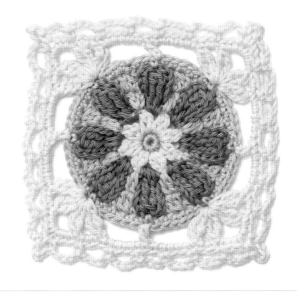

FINISHED SIZE
5" (12.5 cm) across before blocking.

HOOK
G-6 (4.0 mm).

GAUGE
First 3 rnds = 3¼" (8.5 cm) across.

COLORS
(A) #3747 Gold
(B) #3718 Natural
(C) #3805 Colony Blue
(D) #3763 Water Lily

#59

notes

• Ch 1 at the beg of rnds does not count as a st.

With A, make an adjustable ring.

Rnd 1: (RS) Ch 1, work 8 sc in ring, join with a sl st in first sc—8 sc. Fasten off A.

Rnd 2: With RS facing, join B with a sl st in any st, ch 3 (counts as dc here and throughout), dc in same st, ch 1, (2 dc, ch 1) in each st around, join with a sl st in top of beg ch-3—16 dc; 8 ch-1 sps. Fasten off B.

Rnd 3: With RS facing, join C with a sl st in any ch-1 sp, *(ch 6, 2-dtr cluster, ch 6, sl st) in ch-1 sp, sk next 2 dc, sl st in next ch-1 sp; rep from * around, join with a sl st in first sl st—16 ch-6 sps, 8 2-dtr clusters; 16 sl sts. Fasten off C.

Rnd 4: With RS facing, join D with a sl st in same st as join, ch 3, dc in same st, *working behind the sts in Rnd 3, ch 3, sk (ch 6, 2-dtr cluster, ch 6, sl st)**, 2 dc in next sl st; rep from * around, ending last rep at **, join with a sl st in top of beg ch-3—16 dc; 8 ch-3 sps.

Rnd 5: Ch 2, dc in next st (counts as dc2tog), *5 dc in next ch-3 sp**, dc2tog over next 2 dc; rep from * around, ending last rep at **, join with a sl st in first dc—40 dc; 8 dc2tog.

Rnd 6: Ch 1, 2 sc in same st, *sc in each of next 2 sts, sc in 2-dtr cluster of Rnd 3 and next dc of Rnd 5, sc in each of next 2 sts**, 2 sc in next st; rep from * around, ending last rep at **, join with a sl st in first sc—56 sc. Fasten off D.

Rnd 7: With RS facing, join B with a sl st in any sc worked through both Rnds 3 and 5, ch 3, tr in same st (counts as 2-tr cluster), (ch 2, 2-tr cluster, ch 4, 2-tr cluster, ch 2, 2-tr cluster) in same st, *ch 5, sk next 6 sts, dc in next st, ch 5, sk next 6 sts**, (2-tr cluster, ch 2, 2-tr cluster, ch 4, 2-tr cluster, ch 2, 2-tr cluster) in next st; rep from * around, ending last rep at **, join with a sl st in first tr—16 2-tr clusters; 8 ch-2 sps; 4 dc; 4 ch-4 sps; 8 ch-5 sps.

Rnd 8: Sl st in next ch-2 sp, ch 1, *2 sc in ch-2 sp, (3 sc, ch 2, 3 sc) in next ch-4 sp, 2 sc in next ch-2 sp, 5 sc in next ch-5 sp, sc in next st, 5 sc in next ch-5 sp; rep from * around, join with a sl st in first sc—84 sc; 4 ch-2 sps. Fasten off B.

Rnd 9: With RS facing, join B with a sl st in any ch-2 sp, ch 1, *sc in ch-2 sp, ch 4, [sc in next st, ch 4, sk next 2 sts] 7 times; rep from * around, join with a sl st in first sc—32 sc; 32 ch-4 sps. Fasten off B.

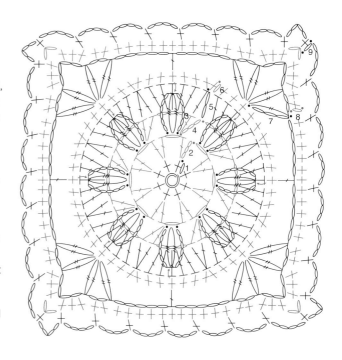

#60

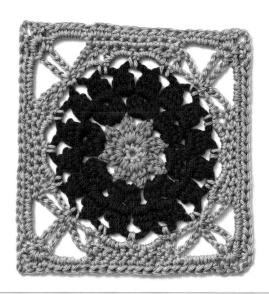

FINISHED SIZE
5¼" (13.5 cm) across
before blocking.

HOOK
G-6 (4.0 mm).

GAUGE
First 3 rnds = 3"
(7.5 cm) across.

COLORS
(A) #3747 Gold
(B) #3735 Jade
(C) #3823 Tomato
(D) #3704 Syrah
(E) #3717 Sand

notes

- Ch 1 at the beg of rnds does not count as a st.
- Change colors on every rnd of the "flower" for a bold look, or use the same color throughout to accent the petals.

With A, make an adjustable ring.

Rnd 1: (RS) Ch 1, work 8 sc in ring, join with a sl st in first sc—8 sc. Fasten off A.

Rnd 2: With RS facing, join B with a sl st in any st, ch 3, 2-dc cluster in same st (counts as 3-dc cluster here and throughout), ch 3, (3-dc cluster, ch 3) in each st around, join with a sl st in first 2-dc cluster—8 3-dc clusters; 8 ch-3 sps. Fasten off B.

Rnd 3: With RS facing, join C with a sl st in any ch-3 sp, ch 3, (2-dc cluster, ch 2, 3-dc cluster) in same sp, ch 2, (3-dc cluster, ch 2, 3-dc cluster, ch 2) in each ch-3 sp around, join with a sl st in first 2-dc cluster—16 3-dc clusters; 16 ch-2 sps. Fasten off C.

Rnd 4: With RS facing, join D with a sl st in any ch-2 sp, ch 3, 4-dc cluster in same sp (counts as 5-dc cluster), ch 4, (5-dc cluster, ch 4) in each ch-2 sp around, join with a sl st in first 4-dc cluster—16 5-dc clusters; 16 ch-4 sps. Fasten off D.

Rnd 5: With RS facing, join E with a sl st in any ch-4 sp, ch 1, (sc, ch 4) in each ch-4 sp around, join with a sl st to first sc—16 sc; 16 ch-4 sps.

Rnd 6: *Ch 10, sl st in same st, ch 5, dc in next ch-4 sp, (dc, hdc, 2 sc) in next ch-4 sp, (2 sc, hdc, dc) in next ch-4 sp, dc in next ch-4 sp, ch 5, sl st in next sc; rep from * around, ending with last sl st in first st of Rnd 5—4 ch-10 sps; 8 ch-5 sps; 16 dc; 8 hdc; 16 sc. Fasten off E.

Rnd 7: With RS facing, join E with a sl st in any ch-10 sp, ch 1, *(sc, ch 3, sc) in ch-10 sp, ch 5, sk next ch-5 sp, sc in each of next 10 sts, ch 5, sk next ch-5 sp; rep from * around, join with a sl st in first sc—48 sc; 4 ch-3 sps; 8 ch-5 sps.

Rnd 8: Sl st in next ch-3 sp, ch 3 (counts as dc), (dc, ch 2, 2 dc) in same sp, *5 hdc in next ch-5 sp, hdc in each of next 10 sts, 5 hdc in next ch-5 sp**, (2 dc, ch 2, 2 dc) in next ch-3 sp; rep from * around, ending last rep at **, join with a sl st in top of beg ch-3—16 dc; 4 ch-2 sps; 80 hdc. Fasten off E.

Alternate Colorway for Motif #60 ▶
(A) #3755 Lipstick Red (Rnd 1)
(B) #3767 Deep Coral (Rnds 2–4)
(C) #3719 Buff (Rnds 5–8)

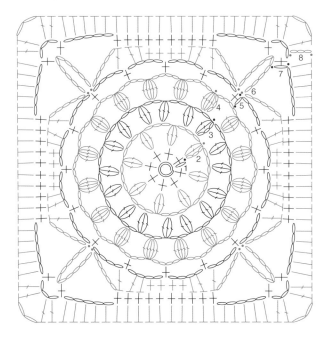

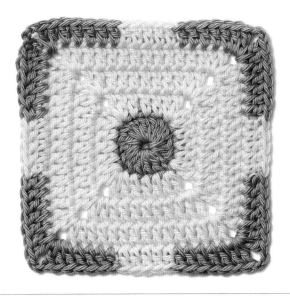

FINISHED SIZE
4″ (10 cm) across
before blocking.

HOOK
G-6 (4.0 mm).

GAUGE
First 3 rnds = 2½″
(6.5 cm) across.

COLORS
(A) #3776 Pink Rose
(B) #3718 Natural

#61

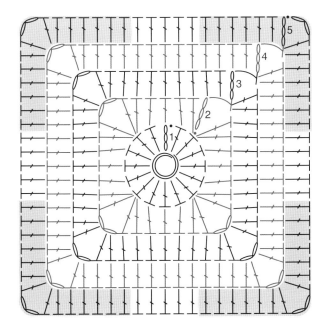

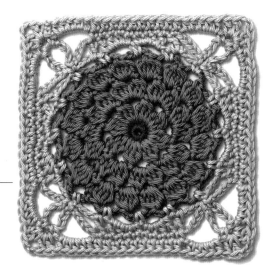

notes

- Ch 1 at the beg of rnds does not count as a st.
- Rnds 2–4 are closed with a hdc which counts as as a ch-2 sp. This better positions the hook to beg the next rnd.

With A, make an adjustable ring.

Rnd 1: (RS) Ch 3 (counts as dc here and throughout), work 15 dc in ring, join with a sl st in top of beg ch-3—16dc. Fasten off A.

Rnd 2: With RS facing, join B with a sl st in any st, ch 3, dc in same st, *dc in each of next 3 sts**, (2 dc, ch 2, 2 dc) in next st; rep from * around, ending last rep at **, 2 dc in first corner sp, join with hdc in top of beg ch-3—28 dc; 4 ch-2 sps.

Rnd 3: Ch 3, dc in first corner sp, *dc in each of next 7 sts**, (2 dc, ch 2, 2 dc) in next st; rep from * around, ending last rep at **, 2 dc in first corner sp, join with hdc in top of beg ch-3—44 dc; 4 ch-2 sps.

Rnd 4: Ch 3, dc in first corner sp, *dc in each of next 11 sts**, (2 dc, ch 2, 2 dc) in next st; rep from * around, ending last rep at **, 2 dc in first corner sp, join with hdc in top of beg ch-3. Drop B, join A—60 dc; 4 ch-2 sps.

Rnd 5: With A, ch 3, working over strand of B, dc in first corner sp, *dc in each of next 5 sts, drop A, pick up B, with B, dc in each of next 5 sts, drop B, pick up A, with A, dc in each of next 5 sts**, (2 dc, ch 2, 2 dc) in next ch-2 sp; rep from * around, ending last rep at **, join with a sl st in top of beg ch-3—76 dc; 4 ch-2 sps. Fasten off A and B.

#62

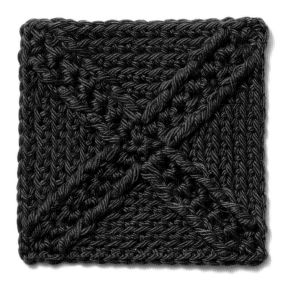

FINISHED SIZE
3¼" (8.5 cm) across before blocking.

HOOK
F-5 (3.75 mm).

GAUGE
First 3 rnds = 1½" (3.8 cm) across.

COLORS
(A) #3779 Pansy

notes

- Ch 1 at the beg of rnds does not count as a st.
- Rnds are closed with a hdc, which counts as a ch-2 sp. This better positions the hook to begin the next round.
- Work all rnds in the back lp, except in the corner sps.
- Work this motif in a single color to create a subtly textured fabric. Change colors on alternate rnds to better highlight the post sts.

With A, make an adjustable ring.

Rnd 1: (RS) Ch 1, [sc, ch 2] 3 times in ring, sc in ring, join with hdc in first sc instead of last ch-2 sp—4 sc; 4 ch-2 sps.

Rnd 2: Ch 1, sc in corner sp formed by hdc, *sc in next st**, (sc, ch 2, sc) in next ch-2 sp; rep from * around, ending last rep at **, sc in first corner sp, join with hdc in first sc instead of last ch-2 sp—12 sc; 4 ch-2 sps.

Rnd 3: Ch 1, sc in corner sp formed by hdc, *sc in each of next 3 sts**, (sc, ch 2, sc) in next ch-2 sp; rep from * around, ending last rep at **, sc in first corner sp, join with hdc in first sc instead of last ch-2 sp—20 sc; 4 ch-2 sps.

Rnd 4: Ch 1, sc in corner sp formed by hdc, *tr in front lp only of next sc in Rnd 1, sk next st in current rnd, sc in each of next 3 sts, tr in front lp of same sc in Rnd 1, sk next st in current rnd**, (sc, ch 2, sc) in next ch-2 sp; rep from * around, ending last rep at **, sc in first corner sp, join with hdc in first sc instead of last ch-2 sp—20 sc, 8 tr, 4 ch-2 sps.

Rnd 5: Ch 1, sc in corner sp formed by hdc, *sc in each of next 7 sts**, (sc, ch 2, sc) in next ch-2 sp; rep from *

around, ending last rep at **, sc in first corner sp, join with hdc in first sc instead of last ch-2 sp—36 sc; 4 ch-2 sps.

Rnd 6: Ch 1, sc in corner sp formed by hdc, *fptr around the post of next tr in Rnd 4, sk next st in current rnd, sc in each of next 7 sts, fptr around the post of next tr in Rnd 4, sk next st in current rnd**, (sc, ch 2, sc) in next ch-2 sp; rep from * around, ending last rep at **, sc in first corner sp, join with hdc in first sc instead of last ch-2 sp—36 sc; 8 fptr; 4 ch-2 sps.

Rnd 7: Ch 1, sc in corner sp formed by hdc, *sc in each of next 11 sts**, (sc, ch 2, sc) in next ch-2 sp; rep from * around, ending last rep at **, sc in first corner sp, join with hdc in first sc instead of last ch-2 sp—52 sc; 4 ch-2 sps.

Rnd 8: Ch 1, sc in corner sp formed by hdc, *fptr around the post of next tr in Rnd 6, sk next st in current rnd, sc in each of next 11 sts, fptr around the post of next tr in Rnd 6, sk next st in current rnd**, (sc, ch 2, sc) in next ch-2 sp; rep from * around, ending last rep at **, sc in first corner sp, join with hdc in first sc instead of last ch-2 sp—52 sc; 8 fptr; 4 ch-2 sps. Fasten off A.

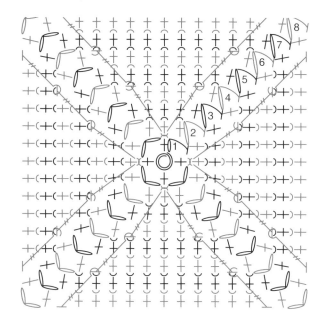

FINISHED SIZE
2" (5 cm) across
before blocking.

HOOK
G-6 (4.0 mm).

GAUGE
First rnd = 1½"
(3.8 cm) across.

COLORS
(A) #3800 Blueberry
(B) #3719 Buff

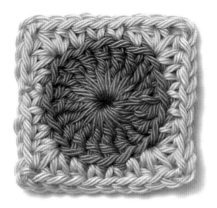

#63

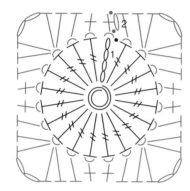

notes

- This sweet little motif is perfect for using up scraps from other motifs! You can also use it as a filler with motifs #96 and #97.

- Ch 1 at the beg of rnd does not count as a st.

With A, make an adjustable ring.

Rnd 1: (RS) Ch 4 (counts as tr), work 19 tr in ring, join with a sl st in top of beg ch-4—20 tr. Fasten off A.

Rnd 2: With RS facing, working in back lps only, join B with a sl st in any st, ch 1, sc in each of first 2 sts, *hdc in next st, (2 hdc, ch 2, 2 hdc) in next st, hdc in next st**, sc in each of next 2 sts; rep from * around, ending last rep at **, join with a sl st in first sc—8 sc; 24 hdc; 4 ch-2 sps. Fasten off B.

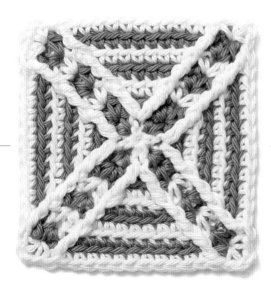

◀ *Alternate Colorway for Motif #62*
(A) #3728 White (Rnds 1, 4, 6, 8)
(B) #3735 Jade (Rnds 2, 3, 5, 7)

#64

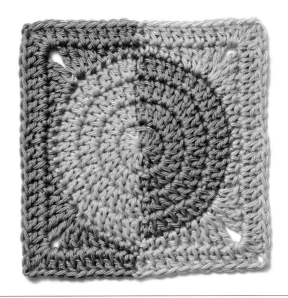

FINISHED SIZE
4½" (11.5 cm) across
before blocking.

HOOK
G-6 (4.0 mm).

GAUGE
First 3 rnds = 2¼"
(5.5 cm) across.

COLORS
(A) #3775 Cool Mint
(B) #3752 Coral

notes

- This motif is worked using tapestry crochet. To switch colors, complete the final step of the previous stitch with the new color. Carry along the unused color behind the working color. The increases in the center circle of this motif are alternated between rows to keep the seam straight.

- Ch 1 and ch 2 at the beginning of rnds do not count as sts.

With A, make an adjustable ring.

Rnd 1: (RS) Ch 3 (counts as dc), 5 dc in ring, drop A, join B, with B, working over strand of A, work 6 dc in ring, drop B, pick up A, join with a sl st in top of beg ch-3—12 dc.

Rnd 2: With A, ch 2, working over strand of B, 2 dc in same st as join, 2 dc in each of next 5 sts, drop A, pick up B, with B, working over strand of A, 2 dc in each of next 6 sts, drop B, pick up A, join with a sl st in first dc—24 dc.

Rnd 3: With A, ch 2, working over strand of B, dc in same st as join, [2 dc in next st, dc in next st] 5 times, 2 dc in next st, drop A, pick up B, with B, working over strand of A, [dc in next st, 2 dc in next st] 6 times, drop B, pick up A, join with a sl st in first dc—36 dc.

Rnd 4: With A, ch 2, working over strand of B, 2 dc in same st as join, [dc in each of next 2 sts, 2 dc in next st] 5 times, dc in each of next 2 sts, drop A, pick up B, with B, working over strand of A, [2 dc in next st, dc in each of next 2 sts] 6 times, join with a sl st in first dc—48 dc.

Rnd 5: With B, working over strand of A, ch 1, *sc in dc, sc in next st, hdc in each of next 2 sts, dc in next st, (dc,

2 tr) in next st, ch 2, (2 tr, dc) in next st, dc in next st, hdc in each of next 2 sts, sc in each of next 4 sts, hdc in each of next 2 sts, dc in next st, (dc, 2 tr) in next st, ch 2, (2 tr, dc) in next st, dc in next st, hdc in each of next 2 sts, sc in each of next 2 sts*, drop B, pick up A, with A, working over strand of B, rep from * to * once; drop A, pick up B, join with a sl st in first sc—16 sc; 16 hdc; 16 dc; 16 tr; 4 ch-2 sps.

Rnd 6: With B, working over strand of A, ch 2, *dc in first 8 sts, (2 dc, ch 2, 2 dc) in next ch-2 sp, dc in each of next 16 sts, (2 dc, ch 2, 2 dc) in next ch-2 sp, dc in each of next 8 sts*, drop B, pick up A, with A, working over strand of B, rep from * to * once, drop A, pick up B, join with a sl st in first dc—80 dc; 4 ch-2 sp. Fasten off.

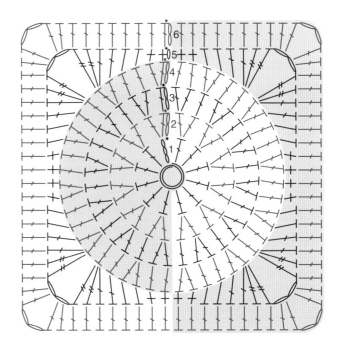

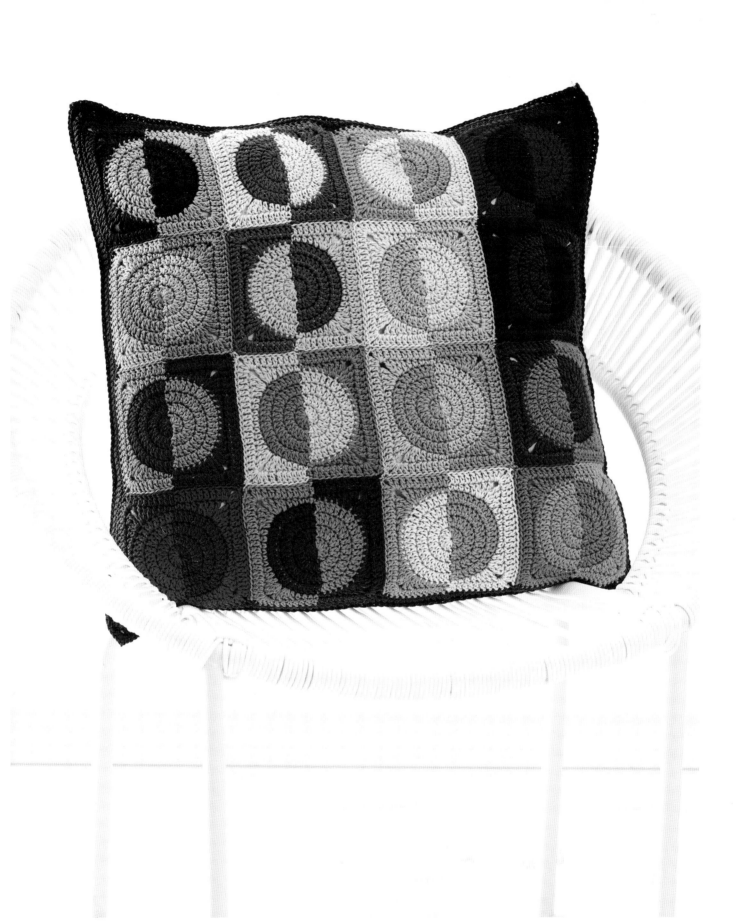

THE MOTIFS:
hexagons

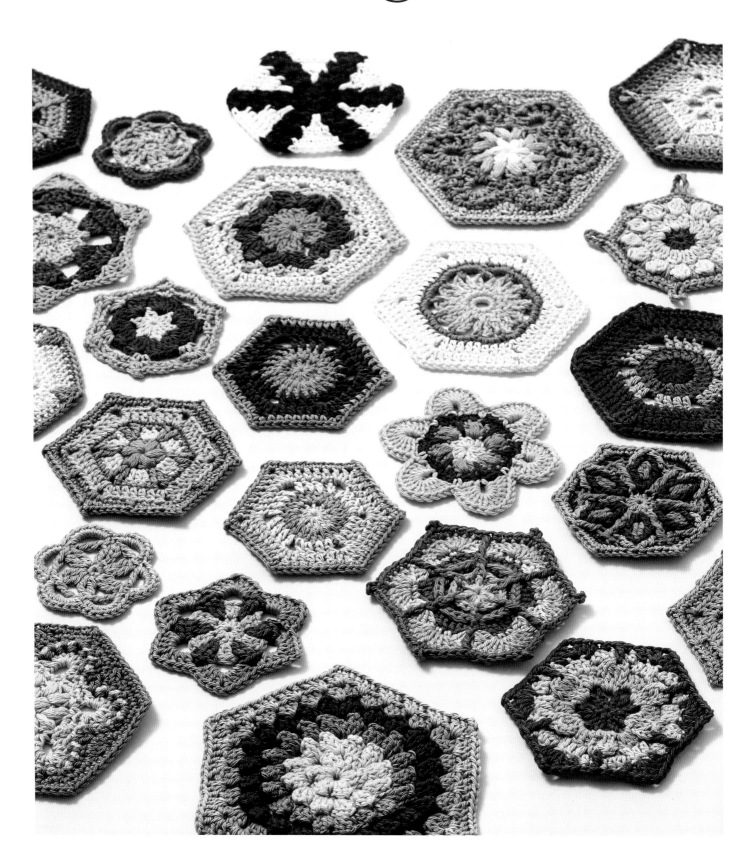

FINISHED SIZE

3¾" (9.5 cm) edge to edge
before blocking

HOOK

G-6 (4.0 mm).

GAUGE

First 3 rnds = 2¾"
(7 cm) edge to edge.

COLORS

(A) #3721 Ginseng
(B) #3793 Indigo Blue
(C) #3710 Orchid

#65

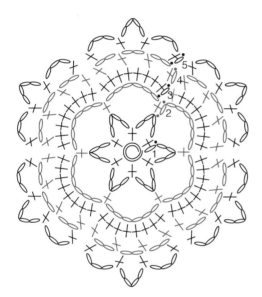

notes

- This lacy motif is worked using only the most basic of sts: ch sts and sc.

- Ch 1 at the beg of rnds does not count as a st.

- You can experiment with using just two colors for this motif by using one color for Rnds 1–3 and a 2nd color for Rnds 4–5.

With A, make an adjustable ring.

Rnd 1: (RS) Ch 1, [sc, ch 4] 6 times in ring, join with a sl st in first sc—6 sc; 6 ch-4 sps. Fasten off A.

Rnd 2: With RS facing, join B with a sl st in any ch-4 sp, ch 1, (sc, ch 6) in each ch-4 sp around, join with a sl st in first sc—6 sc; 6 ch-6 sps.

Rnd 3: Sl st in next ch-6 sp, ch 1, 8 sc in each ch-6 sp around, join with a sl st in first sc—48 sc. Fasten off B.

Rnd 4: With RS facing, join C with a sl st in same st as join, ch 1, sc in first st, *[ch 2, sk next st, sc in next st] 3 times, sk next st; rep from * around, join with a sl st in first sc—24 sc; 18 ch-2 sps.

Rnd 5: Sl st in next ch-2 sp, ch 1, *sc in ch-2 sp, ch 3, (sc, ch 4, sc) in next ch-2 sp, ch 3, sc in next ch-2 sp; rep from * around, join with sl st in first sc—24 sc; 6 ch-4 sps; 12 ch-3 sps. Fasten off C.

#66

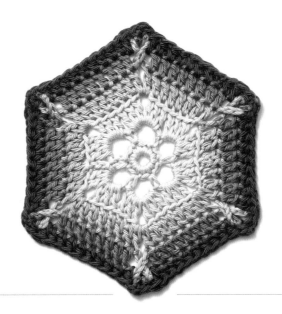

FINISHED SIZE
4½" (11.5 cm) edge to edge
before blocking.

HOOK
G-6 (4.0 mm).

GAUGE
First 3 rnds = 2¼"
(5.5 cm) edge to edge.

COLORS
(A) #3736 Ice
(B) #3727 Sky Blue
(C) #3800 Blueberry
(D) #3725 Cobalt

notes

- The chain lps on Rnds 4 and 5 remain loose until they are worked into while working the final rnd. When pulling the lp from rnd 4 through the lp from Rnd 5, twist the ch-8 sp once, counterclockwise to form a ring, and then, using your hook, pull the ch-6 lp through the resulting ring.

- Ch 1 at the beginning of rnds does not count as a st.

With A, make an adjustable ring.

Rnd 1: (RS) Ch 1, work 12 sc in ring, join with a sl st in first sc—12 sc.

Rnd 2: Ch 1, sc in first sc, *ch 4, sk next st**, sc in next st; rep from * around, ending last rep at **, join with a sl st in first sc—6 sc; 6 ch-4 sps.

Rnd 3: Sl st in next ch-4 sp, ch 3 (counts as dc here and throughout), (2 dc, ch 2, 3 dc) in same ch-4 sp, (3 dc, ch 2, 3 dc) in each ch-4 sp around, join with a sl st in top of beg ch-3—36 dc; 6 ch-2 sps. Fasten off A.

Rnd 4: Work this round in back lp only, with the exception of stitches made into chain spaces. With RS facing, join B with a sl st in any ch-2 sp, ch 11 (counts as dc, ch 8), dc in same sp, *dc in each of next 6 sts**, (dc, ch 8, dc) in next ch-2 sp, rep from * around, ending last rep at **, join with a sl st in 3rd ch of beg ch-11—48 dc; 6 ch-8 sps. Fasten off B.

Rnd 5: With RS facing, join C with a sl st in first st to the left of any ch-8 sp, ch 3 (counts as dc here and through-out), dc in each of next 7 sts, *ch 6, sk next ch-8 sp**, dc in each of next 8 sts; rep from * around, ending last rep at **, join with a sl st in top of beg ch-3. Fasten off C. Twist ch-8 lp from Rnd 4, and pull ch-6 lp from Rnd 5 through resulting ring—48 dc; 6 ch-6 sps.

Rnd 6: With RS facing, join D with a sl st in same st as join, ch 2 (counts as hdc), hdc in each of next 7 sts, *dc in next ch-6 sp of Rnd 5 to the right of the ch-8 lp of Rnd 4, (sc, ch 1, sc) in the part of the ch-6 lp pulled through the ch-8 lp, dc in left-hand side of same ch-6 sp to the left of the ch-8 lp, hdc in each of next 8 sts; rep from * around, join with a sl st in top of beg ch-2—48 hdc; 12 sc; 6 ch-1 sps; 12 dc. Fasten off D.

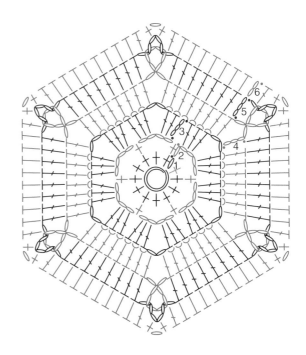

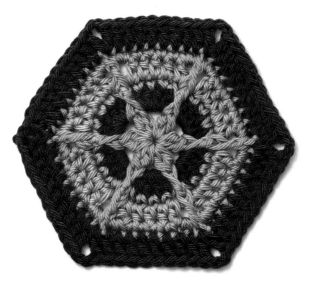

FINISHED SIZE
3¾" (9.5 cm) edge to edge
before blocking

HOOK
G-6 (4.0 mm).

GAUGE
First 3 rnds = 2"
(5 cm) edge to edge.

COLORS
(A) #3776 Pink Rose
(B) #3724 Armada
(C) #3717 Sand

#67

notes

- Ch 1 at the beg of rnds does not count as a st.
- Using just 2 colors instead of 3 highlights the post sts more clearly.

With A, make an adjustable ring.

Rnd 1: (RS) Ch 2, dc in ring (counts as 2-dc cluster), ch 2, [2-dc cluster, ch 2] 5 times in ring, join with a sl st in first dc—6 2-dc clusters; 6 ch-2 sps. Fasten off A.

Rnd 2: With RS facing, join B with a sl st in any ch-2 sp, ch 2 (counts as hdc here and throughout), 3 hdc in same sp, 4 hdc in each ch-2 sp around, join with a sl st in top of beg ch-2—24 hdc. Fasten off B.

Rnd 3: With RS facing, join A with a sl st in 2nd hdc of any 4-hdc group, ch 1, sc in first st, sc in each of next 2 sts, *(sc, working over sts in Rnd 2, fpdc around the post of 2-dc cluster in Rnd 1, sc) between next 2 hdc, sk next st; rep from * around, join with a sl st in first sc—30 sc; 6 fpdc. Fasten off A.

Rnd 4: With RS facing, join C with a sl st in first st to the right of join, ch 2, hdc in each of next 4 sts, *ch 3, sk next fpdc**, hdc in each of next 5 sts; rep from * around, ending last rep at **, join with a sl st in top of beg ch-2—30 hdc; 6 ch-3 sps. Fasten off C.

Rnd 5: With RS facing, join A with a sl st in any ch-3 sp, ch 1, *(2 sc, working over ch-3 sp in Rnd 4, fpdc around the post of next fpdc in Rnd 3, 2 sc) in ch-3 sp, sk next st, sc in each of next 4 sts; rep from * around, join with a sl st in first sc—48 sc; 6 fpdc. Fasten off A.

Rnd 6: With RS facing, join B with a sl st in any fpdc, ch 5 (counts as dc, ch 2), dc in same st, *dc in each of next 8 sts**, (dc, ch 2, dc) in next st; rep from * around, ending last rep at **, join with a sl st in 3rd ch of beg ch-5—60 dc; 6 ch-2 sps. Fasten off B.

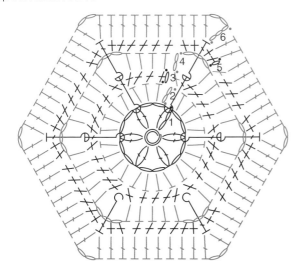

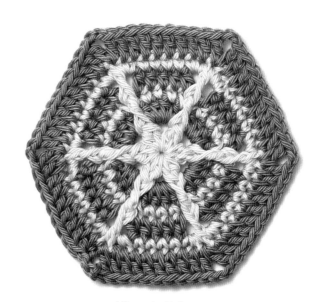

Alternate Colorway
(A) #3711 China Pink (Rnds 1, 3, 5)
(B) #3729 Grey (Rnds 2, 4, 6)

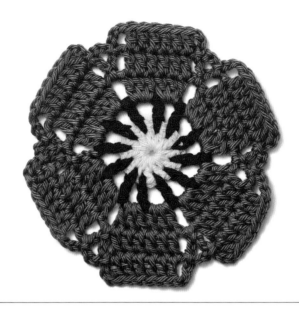

FINISHED SIZE
4½″ (11.5 cm) edge to edge
before blocking.

HOOK
G-6 (4.0 mm).

GAUGE
First 3 rnds = 3″
(7.5 cm) edge to edge.

COLORS
(A) #3718 Natural
(B) #3714 Burgundy
(C) #3792 Brick

notes

- See how to join this motif as you go in the Mod Flower Shawl project on page 134.

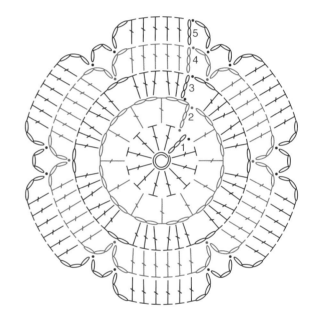

With A, make an adjustable ring.

Rnd 1: (RS) Ch 3 (counts as dc here and throughout), work 11 dc in ring, join with a sl st in top of beg ch-3—12 dc. Fasten off A.

Rnd 2: With RS facing, join B with a sl st between any 2 sts, ch 5 (counts as dc, ch 2), *dc between next 2 sts, ch 2; rep from * around, join with a sl st in 3rd ch of beg ch-5—12 dc; 12 ch-2 sps. Fasten off B.

Rnd 3: With RS facing, join C with a sl st in any ch-2 sp, ch 3, 2 dc in same sp, 3 dc in next ch-2 sp, ch 2, *3 dc in each of next 2 ch-2 sps, ch 2; rep from * around, join with a sl st in top of beg ch-3—36 dc; 6 ch-2 sps.

Rnd 4: Ch 3, dc in each of next 5 sts, *ch 3, sl st in next ch-2 sp, ch 3**, dc in each of next 6 sts; rep from * around, ending last rep at **, join with a sl st in top of beg ch-3—36 dc; 12 ch-3 sps; 6 sl sts.

Rnd 5: Ch 3, dc in each of next 5 sts, *(ch-3, sl st) in each of next 2 ch-3 sps, ch 3**, dc in each of next 6 sts; rep from * around, ending last rep at **, join with a sl st in top of beg ch-3—36 dc; 18 ch-3 sps; 12 sl sts. Fasten off C.

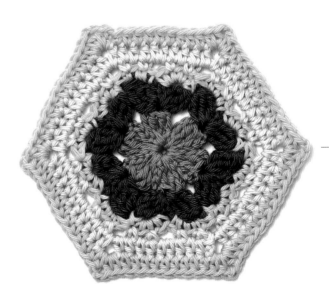

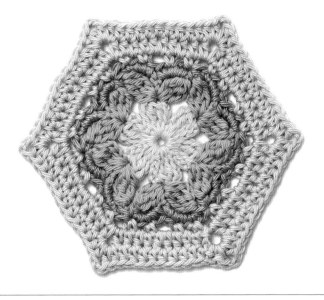

FINISHED SIZE
4″ (10 cm) edge to edge
before blocking.

HOOK
G-6 (4.0 mm).

GAUGE
First 3 rnds = 3″
(7.5 cm) edge to edge.

COLORS
(A) #3753 White Peach
(B) #3752 Coral
(C) #3717 Sand
(D) #3711 China Pink

notes

- Ch 1 at the beg of rnds does not count as a st.
- Frame the central flower by using a contrasting color on Rnd 3, or use a complementary color on outer rnds to integrate all of the rnds of the motif.

With A, make an adjustable ring.

Rnd 1: (RS) (Ch 4, 2-tr cluster, ch 4, sl st) 6 times in ring, join with a sl st in first ch of initial ch-4—12 ch-4 sps; 6 2-tr clusters; 6 sl sts. Fasten off A.

Rnd 2: With RS facing, join B with a sl st in any 2-tr cluster, ch 4, 2-tr cluster (counts as 3-tr cluster) in 2-tr cluster, (ch 4, sl st, ch 4, 3-tr cluster) in same 2-tr cluster, (3-tr cluster, ch 4, sl st, ch 4, 3-tr cluster) in each 2-tr cluster around, join with a sl st in first 2-tr cluster—12 ch-4 sps; 12 3-tr clusters. Fasten off B.

Rnd 3: With RS facing, join C with a sl st in first ch-4 sp, ch 1, *4 sc in ch-4 sp, 4 sc in next ch-4 sp, fpsc2tog over next 2 3-tr clusters; rep from * around, join with a sl st in first sc—48 sc; 6 fpsc2tog. Fasten off C.

Rnd 4: With RS facing, join D with a sl st in first sc to the right of any fpsc2tog, ch 1, *sc in sc, ch 2, sk next st, sc in next st, ch 1, sk next st, sc in next st, ch 2, sk next 2 sts, sc in next st, ch 1, sk next st; rep from * around, join with a sl st in first sc—24 sc; 12 ch-2 sps; 12 ch-1 sps.

Rnd 5: Sl st in next ch-2 sp, ch 4 (counts as hdc, ch 2), hdc in same sp, *hdc in next st, hdc in next ch-1 sp, hdc in next st, 2 hdc in next ch-2 sp, hdc in next st, hdc in next ch-1 sp, hdc in next st**, (hdc, ch 2, hdc) in next ch-2 sp; rep from * around, ending last rep at **, join with a sl st in 2nd ch of beg ch-4—60 hdc; 6 ch-2 sps.

Rnd 6: Sl st in next ch-2 sp, ch 2 (counts as hdc), (hdc, ch 2, 2 hdc) in same sp, *sk next st, hdc in each of next 9 sts**, (2 hdc, ch 2, 2 hdc) in next ch-2 sp; rep from * around, ending last rep at **, join with a sl st to 2nd ch of beg ch-4—78 hdc; 6 ch-2 sps. Fasten off D.

◀ *Alternate Colorway for Motif #69*
(A) #3767 Deep Coral (Rnd 1)
(B) #3793 Indigo Blue (Rnd 2)
(C) #3775 Cool Mint (Rnds 3 and 6)
(D) #3736 Ice (Rnds 4 and 5)

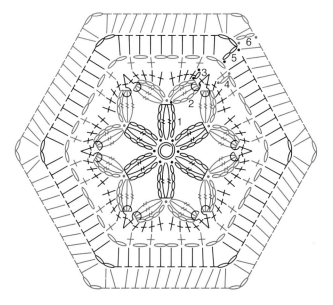

#70

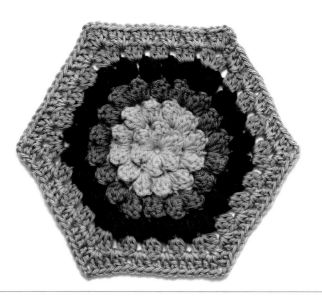

FINISHED SIZE
6″ (15 cm) edge to edge before blocking.

HOOK
G-6 (4.0 mm).

GAUGE
First 3 rnds = 3¼″ (8.5 cm) edge to edge.

COLORS
(A) #3753 White Peach
(B) #3721 Ginseng
(C) #3724 Armada
(D) #3738 Spearmint
(E) #3710 Orchid

notes

- Play around with the color sequence of the popcorn st rnds to achieve different effects. Or consider working the motif in a single color to highlight the texture.

With A, make an adjustable ring.

Rnd 1: (RS) Beg popcorn in ring, ch 3, [popcorn, ch 3] 5 times in ring, join with a sl st in top of beg popcorn—6 popcorns; 6 ch-3 sps.

Rnd 2: Sl st in next ch-3 sp, beg popcorn in ch-3 sp, ch 3, *popcorn in next popcorn, ch 3**, popcorn in next ch-3 sp, ch 3; rep from * around, ending last rep at **, join with a sl st in top of beg popcorn—12 popcorns; 12 ch-3 sps. Fasten off A.

Rnd 3: With RS facing, join B with a sl st in ch-3 sp following the join, beg popcorn in same sp, ch 3, *popcorn in next popcorn, ch 3**, (popcorn, ch 3) in each of next 2 ch-3 sps; rep from * around, ending last rep at **, popcorn in next ch-3 sp, ch 3, join with a sl st in top of beg popcorn—18 popcorns; 18 ch-3sps. Fasten off B.

Rnd 4: With RS facing, join C with a sl st in ch-3 sp following the join, beg popcorn in same sp, ch 3, *popcorn in next popcorn**, (popcorn, ch 3) in each of next 3 ch-3 sps; rep from * around, ending last rep at **, (popcorn, ch 3) in each of next 2 ch-3 sps, join with a sl st in top of beg popcorn—24 pc; 24 ch-3 sps. Fasten off C.

Rnd 5: With RS facing, join D with a sl st in ch-3 sp following the join, ch 3 (counts as dc here and throughout), (dc, ch 2, 2 dc) in same sp, *3 dc in each of next 3 ch-3 sps**, (2 dc, ch 2, 2 dc) in next ch-3 sp; rep from * around, ending last rep at **, join with a sl st in top of beg ch-3—78 dc; 6 ch-2 sps. Fasten off D.

Rnd 6: With RS facing, join E with a sl st in any ch-2 sp, ch 3, (dc, ch 2, 2 dc) in same sp, sk next 2 sts, *[3 dc between next 2 sts, sk next 3 sts] 3 times, 3 dc between next 2 sts, sk next 2 st**, (2 dc, ch 2, 2 dc) in ch-2 sp; rep from * around, ending last rep at **, join with a sl st in top of beg ch-3—96 dc; 6 ch-2 sps. Fasten off E.

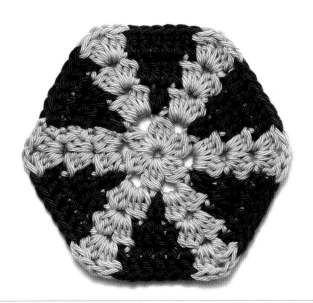

FINISHED SIZE
3¾" (9.5 cm) edge to edge
before blocking.

HOOK
G-6 (4.0 mm).

GAUGE
First 3 rnds = 3"
(7.5 cm) edge to edge.

COLORS
(A) #3711 China Pink
(B) #3793 Indigo Blue

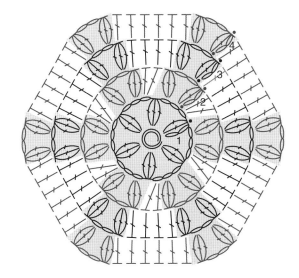

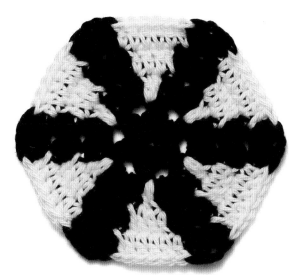

Alternate Colorway
(A) #3754 True Black
(B) #3728 White

notes

- This motif is worked in tapestry crochet. Unused colors are carried along with the working yarn. When switching colors, use the 2nd color to complete the final step of the stitch in the 1st color.

With A, make an adjustable ring.

Rnd 1: (RS) Ch 2, 2-dc cluster in ring (counts as 3-dc cluster here and throughout), ch 3, (3-dc cluster, ch 3) 5 times in ring, join with a sl st in first 2-dc cluster—6 3-dc clusters; 6 ch-3 sps.

Rnd 2: Sl st in next ch-3 sp, ch 2, (2-dc cluster, ch 2, 3-dc cluster) in same sp, *drop A, join B, with B, working over strand of A, 2 dc in first ch of next ch-3 sp, drop B, pick up A**, with A, working over strand of B, (3-dc cluster, ch 2, 3-dc cluster) in next ch-3 sp; rep from * around, ending last rep at **, with A, join with sl st in first 2-dc cluster—12 3-dc clusters; 6 ch-2 sps; 12 dc.

Rnd 3: Sl st in next ch-2 sp, ch 2, (2-dc cluster, ch 2, 3-dc cluster) in same sp, *drop A, pick up B, with B, dc in next 3-dc cluster, dc in each of next 2 dc, dc in next 3-dc cluster, drop B, pick up A**, with A, (3-dc cluster, ch 2, 3-dc cluster) in next ch-2 sp; rep from * around, ending last rep at **, with A, join with sl st in first 2-dc cluster—12 3-dc clusters; 6 ch-2 sps, 24 dc.

Rnd 4: Sl st in next ch-2 sp, ch 2, (2-dc cluster, ch 2, 3-dc cluster) in same sp, *drop A, pick up B, with B, dc in next 3-dc cluster, dc in each of next 4 dc, dc in next 3-dc cluster, drop B, pick up A**, with A, (3-dc cluster, ch 2, 3-dc cluster) in next ch-2 sp; rep from * around, ending last rep at **, with A, join with sl st in first 2-dc cluster—12 3-dc clusters; 6 ch-2 sps; 36 dc. Fasten off A and B.

#72

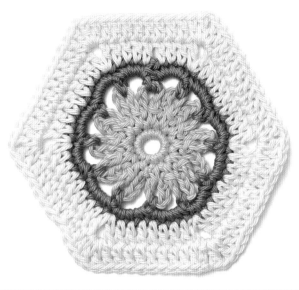

FINISHED SIZE
4½" (11.5 cm) edge to edge
before blocking.

HOOK
G-6 (4.0 mm).

GAUGE
First 3 rnds = 2½"
(6.5 cm) edge to edge.

COLORS
(A) #3775 Cool Mint
(B) #3733 Turquoise
(C) #3718 Natural

notes

- Ch 1 at the beg of rnds does not count as a st.
- You can use different colors for Rnds 1 and 2 to create a contrasting center to the "flower" portion of the motif.

With A, make an adjustable ring.

Rnd 1: (RS) Ch 1, work 12 sc in ring, join with a sl st in first sc—12 sc.

Rnd 2: Ch 1, (sc, ch 6, sc) in each st around, join with sl st in first sc—24 sc; 12 ch-6 sps. Fasten off A.

Rnd 3: With RS facing, join B with a sl st in any ch-6 sp, ch 1, (sc, ch 3) in each ch-6 sp around, join with sl st in first sc—12 sc, 12 ch-3 sps.

Rnd 4: Sl st in next ch-3 sp, ch 1, 4 sc in each ch-3 sp around, join with sl st in first sc—48 sc. Fasten off B.

Rnd 5: With RS facing, join C with a sl st in first sc of any 4-sc group, ch 5 (counts as dc, ch 2), dc in same st, *dc in each of next 7 sts**, (dc, ch 2, dc) in next st; rep from * around, ending last rep at **, join with a sl st in 3rd ch of beg ch-5—54 dc; 6 ch-2 sps.

Rnd 6: Sl st in next ch-2 sp, ch 3 (counts as dc), (dc, ch 1, 2 dc) in same sp, *sk next st, dc in each of next 8 sts**, (2 dc, ch 1, 2 dc) in next ch-2 sp, rep from * around, ending last rep at **, join with a sl st in top of beg ch-3—72 dc; 6 ch-1 sps. Fasten off C.

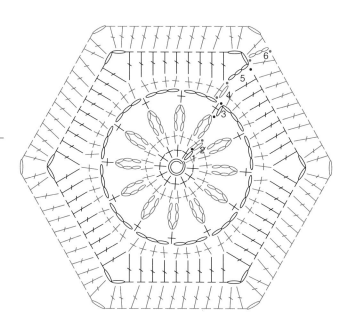

Alternate Colorway for Motif #73 ▶
(A) #3746 Chartreuse (Rnds 1 and 4)
(B) #3797 Dark Sea Foam (Rnd 2)
(C) #3763 Water Lily (Rnd 3)
(D) #3726 Periwinkle (Rnd 5)

FINISHED SIZE

3½" (9 cm) edge to edge before blocking.

HOOK

G-6 (4.0 mm).

GAUGE

First 3 rnds = 2½" (6.5 cm) edge to edge.

COLORS

(A) #3750 Tangerine
(B) #3802 Honeysuckle
(C) #3724 Armada

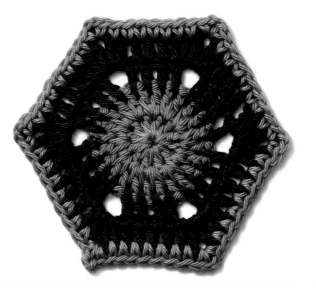

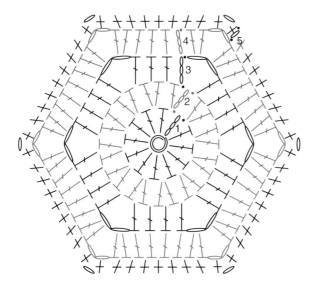

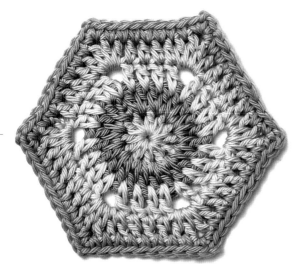

notes

- Vary the rnds on which you change colors to highlight the central circle or create a thicker border.

With A, make an adjustable ring.

Rnd 1: (RS) Ch 3, work 11 dc in ring, join with a sl st in top of beg ch-3—12 dc. Fasten off A.

Rnd 2: With RS facing, join B with a sl st between any 2 sts, ch 3 (counts as dc here and throughout), dc in same sp, *2 dc between next 2 sts; rep from * around, join with a sl st in top of beg ch-3—24 dc. Fasten off B.

Rnd 3: With RS facing, join C with a sl st between any 2 sts, ch 3, [dc between next 2 sts] 3 times, ch 2, *[dc between next 2 sts] 4 times, ch 2; rep from * around, join with a sl st in top of beg ch-3—24 dc; 6 ch-2 sps.

Rnd 4: Ch 3, dc in each of next 3 sts, *(2 dc, ch 2, 2 dc) in next ch-2 sp**, dc in each of next 4 sts; rep from * around, ending last rep at **, join with a sl st in top of beg ch-3—48 dc; 6 ch-2 sps. Fasten off C.

Rnd 5: With RS facing, join A with a sl st in any ch-2 sp, ch 1, *(sc, ch 1, sc) in ch-2 sp, [sc between next 2 sts] 7 times; rep from * around, join with a sl st in first sc—54 sc; 6 ch-2 sps. Fasten off A.

#74

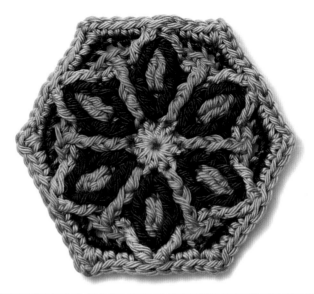

FINISHED SIZE
3½" (9 cm) edge to edge
before blocking.

HOOK
G-6 (4.0 mm).

GAUGE
First 3 rnds = 1¾"
(4.5 cm) edge to edge.

COLORS
(A) #3776 Pink Rose
(B) #3724 Armada
(C) #3733 Turquoise

notes

- Ch 1 at the beg of rnds counts as a st.
- All rnds are worked into the back lp only unless otherwise specified.
- This motif is worked using some overlaid sts. Overlay crochet is worked as a series of rnds worked in the back lp, with additional sts "overlaid," or anchored in the front lp. When making overlaid sts, there are times when the st(s) in the row below (underneath the overlaid st) is skipped, and times when it is not. This is specified in the patt. Each rnd is closed with an "invisible join" (see Glossary), unless indicated otherwise.

With A, make an adjustable ring.

Rnd 1: (RS) Ch 2 (count as hdc), work 11 hdc in ring, work invisible join in 2nd hdc—12 hdc. Fasten off A.

Rnd 2: With RS facing, join B with a sl st in any st, ch 1 (counts as sc here and throughout), sc in same st, 2 sc in each st around, work invisible join in 2nd sc—24 sc. Fasten off B.

Rnd 3: With RS facing, join C with a sl st in first sc of any 2-sc group, ch 1, *dc in front lp of next corresponding hdc in Rnd 1**, sc in each of next 4 sts; rep from * around, ending last rep at **, sc in each of next 3 sts, work invisible join in first dc—24 sc; 6 dc. Fasten off C.

Rnd 4: With RS facing, join B with a sl st in any dc, ch 1, *sc in next st, tr in front lp of next corresponding hdc in Rnd 1, sc in each of next 2 sts, tr in front lp of same hdc in Rnd 1 holding previous tr, sk next st**, sc in next st; rep from * around, ending last rep at **, work invisible join in 2nd sc—24 sc; 12 tr. Fasten off B.

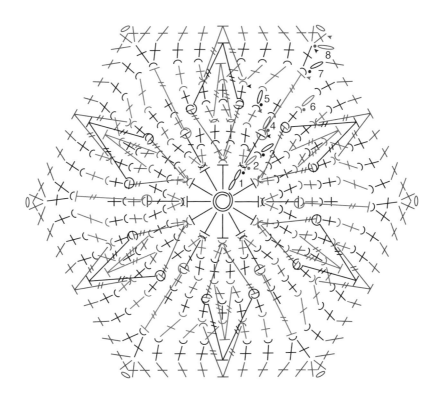

Rnd 5: With RS facing, join A with a sl st in any st, ch 1, sc in each st around, work invisible join in 2nd sc—36 sc. Fasten off A.

Rnd 6: With RS facing, join C with a sl st in any st in Rnd 5 that is worked into the left "leg" of the "V" formed by 2 tr of Rnd 4, ch 1, *fptr around the post of next corresponding dc in Rnd 3, sk next st, sc in each of next 3 sts, tr2tog in front lps only of next 2 corresponding sc in Rnd 3, visible between the "legs" of the "V" in Rnd 4**, sc in each of next 2 sts; rep from * around, ending last rep at **, sc in last st, work invisible join in first fptr—6 fptr; 30 sc; 6 tr2tog. Fasten off C.

Rnd 7: With RS facing, join B with a sl st in any fptr, ch 1, sc in same st, *sc in each of next 3 sts, fptr2tog around the posts of 2 tr of next "V" in Rnd 4, sk next st, sc in each of next 2 sts**, 2 sc in next st; rep from * around, ending last rep at **, work invisible join in 2nd sc—42 sc; 6 fptr2tog. Fasten off B.

Rnd 8: With RS facing, working in both lps of sts, join A with a sl st in 2nd sc of any 2-sc group, ch 1, (sc, ch 1, 2 sc) in same st, *sc in each of next 3 sts, tr2tog in front lps only of the 2 underlying sts of Rnd 5 visible to the right and left of the fptr2tog of Rnd 7, sk next st, sc in each of next 3 sts**, (2 sc, ch 1, 2 sc) in next st; rep from * around, ending last rep at **, work invisible join in 2nd sc—60 sc; 6 ch-1 sps; 6 tr2tog. Fasten off A.

#75

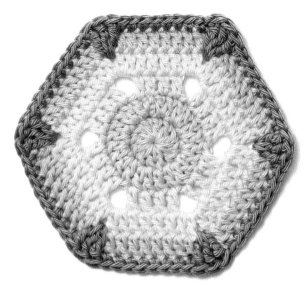

FINISHED SIZE
4¼" (11 cm) edge to edge
before blocking.

HOOK
G-6 (4.0 mm).

GAUGE
First 3 rnds = 2¼"
(5.5 cm) edge to edge.

COLORS
(A) #3763 Water Lily
(B) #3736 Ice
(C) #3710 Natural
(D) #3805 Colony Blue

With A, make an adjustable ring.

Rnd 1: (RS) Ch 3 (counts as dc here and throughout), work 11 dc in ring, join with a sl st in top of beg ch 3—12 dc. Fasten off A.

Rnd 2: With RS facing, join B with a sl st in any st, ch 3, dc in same st, 2 dc in each st around, join with a sl st in top of beg ch-3—24 dc. Fasten off B.

Rnd 3: With RS facing, join C with a sl st in any st, ch 3, dc in each of next 3 sts, ch 3, *dc in each of next 4 sts, ch 3; rep from * around, join with a sl st in top of beg ch-3—24 dc; 6 ch-3 sps.

Rnd 4: Ch 3, dc in each of next 3 sts, *(2 dc, ch 1, 2 dc) in next ch-3 sp**, dc in each of next 4 sts; rep from * around, ending last rep at **, join with a sl st in top of beg ch 3—48 dc; 6 ch-1 sps. Fasten off C.

Rnd 5: With RS facing, join A with a sl st in first dc of any 8-dc group, ch 3, dc in each of next 7 sts, *ch 2, sk next ch-1 sp**, dc in each of next 8 sts; rep from * around, ending last rep at **, join with a sl st in top of beg ch-3—48 dc; 6 ch-2 sps. Fasten off A.

Rnd 6: With RS facing, join D with a sl st in same st as join, ch 1, *sc in each of next 8 sts, working in front of ch-2 sp of Rnd 5, 3 tr in next ch-1 sp of Rnd 4; rep from * around, join with a sl st in first sc—48 sc; 18 tr. Fasten off D.

Alternate Colorway
(A) #3823 Tomato (Rnds 1 and 5)
(B) #3734 Teal (Rnd 2)
(C) #3717 Sand (Rnd 3)
(D) #3703 Magenta (Rnds 4 and 6)

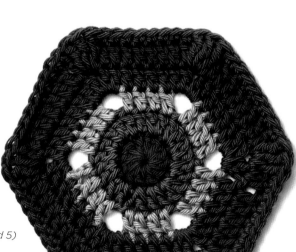

FINISHED SIZE
5″ (12.5 cm) point to point before blocking.

HOOK
G-6 (4.0 mm).

GAUGE
First 3 rnds = 2½″
(6.5 cm) point to point.

COLORS
(A) #3717 Sand
(B) #3732 Aqua
(C) #3725 Cobalt
(D) #3752 Coral

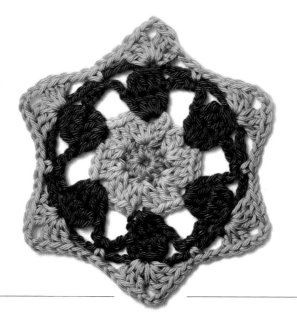

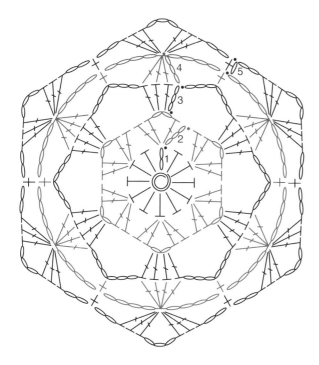

notes

- You can join this motif as you go using the ch-3 sps on the final rnd.
- Ch 1 at the beg of rnds does not count as a st.

With A, make an adjustable ring.

Rnd 1: (RS) Ch 2 (counts as hdc), work 11 hdc in ring, join with a sl st in top of beg ch-2—12 hdc. Fasten off A.

Rnd 2: With RS facing, join B with a sl st in any st, ch 3 (counts as dc here and throughout), (dc, ch 2, 2 dc) in same st, sk next st, *(2 dc, ch 2, 2 dc) in next st, sk next st; rep from * around, join with a sl st in top of beg ch-3—24 dc; 6 ch-2 sps. Fasten off B.

Rnd 3: With RS facing, join C with a sl st in any ch-2 sp, ch 3, 3 dc in same sp, ch 6, (4 dc, ch 6) in each ch-2 sp around, join with a sl st in top of beg ch-3—24 dc; 6 ch-6 sps.

Rnd 4: Ch 3, dc3tog over next 3 dc (counts as dc4tog), *ch 4, sc in next ch-6 sp, ch 4**, dc4tog over next 4 dc; rep from * around, ending last rep at **, join with a sl st in first dc3tog—6 dc4tog; 12 ch-4 sps; 6 sc. Fasten off C.

Rnd 5: With RS facing, join D with a sl st in any sc, ch 1, sc in first sc, *ch 2, (3 dc, ch 3, 3 dc) in next dc4tog, ch 2**, sc in next sc; rep from * around, ending last rep at **, join with a sl st in first sc—6 sc; 12 ch-2 sps; 36 dc; 6 ch-3 sps. Fasten off D.

#77

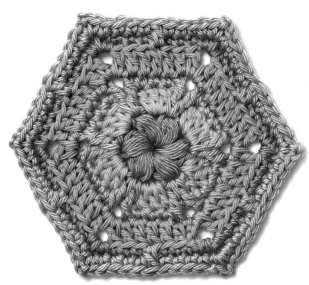

FINISHED SIZE
3¾" (9.5 cm) edge to edge
before blocking.

HOOK
G-6 (4.0 mm).

GAUGE
First 3 rnds = 2¼"
(5.5 cm) edge to edge.

COLORS
(A) #3778 Lavender
(B) #3732 Aqua
(C) #3717 Sand
(D) #3738 Spearmint

notes

- Ch 1 at the beg of rnds does not count as a st.

With A, make an adjustable ring.

Rnd 1: (RS) Work beg puff st in ring, ch 2, [puff st, ch 2] 5 times in ring, join with a sl st in beg puff st—6 puff sts; 6 ch-2 sps. Fasten off A.

Rnd 2: With RS facing, join B with a sl st in any ch-2 sp, ch 3 (counts as dc), 2 dc in same sp, ch 2, (3 dc, ch 2) in each ch-2 sp around, join with sl st in top of beg ch-3—18 dc; 6 ch-2 sps. Fasten off B.

Rnd 3: With RS facing, join C with a sl st in same st as join, ch 1, sc in each of first 3 dc, *working in front of ch-2 sp of Rnd 2, (tr, ch 2, tr) in corresponding puff st in Rnd 1**, sc in each of next 3 sts; rep from * around, ending last rep at **, join with a sl st in first sc—18 sc; 12 tr; 6 ch-2 sps. Fasten off A.

Rnd 4: With RS facing, join D with a sl st in any ch-2 sp, ch 5 (counts as dc, ch 2), dc in same sp. *dc in each of next 5 sts**, (dc, ch 2, dc) in next ch-2 sp; rep from * around, ending last rep at **, join with a sl st in 3rd ch of beg ch-5—42 dc; 6 ch-2 sps. Fasten off D.

Rnd 5: With RS facing, working in back lps only, join A with a sl st in any ch-2 sp, ch 1, *(sc, ch 2, sc) in ch-2 sp, sc in each of next 7 sts; rep from * around, join with a sl st in first sc—54 sc; 6 ch-2 sps. Fasten off A.

Rnd 6: With RS facing, join C with a sl st in any ch-2 sp, ch 1, *(sc, ch 2, sc) in ch-2 sp, sc in each of next 4 sts, working in front of ch-2 sp in Rnd 5, dc in front lp of next st in Rnd 4, sk next st, sc in each of next 4 sts; rep from * around, join with a sl st in first sc—60 sc; 6 dc; 6 ch-2 sps. Fasten off C.

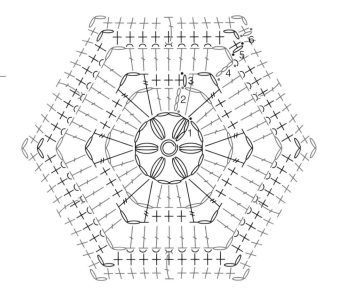

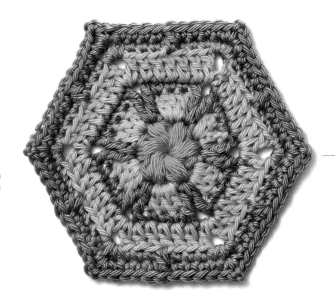

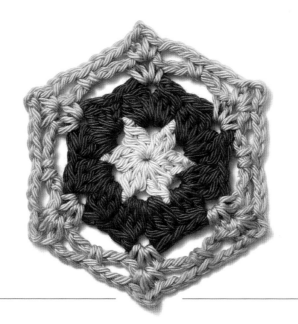

FINISHED SIZE
3" (7.5 cm) edge to edge before blocking.

HOOK
G-6 (4.0 mm).

GAUGE
First 3 rnds = 2" (5 cm) edge to edge.

COLORS
(A) #3711 China Pink
(B) #3701 Cranberry
(C) #3747 Gold

#78

notes

- Ch 1 at the beg of rnds does not count as a st.

With A, make an adjustable ring.

Rnd 1: (RS) Ch 3, dc in ring (counts as 2-dc cluster), ch 2, [2-dc cluster, ch 2] 5 times in ring, join with a sl st in first dc—6 2-dc cluster; 6 ch-2 sps. Fasten off A.

Rnd 2: With RS facing, join B with a sl st in any ch-2 sp, ch 3, 2-dc cluster in same sp (counts as 3-dc cluster), ch 2, 3-dc cluster in same sp, ch 1, (3-dc cluster, ch 2, 3-dc cluster, ch 1) in each ch-2 sp around, join with a sl st in first 2-dc cluster—12 3-dc clusters; 6 ch-2 sps; 6 ch-1 sps. Fasten off B.

Rnd 3: With RS facing, join C with a sl st in any ch-2 sp, ch 1, *(sc, ch 2, sc) in ch-2 sp, ch 5, sk next ch-1 sp; rep from * around, join with a sl st in first sc—12 sc; 6 ch-5 sps ; 6 ch-2 sps.

Rnd 4: Sl st in next ch-2 sp, ch 1, *(sc, ch 2, sc) in ch-2 sp, ch 3, sc in next ch-5 sp, ch 3; rep from * around, join with a sl st in first sc—18 sc; 6 ch-2 sps; 12 ch-3 sps. Fasten off C.

◀ ***Alternate Colorway for Motif #77***
(A) #3767 Deep Coral (Rnds 1 and 5)
(B) #3753 White Peach (Rnd 2)
(C) #3805 Colony Blue (Rnds 3 and 6)
(D) #3732 Aqua (Rnd 4)

#79

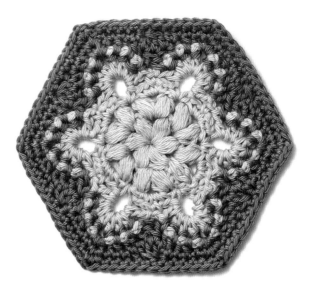

FINISHED SIZE
5" (12.5 cm) edge to edge
before blocking.

HOOK
G-6 (4.0 mm).

GAUGE
First 3 rnds = 2½"
(6.5 cm) edge to edge.

COLORS
(A) #3711 China Pink
(B) #3729 Gray

notes

- Ch 1 at the beg of rds does not count as a st.

With A, make an adjustable ring.

Rnd 1: (RS) Beg puff st in ring, ch 2, [puff st, ch 2] 5 times in ring, join with a sl st in beg puff st—6 puff sts; 6 ch-2 sps.

Rnd 2: Sl st in next ch-2 sp, (beg puff st, ch 2, puff st) in same sp, ch 1, (puff st, ch 2, puff st, ch 1) in each ch-2 sp around, join with a sl st in beg puff st—12 puff sts; 6 ch-2 sps; 6 ch-1 sps.

Rnd 3: Sl st in next ch-2 sp, ch 1, *(2 sc, ch 1, 2 sc) in ch-2 sp, (sc, ch 6, sc) in next ch-1 sp; rep from * around, join with a sl st in first sc—36 sc; 6 ch-6 sps; 6 ch-1 sps.

Rnd 4: Sl st to next ch-1 sp, ch 1, *sc in ch-1 sp, ([dc, ch 1] 3 times, dc, ch 2, [dc, ch 1] 3 times, dc) in next ch-6 sp; rep from * around, join with a sl st in first sc—48 dc; 36 ch-1 sps; 6 ch-2 sps; 6 sc. Fasten off A.

Rnd 5: With RS facing, join B with a sl st in any ch-2 sp, ch 1, *(sc, ch 1, sc) in ch-2 sp, [bphdc around the post of next dc, hdc in next ch-1 sp] twice, bpdc around the post of next dc, dc2tog over next 2 ch-1 sps, bpdc around the post of next dc, [hdc in next ch-1 sp, bphdc around the post of next dc] twice; rep from * around, join with a sl st in first sc—12 sc; 6 ch-1 sps; 24 bphdc; 24 hdc; 12 bpdc; 6 dc2tog.

Rnd 6: Sl st in next ch-1 sp, ch 1, *(sc, ch 1, sc) in ch-1 sp, sk next st, sc in each of next 3 sts, hdc in next st, dc3tog over next 3 sts, hdc in next st, sc in each of next 4 sts; rep from * around, join with a sl st in first sc—54 sc; 12 hdc; 6 dc3tog; 6 ch-1 sps.

Rnd 7: Sl st in next ch-1 sp, ch 1, *(sc, ch 1, sc) in ch-1 sp, sk next st, sc in each of next 11 sts; rep from * around, join with a sl st in first sc—78 sc; 6 ch-1 sps. Fasten off B.

Alternate Colorway for Motif #79 ▶
(A) #3718 Natural (Rnd 1)
(B) #3808 Light Gray (Rnds 2, 6, 7)
(C) #3729 Gray (Rnds 3 and 5)
(D) #3776 Pink Rose (Rnd 4)

FINISHED SIZE
4" (10 cm) point to point before blocking.

HOOK
G-6 (4.0 mm).

GAUGE
First 3 rnds = 2" (5 cm) point to point.

COLORS
(A) #3764 Sunshine
(B) #3750 Tangerine
(C) #3823 Tomato
(D) #3775 Cool Mint

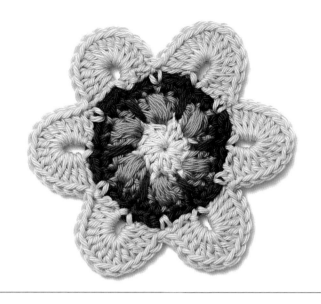

#80

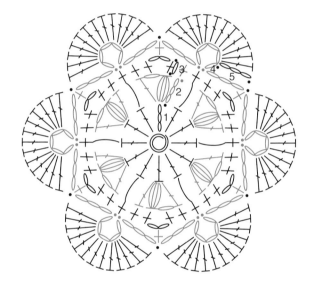

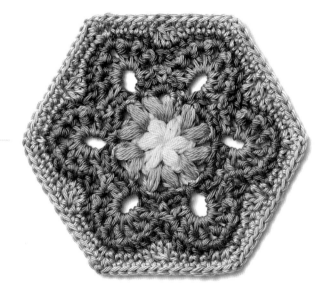

notes

- Bold contrasting colors set apart the center of the motif from the surrounding outer rnds.
- Ch 1 at the beg of rnds does not count as a st.

With A, make an adjustable ring.

Rnd 1: (RS) Ch 3 (counts as dc here and throughout), work 11 dc in ring, join with a sl st in top of beg ch-3—12 dc. Fasten off A.

Rnd 2: With RS facing, join B with a sl st in any st, ch 3, (puff st, ch 1, dc) in same st, *sk next st, (dc, puff st, ch 1, dc) in next st; rep from * around, join with a sl st in top of beg ch-3—12 dc; 6 puff st; 6 ch-1 sps. Fasten off B.

Rnd 3: With RS facing, join C with a sl st in any puff st, ch 1, *sc in puff st, ch 2, sc in next ch-1 sp, sc in next dc, working over sts in last rnd, sp sc in corresponding skipped st in Rnd 1, sc in next dc; rep from * around, join with a sl st in first sc—24 sc; 6 sp sc; 6 ch-2 sps. Fasten off C.

Rnd 4: With RS facing, join D with a sl st in any sp sc, (ch 5, sl st) in same sp sc, *ch 3, sk next 2 sts, sc in next ch-2 sp, ch 3, sk next 2 st**, (sl st, ch 5, sl st) in next sp sc; rep from * around, ending last rep at **, join with a sl st in first sl st—12 sl sts; 6 ch-5 sps; 12 ch-3 sps; 6 sc.

Rnd 5: Sl st in next ch-5 sp, ch 3, 12 dc in ch-5 sp, *sl st in next sc**, 13 dc in next ch-5 sp; rep from * around, ending last rep at **, join with a sl st in top of beg ch-3—78 dc; 6 sl sts. Fasten off D.

#81

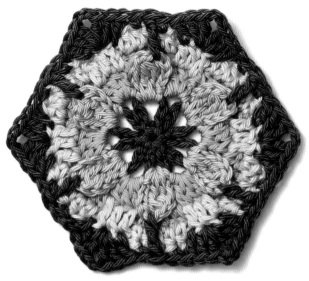

FINISHED SIZE
3¾" (9.5 cm) edge to edge
before blocking.

HOOK
G-6 (4.0 mm).

GAUGE
First 3 rnds = 2½"
(6.5 cm) edge to edge.

COLORS
(A) #3701 Cranberry
(B) #3710 Orchid
(C) #3752 Coral
(D) #3764 Sunshine

notes

- This motif "layers" colors in alternating rnds of sts and ch sps. Work sts of subsequent rnds in front of skipped ch sps of previous rnds.
- Ch 1 at the beg of rnd does not count as a st.

With A, make an adjustable ring.

Rnd 1: (RS) [Ch 6, sl st] 6 times in ring, join with a sl st in first ch of beg ch-6—6 ch-6 sps; 6 sl sts. Fasten off A.

Rnd 2: With RS facing, join B with a sl st in any ch-6 sp, (ch 4, 2-tr cluster, ch 4, sl st) in same ch-6 sp, ch 3, *(sl st, ch 4, 2-tr cluster, ch 4, sl st, ch 3) in each ch-6 sp around, join with s sl st in first sl st—12 ch-4 sps; 6 2-tr clusters; 12 sl sts; 6 ch-3 sps. Fasten off B.

Rnd 3: With RS facing, join C with a sl st in any ch-3 sp, ch 3 (counts as dc here and throughout), 2 dc in same sp, working behind "petals" of Rnd 2, ch 3, *3 dc in next ch-3 sp, ch 3; rep from * around, join with a sl st in top of beg ch-3—18 dc; 6 ch-3 sps.

Rnd 4: Sl st in next ch-3 sp, ch 2 (counts as hdc here and throughout), 4 hdc in same sp, working behind st in Rnd 3, ch 4, sk next 3 dc, (5 hdc, ch 3) in each ch-3 sp around, join with sl st in top of beg ch-2—30 hdc; 6 ch-4 sps. Fasten off C.

Rnd 5: With RS facing, join D with a sl st in first dc of any 3-dc group in Rnd 3, working in front of ch-4 sp of Rnd 4, ch 3, dc in each of next 2 sts, *ch 5, sk next 5 hdc in Rnd 4**, working in front of ch-4 sp of Rnd 4, dc in each of next 3 sts in Rnd 3; rep from * around, ending last rep at **, join with a sl st in top of beg ch-3—18 dc; 6 ch-5 sps.

Rnd 6: Sl st in each of next 2 dc, sl st in next skipped hdc in Rnd 4, working in front of ch-5 sp of Rnd 5, ch 2, hdc in each of next 4 sts, *ch 6, sk next 3 dc in Rnd 5**, working in front of ch-5 sp of Rnd 5, hdc in each of next 5 sts in Rnd 4; rep from * around, ending last rep at **, join with a sl st in top of beg ch-2—30 hdc; 6 ch-6 sps ; 3 sl sts. Fasten off D.

Rnd 7: With RS facing, join A with a sl st in 2nd hdc of any 5-hdc group, ch 1, sc in first hdc, *working over sts in previous rnds, tr in next corresponding 2-tr cluster in Rnd 2, sk st behind tr, sc in next st, sk next st, working in front of ch-6 sp in Rnd 6, dc in next dc in Rnd 5, (2 dc, ch 2, 2 dc) in next dc in Rnd 5, dc in next dc in Rnd 5, sk next st in Rnd 6**, sc in next st; rep from * around, ending last rep at **, join with sl st in first sc—12 sc; 6 tr; 36 dc; 6 ch-2 sps. Fasten off A.

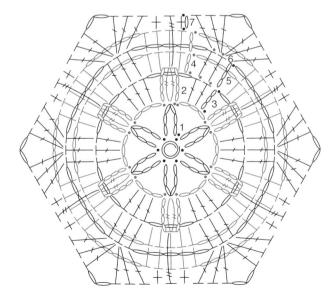

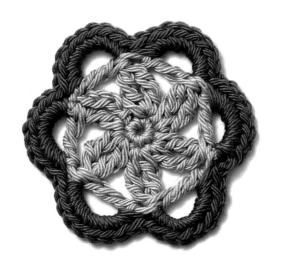

FINISHED SIZE
3″ (7.5 cm)
before blocking.

HOOK
G-6 (4.0 mm).

GAUGE
First 3 rnds = 3″
(7.5 cm) in diameter—point to
point.

COLORS
(A) #3772 Cornflower
(B) #3725 Cobalt

#82

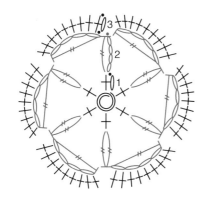

notes

- You can omit Rnd 3 on this motif and use the join-as-you-go method to join motifs on Rnd 2.

- Ch 1 at the beg of rnds does not count as a st.

With A, make an adjustable ring.

Rnd 1: (RS) Ch 1, work 6 sc in ring, join with a sl st in first sc—6 sc.

Rnd 2: Ch 4, tr in same st (counts as 2-tr cluster), *ch 4, tr in last 2-tr cluster made**, 2-tr cluster in next st; rep from * around, ending last rep at **, join with a sl st in first tr—6 2-tr cluster; 6 ch-4 sps, 6 tr. Fasten off A.

Rnd 3: With RS facing, join B with a sl st in any ch-4 sp, ch 1, 9 sc in each ch-4 sp around, join with a sl st in first sc—54 sc. Fasten off B.

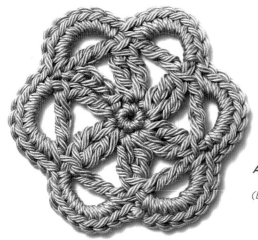

Alternate Colorway
(A) #3759 Taupe
(B) #3757 Zen Green

#83

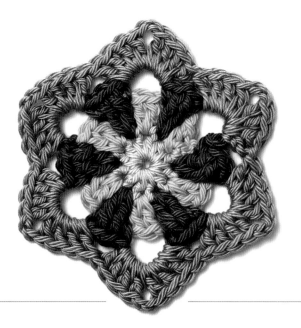

FINISHED SIZE
4" (10 cm) point to point
before blocking.

HOOK
G-6 (4.0 mm).

GAUGE
First 3 rnds = 2¼"
(5.5 cm) point to point.

COLORS
(A) #3808 Light Gray
(B) #3732 Aqua
(C) #3793 Indigo Blue
(D) #3778 Lavender

notes

- You can join these motifs as you go using the ch-2 sps on the final rnd.
- Ch 1 at the beg of rnd does not count as a st.

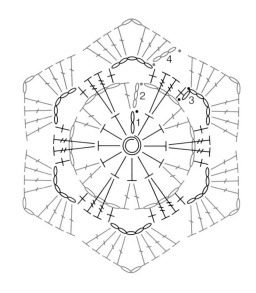

With A, make an adjustable ring.

Rnd 1: (RS) Ch 2 (counts as hdc), work 11 hdc in ring, join with sl st in top of beg ch-2—12 hdc. Fasten off A.

Rnd 2: With RS facing, join B with a sl st in any st, ch 3 (counts as dc here and throughout), dc in same st, ch 3, sk next st, *2 dc in next st, ch 3, sk next st; rep from * around, join with a sl st in top of beg ch-3—12 dc; 6 ch-3 sps. Fasten off B.

Rnd 3: With RS facing, join C with a sl st in any ch-3 sp, ch 1, *sc in ch-3 sp, working in front of ch-3 sp of Rnd 2, work 2 tr in next skipped st of Rnd 1, sc in same ch-3 sp, ch 5, sk next 2 dc; rep from * around, join with a sl st in first sc—12 sc; 12 tr; 6 ch-5 sps. Fasten off C.

Rnd 4: With RS facing, join D with a sl st in any ch-5 sp, ch 3, (3 dc, ch 2, 4 dc) in same sp, (4 dc, ch 2, 4 dc) in each ch-5 sp around, join with a sl st in top of beg ch-3—48 dc; 6 ch-2 sps. Fasten off D.

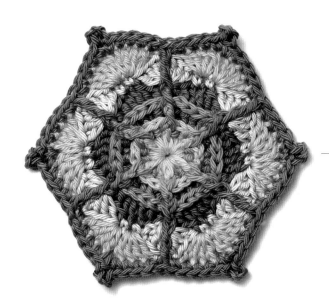

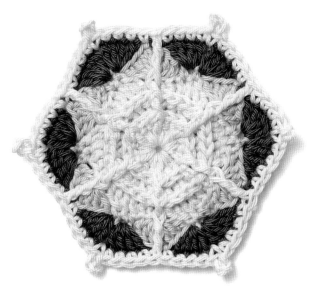

FINISHED SIZE
4″ (10 cm) edge to edge
before blocking.

HOOK
G-6 (4.0 mm).

GAUGE
First 3 rnds = 2½″
(6.5 cm) edge to edge.

COLORS
(A) #3718 Natural
(B) #3753 White Peach
(C) #3792 Brick

notes

- You may need to pull outward on the sts in the first few rnds to shape the motif correctly.

- Use the same color for Rnds 1–3 to help the texture of the post sts stand out, or change colors on each rnd to create a different look.

With A, make an adjustable ring.

Rnd 1: (RS) Ch 3 (counts as dc), work 17 dc in ring, join with a sl st in top of beg ch 3—18 dc.

Rnd 2: Ch 2 (does not count as a st here and throughout), fpdc around the post of same st, *2 bpdc around the post of each of next 2 sts**, fpdc around the post of next st; rep from * around, ending last rep at **, join with a sl st in first fpdc—6 fpdc; 24 bpdc.

Rnd 3: Ch 2, fpdc around the post of first fpdc, *2 bpdc around the post of next st, bpdc around the post of each of next 2 sts, 2 bpdc around the post of next st**, fpdc around the post of next st; rep from * around, ending last rep at **, join with a sl st in first fpdc—6 fpdc; 36 bpdc. Fasten off A.

Rnd 4: With RS facing, join B with a sl st in any fpdc, ch 3 (counts as dc), 6 dc in same st, sk next 2 sts, *sc in each of next 2 sts, sk next 2 sts**, 7 dc in next fpdc, sk next 2 sts; rep from * around, ending last rep at **, join with a sl st in top of beg ch-3—42 dc, 12 sc. Fasten off B.

Rnd 5: With RS facing, join C with a sl st in 4th dc of any 7-dc group, *sk next 3 sts, 4 dc in next sc, ch 1, 4 dc in next sc, sk next 3 sts, sl st in next st; rep from * around, ending with last sl st in first sl st—6 sl sts; 48 dc; 6 ch-1 sps. Fasten off C.

Rnd 6: With RS facing, join A with a sl st in first dc after the join, ch 1, sc in each of first 4 sts, *sc in next ch-1 sp, picot, sc in each of next 4 sts, working in front of sts in Rnd 5, fptr around the post of next fpdc in Rnd 3, sk next sl st**, sc in each of next 4 sts; rep from * around, ending last rep at **, join with a sl st in first sc—54 sc; 6 picots; 6 fptr. Fasten off A.

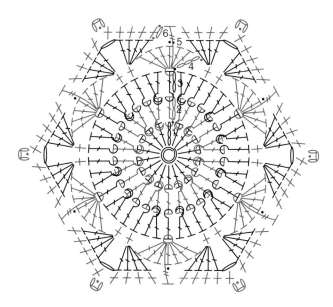

THE MOTIFS:
triangles
and other shapes

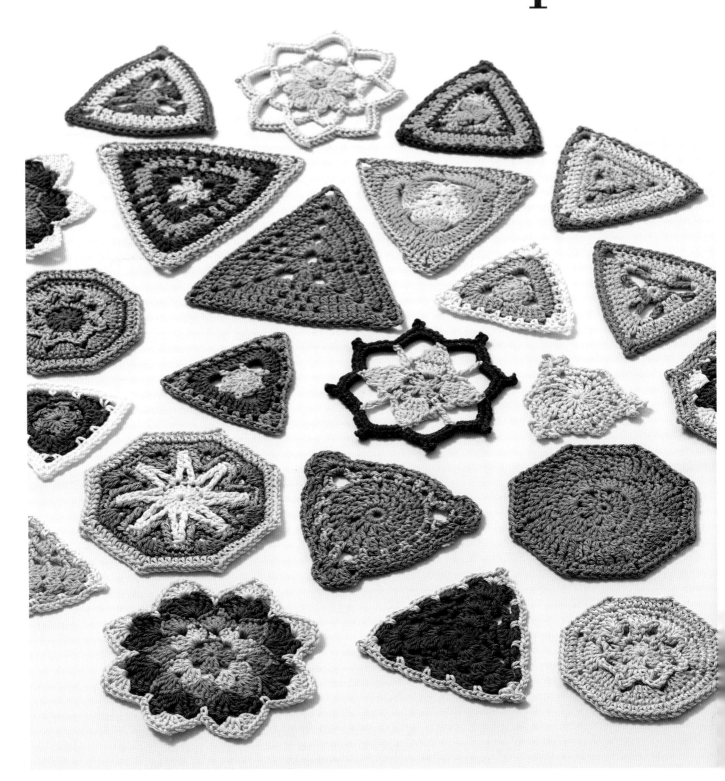

FINISHED SIZE
4½″ (11.5 cm) point to edge before blocking.

HOOK
G-6 (4.0 mm).

GAUGE
First 3 rnds = 2½″ (6.5 cm) in diameter.

COLORS
(A) #3726 Periwinkle
(B) #3727 Sky Blue
(C) #3798 Suede

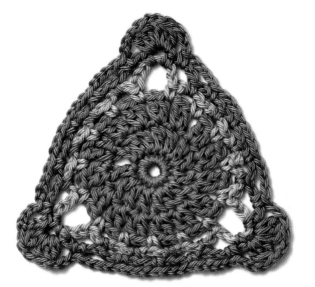

#85

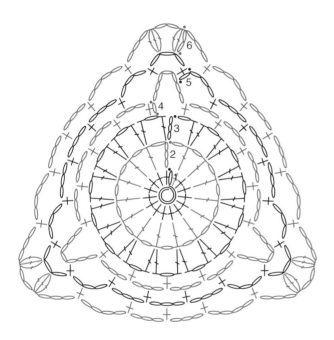

notes

- Ch 1 at the beg of rnds does not count as a st.

With A, make an adjustable ring.

Rnd 1: (RS) Ch 1, work 15 sc in ring, join with a sl st in first sc—15 sc.

Rnd 2: Ch 4 (counts as dc, ch 1), (dc, ch 1) in each st around, join with a sl st in 3rd ch of beg ch-4—15 dc; 15 ch-1 sps.

Rnd 3: Ch 3 (counts as dc here and throughout), dc in same st, ch 1, (2 dc, ch 1) in each dc around, join with a sl st in top of beg ch-3—30 dc; 15 ch-1 sps. Fasten off A.

Rnd 4: With RS facing, join B with a sl st in any ch-1 sp, ch 1, *[sc in ch-1 sp, ch 3] 4 times, sc in next ch-1 sp, ch 7; rep from * around, join with a sl st in first sc—15 sc; 12 ch-3 sps; 3 ch-7 sps. Fasten off B.

Rnd 5: With RS facing, join C with a sl st in any ch-7 sp, ch 1, *(sc, ch 3, sc) in ch-7 sp, (ch 3, sc) in each of next 4 ch-3 sps, ch 3; rep from * around, join with a sl st in first sc—18 sc; 18 ch-3 sps.

Rnd 6: Sl st in next ch-3 sp, ch 2, 2-dc cluster in same sp (counts as 3-dc cluster), ch 2, 3-dc cluster in same sp, *ch 3, sc in next ch-3 sp, ch 4, (sc, ch 3) in each of next 2 ch-3 sps, sc in next ch-3 sp, ch 4, sc in next ch-3 sp, ch 3**, (3-dc cluster, ch 2, 3-dc cluster) in next ch-3 sp; rep from * around, ending last rep at **, join with sl st in first 2-dc cluster—6 3-dc clusters; 3 ch-2 sps; 15 sc; 12 ch-3 sps; 6 ch-4 sps. Fasten off C.

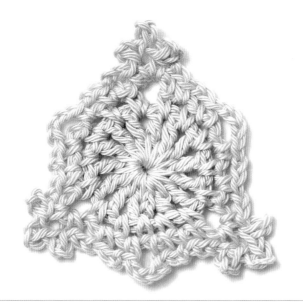

#86

FINISHED SIZE
3¼" (8.5 cm) point to edge
before blocking.

HOOK
G-6 (4.0 mm).

GAUGE
First 3 rnds = 3¼"
(8.5 cm) point to edge.

COLORS
(A) #3763 Water Lily
(B) #3753 White Peach

notes

• Ch 1 at the beg of rnds does not count as a st.

With A, make an adjustable ring.

Rnd 1: (RS) Ch 4 (counts as tr), work 14 tr in ring, join with a sl st in top of beg ch-4—15 tr. Fasten off A.

Rnd 2: With RS facing, join B with a sl st between any 2 sts, ch 1, *(sc between 2 tr, ch 2) 4 times, sc between next 2 tr, ch 4; rep from * around, join with a sl st in first sc—15 sc; 12 ch-2 sps; 3 ch-4 sps.

Rnd 3: Sl st in next ch-2 sp, ch 1, *sc in ch-2 sp, ch 2, sc in next ch-2 sp, ch 4, (sc, ch 2) in each of next 2 ch-2 sps, (sc, 3 picots, sc) in next ch-4 sp, ch 2; rep from * around, join with a sl st in first sc—18 sc; 12 ch-2 sps; 3 ch-4 sps; 9 picots. Fasten off B.

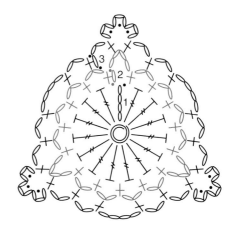

Alternate Colorway for Motif #87 ▶
(A) #3823 Tomato (Rnd 1)
(B) #3703 Magenta (Rnds 2–4)
(C) #3763 Water Lily (Rnd 5)

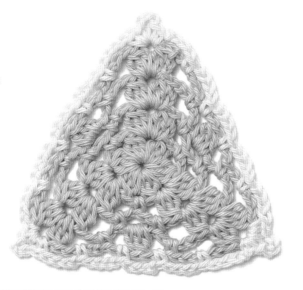

FINISHED SIZE
4½" (11.5 cm) point to edge
before blocking.

HOOK
G-6 (4.0 mm).

GAUGE
First 3 rnds = 2¾"
(7 cm) point to edge.

COLORS
(A) #3775 Cool Mint
(B) #3718 Natural

notes

- Keep things simple with a single color for the center of the triangle, with a contrasting final rnd. Or spice things up with bold colors and a center circle that you can vary or keep the same across multiple motifs.

- Ch 1 at the beg of rnds does not count as a st.

With A, make an adjustable ring.

Rnd 1: (RS) Ch 2, 2-dc cluster in ring (counts as 3-dc cluster here and throughout), ch 2, [3-dc cluster, ch 2] 5 times in ring; rep from * around, join with a sl st in first 2-dc cluster—6 3-dc clusters; 6 ch-2 sps.

Rnd 2: Sl st in next ch-2 sp, ch 2, (2-dc cluster, ch 2, 3-dc cluster) in same sp, *ch 3, sc in next ch-2 sp, ch 3**, (3-dc cluster, ch 2, 3-dc cluster) in next ch-2 sp; rep from * around, ending last rep at **, join with a sl st in first 2-dc cluster—6 3-dc clusters; 3 ch-2 sps: 6 ch-3 sps; 3 sc.

Rnd 3: Sl st in next ch-2 sp, ch 2, (2-dc cluster, ch 2, 3-dc cluster) in same sp, *ch 4, sc in next ch-3 sp, ch 3, sc in next ch-3 sp, ch 4**, (3-dc cluster, ch 2, 3-dc cluster) in next ch-2 sp; rep from * around, ending last rep at **, join with a sl st in first 2-dc cluster—6 3-dc clusters; 3 ch-2 sps; 3 ch-3 sps; 6 ch-4 sps; 6 sc.

Rnd 4: Sl st in next ch-2 sp, ch 2, (2-dc cluster, ch 2, 3-dc cluster) in same sp, *ch 5, sc in next ch-4 sp, ch 2, 3-dc cluster in next ch-3 sp, ch 2, sc in next ch-4 sp, ch 5**, (3-dc cluster, ch 2, 3-dc cluster) in next ch-2 sp; rep from * around, ending last rep at **, join with a sl st in first 2-dc cluster—9 3-dc clusters; 6 ch-5 sps; 9 ch-2 sps; 6 sc. Fasten off A.

Rnd 5: With RS facing, join B with a sl st in any corner ch-2 sp, ch 1, *(2 sc, ch 3, 2 sc) in ch-2 sp, ch 4, (sc, ch 4) in each of next 4 sps; rep from * around, join with a sl st in first sc—24 sc; 3 ch-3 sps; 15 ch-4 sps. Fasten off B.

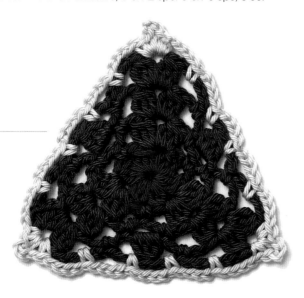

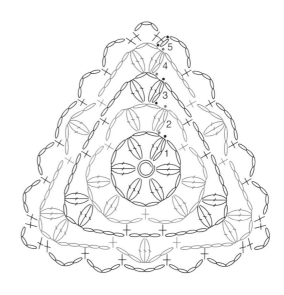

#88

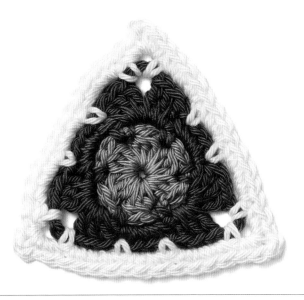

FINISHED SIZE
3¼" (8.5 cm) point to edge before blocking.

HOOK
G-6 (4.0 mm).

GAUGE
First 3 rnds = 2½" (6.5 cm) point to edge

COLORS
(A) #3778 Lavender
(B) #3779 Pansy
(C) #3728 White

notes
● Ch 1 at the beg of rnds does not count as a st.

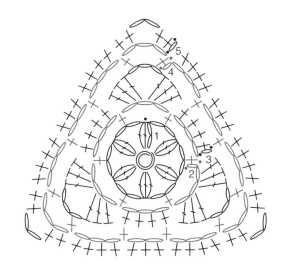

With A, make an adjustable ring.

Rnd 1: (RS) Ch 2, 2-dc cluster in ring (counts as 3-dc cluster), ch 2, [3-dc cluster, ch 2] 5 times in ring, join with a sl st in first 2-dc cluster—6 3-dc clusters: 6 ch-2 sps. Fasten off A.

Rnd 2: With RS facing, join B with a sl st in any ch-2 sp, ch 1, (sc, ch 3) in each ch-2 sp around, join with a sl st in first sc—6 sc; 6 ch-3 sps.

Rnd 3: Sl st in next ch-3 sp, ch 1, *4 sc in ch-3 sp, (3 dc, ch 3, 3 dc) in next ch-3 sp; rep from * around, join with a sl st in first sc—12 sc; 12 dc; 3 ch-3 sps. Fasten off B.

Rnd 4: With RS facing, join C with a sl st in any ch-3 sp, ch 1, *(sc, ch 3, sc) in ch-3 sp, ch 3, sk next 3 sts, sc in next st, ch 2, sk next 2 sts, sc in next st, ch 3, sk next 3 sts; rep from * around, join with a sl st in first sc—12 sc; 9 ch-3 sps; 3 ch-2 sps.

Rnd 5: Sl st in next ch-3 sp, ch 1, *(2 sc, ch 2, 2 sc) in ch-3 sp, 4 sc in next ch-3 sp, 3 sc in next ch-2 sp, 4 sc in next ch-3 sp; rep from * around, join with a sl st in first sc—45 sc; 3 ch-2 sps. Fasten off C.

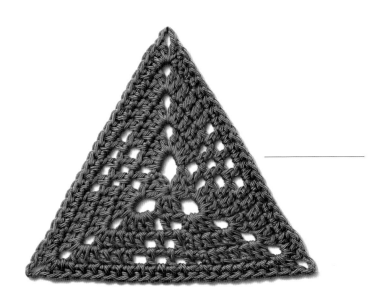

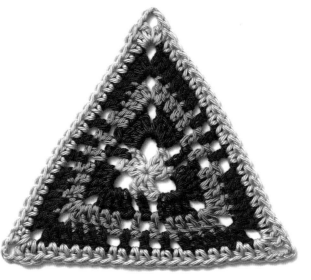

FINISHED SIZE
5" (12.5 cm) point to edge
before blocking.

HOOK
G-6 (4.0 mm).

GAUGE
First 3 rnds = 3½"
(9 cm) point to edge.

COLORS
(A) #3720 Sage
(B) #3701 Cranberry
(C) #3776 Pink Rose
(D) #3703 Magenta

notes

- Use the same color for Rnds 2–4 to make a clean, simple triangle, or change colors on each rnd to create beautiful stripes of color.

With A, make an adjustable ring.

Rnd 1: (RS) Ch 3 (counts as dc here and throughout), 2 dc in ring, ch 5, [3 dc, ch 5] twice in ring, join with a sl st in top of beg ch-3—9 dc; 3 ch-5 sps. Fasten off A.

Rnd 2: With RS facing, join B with a sl st in any ch-5 sp, ch 3, (3 dc, ch 3, 4 dc) in same sp, *ch 1, sk next st, dc in next st, ch 1, sk next st**, (4 dc, ch 3, 4 dc) in next ch-5 sp; rep from * around, ending last rep at **, join with a sl st in top of beg ch-3—27 dc; 3 ch-3 sps; 6 ch-1 sps. Fasten off B.

Rnd 3: With RS facing, join C with a sl st in any ch-3 sp, ch 3, (dc, ch 3, 2 dc) in same sp, *dc in each of next 3 sts, ch 1, sk next st, (dc, ch 1) in each of next 2 ch-1 sps, sk next st, dc in each of next 3 sts**, (2 dc, ch 3, 2 dc) in next ch-3 sp; rep from * around, ending last rep at **, join with a sl st in top of beg ch-3—36 dc; 3 ch-3 sps; 9 ch-1 sps. Fasten off C.

Rnd 4: With RS facing, join D with a sl st in any ch-3 sp, ch 3, (dc, ch 3, 2 dc) in same sp, *dc in each of next 4 sts, ch 1, sk next st, (dc, ch 1) in each of next 3 ch-1 sps, sk next st, dc in each of next 4 sts**, (2 dc, ch 3, 2 dc) in next ch-3 sp; rep from * around, ending last rep at **, join with a sl st in top of beg ch-3—45 dc; 3 ch-3 sps; 12 ch-1 sps. Fasten off D.

Rnd 5: With RS facing, join A with a sl st in any ch-3 sp, ch 3, (dc, ch 3, 2 dc) in same sp, *hdc in each of next 6 sts, [hdc in next ch-1 sp, hdc in next st] 4 times, hdc in each of next 5 sts**, (2 dc, ch 3, 2 dc) in next ch-3 sp; rep from * around, ending last rep at **, join with a sl st in top of beg ch-3—12 dc; 3 ch-3 sps; 57 hdc. Fasten off A.

◄ *Alternate Colorway for Motif #89*
(A) #3733 Turquoise (Rnd 1)
(B) #3800 Blueberry (Rnds 2–4)
(C) #3798 Suede (Rnd 5)

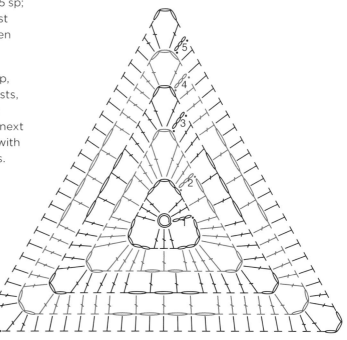

#90

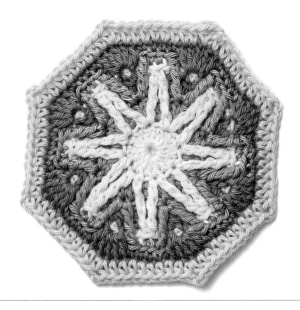

FINISHED SIZE
5" (12.5 cm) edge to edge
before blocking.

HOOK
G-6 (4.0 mm).

GAUGE
First 3 rnds = 3"
(7.5 cm) in diameter.

COLORS
(A) #3718 Natural
(B) #3717 Sand
(C) #3798 Suede
(D) #3753 White Peach

notes

- This motif is worked using some overlaid sts. Overlay crochet is worked as a series of rounds worked in the back lp, with additional sts "overlaid," or anchored in the front lp. When making overlaid sts, there are times when the st(s) in the row below (underneath the overlaid st) is skipped, and times when it is not. This is specified in the patt. Each rnd is closed with an "invisible join" (see Glossary).

- You can work dtr2tog from top to bottom through the front lp of the stitch in Rnd 1 (rather than from bottom to top).

With A, make an adjustable ring.

Rnd 1: (RS) Ch 2 (counts as dc here and throughout), work 15 dc, work invisible join in 2nd dc—16 dc.

Rnd 2: Work this round in back lps only of sts. With RS facing, join B with a sl st in any st, ch 2 (counts as dc), dc in same st, 2 dc in each st around, work invisible join in 2nd dc—32 dc.

Rnd 3: Work this round in back lps only of sts. With RS facing, join C with a sl st in first dc of any 2-dc group, ch 2, dc in same st, dc in next st, *2 dc in next st, dc in next st; rep from * around, work invisible join in 2nd dc—48 dc.

Rnd 4: Work this round in back lps only of sts, except where indicated. With RS facing, join A with a sl st in first dc of any 2-dc group, ch 1 (counts as sc here and throughout), sc in each of next 5 sts, *working in remaining front lps of sts, work dtr2tog (see Notes) working first leg in dc to the right in Rnd 1, sk next st in Rnd 1, work 2nd leg in next st in Rnd 1, sk no sts in Rnd 4**, sc in each of next 6 sts; rep from * around, ending last rep at **, work invisible join in 2nd sc—48 sc; 8 dtr2tog.

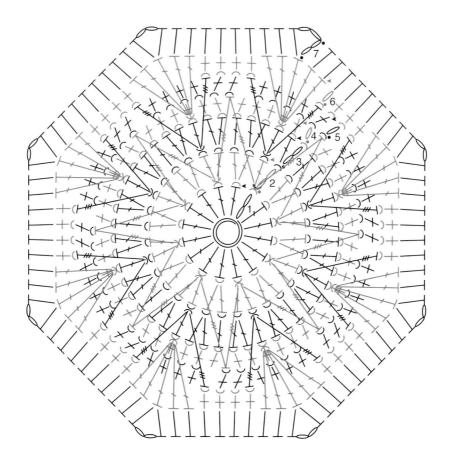

Rnd 5: Work this round in back lps only of sts, except where indicated. With RS facing, join B with a sl st in any dtr2tog, ch 1, sc in next st, *working in front lps of sts in Rnd 2, dtr in center dc of underlying dc of Rnd 2 visible between 2 dtr2tog, sk no sts in Rnd 5, sc in each of next 4 sts, dtr in front lp of same st of Rnd 2 as previous dtr, sk next st in Rnd 5**, sc in each of next 2 sts; rep from * around, work invisible join in 2nd sc—48 sc; 16 dtr.

Rnd 6: Work this round in back lps only of sts, except where indicated. With RS facing, join C with a sl st in dtr following the join, ch 1, *5 dc in front lp of center dc of underlying dc of Rnd 3, sk 4 st in Rnd 6**, sc in each of next 4 sts; rep from * around, ending last rep at **, sc in each of last 3 sts, work invisible join in first dc—32 sc; 40 dc. Fasten off C.

Rnd 7: With RS facing, join D with a sl st in 3rd dc of any 5-dc group, ch 4 (counts as hdc, ch 2), hdc in same st, *hdc in each of next 8 sts**, (hdc, ch 2, hdc) in next st; rep from * around, ending last rep at **, join with sl st in 2nd ch of beg ch-4—80 hdc; 8 ch-2 sps. Fasten off D.

#91

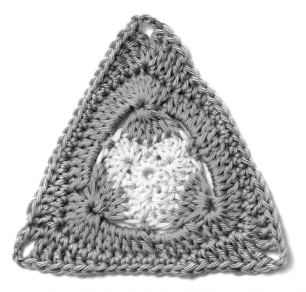

FINISHED SIZE
4¼" (11 cm) point to edge
before blocking.

HOOK
G-6 (4.0 mm).

GAUGE
First 3 rnds = 2"
(5 cm) point to edge.

COLORS
(A) #3743 Yellow Rose
(B) #3752 Coral
(C) #3727 Sky Blue

notes

- Ch 1 at the beg of rnds does not count as a st.
- Using the same color for Rnds 1–3 will change the appearance of the inner part of this motif.

With A, make an adjustable ring.

Rnd 1: (RS) Ch 2 (counts as hdc), work 11 hdc in ring, join with a sl st in top of beg ch-2—12 hdc.

Rnd 2: Ch 1, sc in same st as join, *sk next st, 7 dc in next st, sk next st**, sc in next st; rep from * around, ending last rep at **, join with a sl st in first sc—3 sc; 21 dc. Fasten off A.

Rnd 3: With RS facing, join B with a sl st in 4th dc of any 7-dc group, ch 1, sc in first dc, *ch 5, dc7tog over next 7 sts, ch 5**, sc in next st; rep from * around, ending last rep at **, join with a sl st in first sc—3 sc; 6 ch-5 sps; 3 dc7tog.

Rnd 4: Ch 2 (does not count as a st), dc in same st, *5 dc in next ch-5 sp, sk next dc7tog, 7 tr in first ch of next ch-5 sp, 5 dc in same ch-5 sp**, dc in next sc; rep from * around, ending last rep at **, join with a sl st in first dc—33 dc; 21 tr. Fasten off B.

Rnd 5: With RS facing, join C with a sl st in 4th dc of any 7-dc group, ch 4 (counts as tr), (tr, ch 3, 2 tr) in same st, *tr in next st, dc in each of next 2 sts, hdc in each of next 2 sts, sc in each of next 7 sts, hdc in each of next 2 sts, dc in each of next 2 sts, tr in next st**, (2 tr, ch 3, 2 tr) in next st; rep from * around, ending last rep at **, join with a sl st in top of beg ch-4—18 tr; 12 dc; 12 hdc; 21 sc; 3 ch-3 sps. Fasten off C.

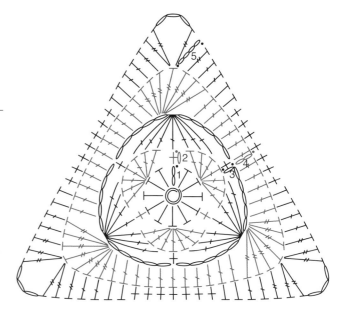

Alternate Colorway for Motif #92 ▶
(A) #3726 Periwinkle (Rnds 1 and 2)
(B) #3774 Major Teal (Rnds 3 and 5)
(C) #3763 Water Lily (Rnd 4)

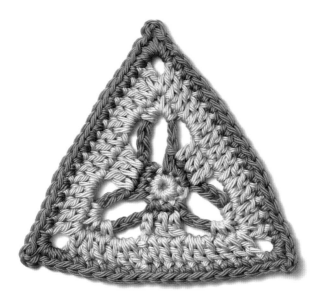

FINISHED SIZE
4" (10 cm) point to edge
before blocking.

HOOK
G-6 (4.0 mm).

GAUGE
First 3 rnds = 2¼"
(5.5 cm) point to edge.

COLORS
(A) #3746 Chartreuse
(B) #3733 Turquoise

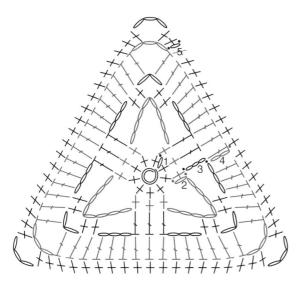

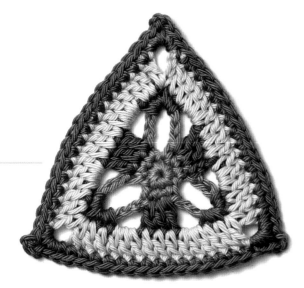

notes

- Ch 1 at the beg of rnds does not count as a st.
- Using the same color for Rnds 1 and 2 creates a subtly integrated center for this motif.

With A, make an adjustable ring.

Rnd 1: (RS) Ch 1, work 9 sc in ring, join with a sl st in first sc—9 sc. Fasten off A.

Rnd 2: With RS facing, join B with a sl st in any st, ch 1, sc in each of first 3 sts, ch 8, *sc in each of next 3 sts, ch 8; rep from * around, join with a sl st in first sc—9 sc; 3 ch-8 sps. Fasten off B.

Rnd 3: With RS facing, join A with a sl st in first sc of any 3-sc group, ch 3 (counts as dc), dc in each of next 2 sts, *ch 3, (2 sc, ch 2, 2 sc) in next ch-8 sp, ch 3**, dc in each of next 3 sts; rep from * around, ending last rep at **, join with a sl st in top of beg ch-3—9 dc; 12 sc; 6 ch-3 sps; 3 ch-2 sps.

Rnd 4: Ch 2 (does not count as st), dc in same st, dc in each of next 2 sts, *3 dc in next ch-3 sp, dc in each of next 2 sts, (dc, ch 3, dc) in next ch-2 sp, dc in each of next 2 sts, 3 dc in next ch-3 sp**, dc in each of next 3 sts; rep from * around, ending last rep at **, join with a sl st in top of first dc—45 dc; 3 ch-3 sps. Fasten off A.

Rnd 5: With RS facing, join C with a sl st in any ch-3 sp, ch 1, *(2 sc, ch 3, 2 sc) in ch-3 sp, sc in each of next 15 sts; rep from * around, join with a sl st in first sc—57 sc; 3 ch-3 sps. Fasten off C.

#93

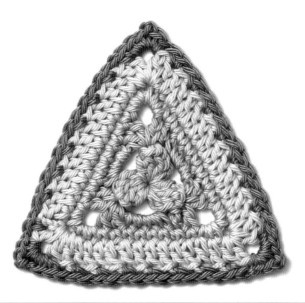

FINISHED SIZE
3¾" (9.5 cm) point to edge
before blocking.

HOOK
G-6 (4.0 mm).

GAUGE
First 3 rnds = 2½"
(6.5 cm) point to edge.

COLORS
(A) #3727 Sky Blue
(B) #3746 Chartreuse
(C) #3763 Water Lily;
(D) #3729 Grey

notes

- Change colors between Rnds 1 and 2 to make the center popcorn sts stand out.
- Ch 1 at the beg of rnds does not count as a st.

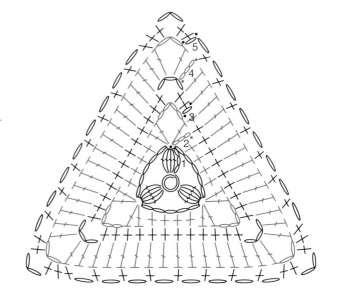

With A, make an adjustable ring.

Rnd 1: (RS) Beg popcorn in ring, ch 5, (popcorn, ch 5) twice in ring, join with a sl st in beg popcorn—3 popcorns; 3 ch-5 sps.

Rnd 2: Ch 3 (counts as dc here and throughout), (dc, ch 4, 2 dc) in same st, *4 sc in next ch-5 sp**, (2 dc, ch 4, 2 dc) in next popcorn; rep from * around, ending last rep at **, join with a sl st in top of beg ch-3—12 dc; 12 sc; 3 ch-4 sps. Fasten off A.

Rnd 3: With RS facing, join B with a sl st in any ch-4 sp, ch 1, *(2 sc, ch 3, 2 sc) in ch-4 sp, sc in each of next 8 sts; rep from * around, join with a sl st in first sc—36 sc; 3 ch-3 sps. Fasten off B.

Rnd 4: With RS facing, join C with a sl st in any ch-3 sp, ch 3, (dc, ch 2, 2 dc) in same sp, *dc in each of next 12 sts**, (2 dc, ch 2, 2 dc) in next ch-3 sp; rep from * around, ending last rep at **, join with a sl st in top of beg ch-3—48 dc; 3 ch-2 sps. Fasten off C.

Rnd 5: With RS facing, join D with a sl st in any ch-2 sp, ch 1, *(2 sc, ch 2, 2 sc) in ch-2 sp, sc in next st, [ch 1, sk next st, sc in next st] 7 times, ch 1, sk next st; rep from * around, join with a sl st in first sc—36 sc; 3 ch-2 sps; 24 ch-1 sps. Fasten off D.

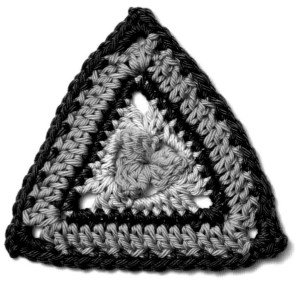

Alternate Colorway
(A) #3712 Primrose (Rnds 1 and 4)
(B) #3746 Chartreuse (Rnd 2)
(C) #3793 Indigo Blue (Rnds 3 and 5)

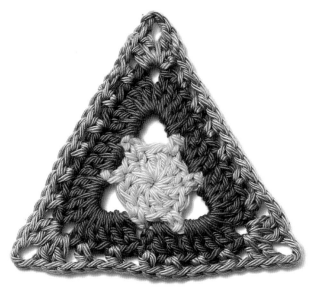

FINISHED SIZE

3½" (9 cm) point to edge before blocking.

HOOK

G-6 (4.0 mm).

GAUGE

First 3 rnds = 2¾" (7 cm) point to edge.

COLORS

(A) #3775 Cool Mint
(B) #3734 Teal
(C) #3778 Lavender

#94

notes

- Changing colors between Rnds 1 and 2 accentuates the central circle, whereas keeping the same color for Rnds 1 and 2 creates a different profile to the motif.

- Ch 1 at the beg of rnd does not count as a st.

With A, make an adjustable ring.

Rnd 1: (RS) Ch 3 (counts as dc here and throughout), work 11 dc in ring, join with a sl st in top of beg ch-3—12 dc.

Rnd 2: Ch 1, sc in first st, *ch 2, sk next st, sc in next st, ch 5, sk next st**, sc in next st; rep from * around, ending last rep at **, join with a sl st in first sc—6 sc; 3 ch-2 sps; 3 ch-5 sps. Fasten off A.

Rnd 3: With RS facing, join B with a sl st in any ch-2 sp, ch 3, 2 dc in same sp, *(5 dc, ch 2, 5 dc) in next ch-5 sp**, 3 dc in next ch-2 sp; rep from * around, ending last rep at **, join with a sl st in top of beg ch-3—39 dc; 3 ch-2 sps. Fasten off B.

Rnd 4: With RS facing, join C with a sl st in any ch-2 sp, ch 3, (dc, ch 3, 2 dc) in same sp, *[ch 1, sk next st, hdc in next st] 6 times, ch 1, sk next st**, (2 dc, ch 3, 2 dc) in next ch-2 sp; rep from * around, ending last rep at **, join with a sl st in top of beg ch-3—12 dc; 18 hdc; 21 ch-1 sps, 3 ch-3 sps. Fasten off C.

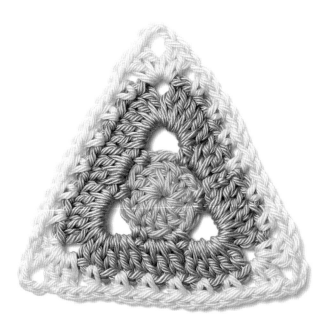

Alternate Colorway
(A) #3732 Aqua (Rnd 1)
(B) #3772 Cornflower (Rnds 2 and 3)
(C) #3718 Natural (Rnd 4)

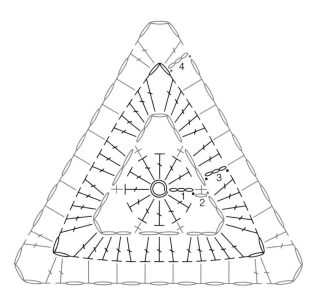

#95

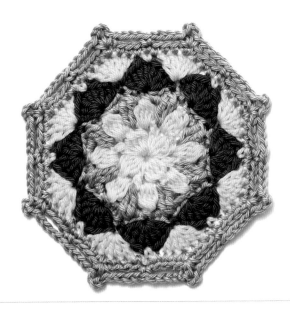

FINISHED SIZE
4¾" (12 cm) edge to edge
before blocking.

HOOK
G-6 (4.0 mm).

GAUGE
First 3 rnds = 2½"
(6.5 cm) edge to edge.

COLORS
(A) #3718 Natural
(B) #3772 Cornflower
(C) #3793 Indigo Blue
(D) #3717 Sand

notes

- Ch 1 at the beg of rnds does not count as a st.
- Rnds are closed with a hdc, which counts as a ch-2 sp. This better positions the hook to beg the next rnd.
- Work all rounds in the back lp, except in the corner sps.
- Work this motif in a single color to create a subtly textured fabric. Change colors on alternate rnds to better highlight the post sts.

With A, make an adjustable ring.

Rnd 1: (RS) Ch 2, 3-dc cluster (counts as 4-dc cluster here and throughout), [ch 2, dc, ch 2, 4-dc cluster] 3 times in ring, ch 2, dc in ring, ch 2, join with a sl st in first 3-dc cluster—4 4-dc clusters; 4 dc; 8 ch-2 sps.

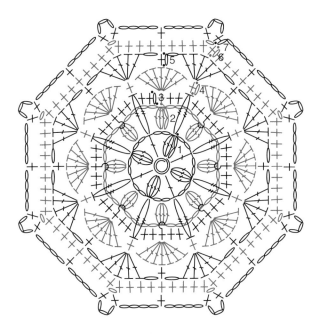

Rnd 2: Sl st in next ch-2 sp, ch 2, 3-dc cluster, ch 4, (4-dc cluster, ch 4) in each ch-2 sp around, join with a sl st in first 3-dc cluster—8 3-dc clusters; 8 ch-4 sps. Fasten off A.

Rnd 3: With RS facing, join B with a sl st in any ch-4 sp, ch 1, *2 sc in ch-4 sp, working in front of ch-4 sp of Rnd 2, 2-tr cluster in corresponding skipped 4-dc cluster in Rnd 1, 2 sc in same ch-4 sp, fpsc around the post of next 4-dc cluster; rep from * around, join with a sl st in first sc—32 sc; 8 2-tr clusters; 8 fpsc. Fasten off B.

Rnd 4: With RS facing, join C with a sl st in any 2-tr cluster, ch 1, sc in same st, *sk next 2 sts, 7 dc in next fpsc, sk next 2 sts**, sc in next 2-tr; rep from * around, ending last rep at **, join with a sl st in first sc—8 sc; 56 dc. Fasten off C.

Rnd 5: With RS facing, join A with a sl st in 4th dc of any 7-dc group, ch 1, sc in same st, *ch 1, sk next 3 sts, 5 dc in next sc, ch 1, sk next 3 sts**, sc in next st; rep from * around, ending last rep at **, join with a sl st in first sc—8 sc; 16 ch-1 sps; 40 dc. Fasten off A.

Rnd 6: With RS facing, join D with a sl st in 3rd dc of any 5-dc group, ch 1, (sc, ch 1, sc) in same st, *sc in each of next 2 sts, sc in next ch-1 sp, sc in next st, sc in next ch-1 sp, sc in each of next 2 sts**, (sc, ch 1, sc in next st; rep from * around, ending last rep at **, join with a sl st in first sc—72 sc; 8 ch-1 sps. Fasten off D.

Rnd 7: With RS facing, join B with a sl st in any ch-1 sp, ch 1, *(sc, ch 3, sc) in ch-1 sp, ch 4, sk next 4 sts, sc in next st, ch 4, sk next 4 sts; rep from * around, join with a sl st in first sc—24 sc; 16 ch-4 sps; 8 ch-3 sps. Fasten off B.

Alternate Colorway for Motif #96 ▶
((A) #3753 White Peach
(B) #3760 Celery
(C) #3763 Water Lily

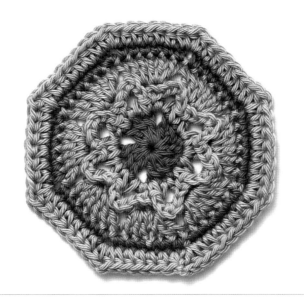

FINISHED SIZE
4" (10 cm) edge to edge before blocking.

HOOK
G-6 (4.0 mm).

GAUGE
First 3 rnds = 2¼" (5.5 cm) edge to edge.

COLORS
(A) #3774 Major Teal
(B) #3759 Taupe
(C) #3807 Jasmine Green

notes

- Try picking a neutral color for Rnds 2 and 4 to allow the central "waves" to pop.
- Ch 1 at the beg of rnds does not count as a st.

With A, make an adjustable ring.

Rnd 1: (RS) Ch 3 (counts as dc here and throughout), 2 dc in ring, ch 2, [3 dc, ch 2] 3 times in ring, join with a sl st in top of beg ch-3—12 dc; 4 ch-2 sps. Fasten off A.

Rnd 2: With RS facing, join B with a sl st in any ch-2 sp, ch 5 (counts as dc, ch 2), dc in same sp, *sk next st, (dc, ch 2, dc) in next st**, (dc, ch 2, dc) in next ch-2 sp; rep from * around, ending last rep at **, join with a sl st in 3rd ch of beg ch-5—16 dc; 8 ch-2 sps. Fasten off B.

Rnd 3: With RS facing, join C with a sl st in any ch-2 sp, ch 1, *3 sc in ch-2 sp, ch 2, working in front of Rnd 2, sc in next skipped st in Rnd 1, ch 2; rep from * around, join with a sl st in first sc—32 sc; 16 ch-2 sps. Fasten off C.

Rnd 4: With RS facing, join B with a sl st in any skipped dc in Rnd 2, ch 3, 2 dc in same st, 3 dc in each skipped dc of Rnd 2 around, join with a sl st in top of beg ch-3—48 dc. Fasten off B.

Rnd 5: With RS facing, join A with a sl st in first dc of any 6-dc group worked in 2 adjacent sts, ch 1, sc in each of first 6 sts, ch 2, *sc in each of next 6 sts, ch 2; rep from * around, join with a sl st in first sc—48 sc; 8 ch-2 sps. Fasten off A.

Rnd 6: With RS facing, join C with a sl st in any ch-2 sp, ch 3 (counts as hdc, ch 1), hdc in same sp, *hdc in each of next 6 sts**, (hdc, ch 1, hdc) in next ch-2 sp; rep from * around, ending last rep at **, join with a sl st in 2nd ch of beg ch-3—64 hdc; 8 ch-1 sps. Fasten off C.

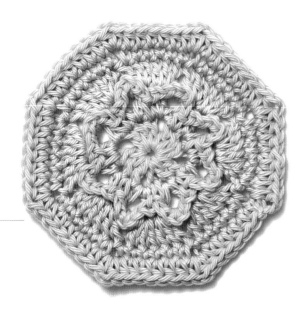

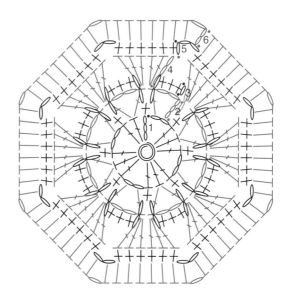

#97

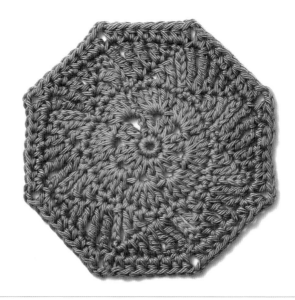

FINISHED SIZE
4½″ (11.5 cm) edge to edge
before blocking.

HOOK
G-6 (4.0 mm).

GAUGE
First 3 rnds = 2″
(5 cm) in diameter.

COLORS
(A) #3735 Jade
(B) #3798 Suede

notes

- Ch 1 at the beg of rnds does not count as a st.
- Use a single color to accent the central "star" in this motif, or go with a more vintage look using different rust-toned colors on subsequent rnds.

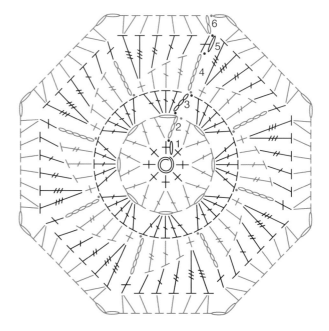

With A, make an adjustable ring.

Rnd 1: (RS) Ch 1, work 8 sc in ring, join with a sl st in first sc—8 sc.

Rnd 2: Ch 4 (counts as dc, ch 1), dc in same st, (1 dc, ch 1, 1 dc) in each st around, join with a sl st in 3rd ch of beg ch-4—16 dc; 8 ch-1 sps.

Rnd 3: Sl st in next ch-1 sp, ch 3 (counts as dc), 4 dc in same sp, 5 dc in each ch-1 sp around, join with a sl st in top of beg ch-3—40 dc.

Rnd 4: *Ch 5 (counts as dtr here and throughout), tr in next st, dc in next st, hdc in next st, sc in next st, sl st in next st; rep from * around, ending with last sl st in top of beg ch-3 in Rnd 3—8 dtr; 8 tr; 8 dc; 8 hdc; 8 sc; 8 sl sts. Fasten off A.

Rnd 5: With RS facing, join B with a sl st in top of any ch-5 "dtr," ch 1, *sc in top of ch-5, hdc in next tr, dc in next dc, tr in next hdc, 2 dtr in next sc; rep from * around, join with a sl st in first sc—8 sc; 8 hdc; 8 dc; 8 tr; 16 dtr.

Rnd 6: Ch 2 (counts as hdc), hdc in same st, *hdc in each of next 4 sts, 2 hdc in next st, ch 2, 2 hdc in next st; rep from * around, ending last rep at **, join with a sl st in top of beg ch-2—64 hdc; 8 ch-2 sps. Fasten off B.

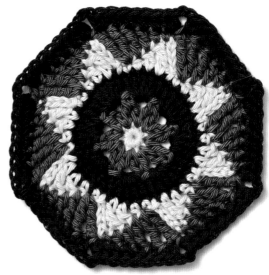

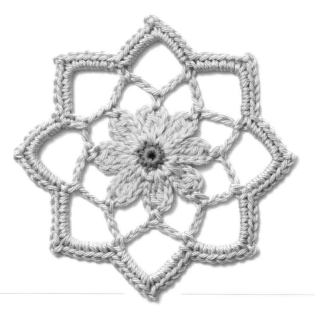

FINISHED SIZE
4¾" (12 cm) point to point before blocking.

HOOK
G-6 (4.0 mm).

GAUGE
First 3 rnds = 3"
(7.5 cm) in diameter.

COLORS
(A) #3750 Tangerine
(B) #3748 Buttercup
(C) #3736 Ice

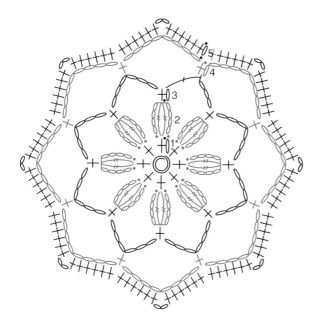

◀ Alternate Colorway for Motif #97
(A) #3753 White Peach (Rnds 1 and 4)
(B) #3769 Ginger (Rnds 2 and 5)
(C) #3714 Burgundy (Rnds 3 and 6)

notes

- Ch 1 at the beg of rnds does not count as a st.
- Rnd 3 is closed with (ch 3, dc), which counts as a ch-6 sp. This better positions the hook for the beg of the next rnd.

With A, make an adjustable ring.

Rnd 1: (RS) Ch 1, work 8 sc in ring, join with a sl st in first sc—8 sc. Fasten off A.

Rnd 2: With RS facing, join B with a sl st in any st, (ch 4, 2-tr cluster, ch 4, sl st) in same st, (sl st, ch 4, 2-tr cluster, ch 4, sl st) in each st around, join with a sl st in first sc at beg of Rnd 1—16 sl sts; 16 ch-4 sps; 8 2-tr clusters. Fasten off B.

Rnd 3: With RS facing, join C with a sl st in any 2-tr cluster, ch 1, sc in same st, (ch 6, sc) in each 2-tr cluster around, ch 3, join with dc in first sc instead of last ch-6 sp—8 sc; 8 ch-6 sps.

Rnd 4: Ch 1, (sc, ch 8) in each ch-6 sp around, join with a sl st in first sc—8 sc; 8 ch-8 sps.

Rnd 5: Sl st in next ch-8 sp, ch 1, (6 sc, ch 2, 6 sc) in each ch-8 sp around, join with a sl st in first sc—96 sc; 8 ch-2 sps. Fasten off C.

#99

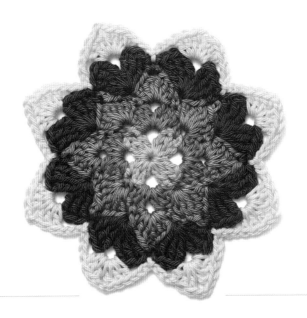

FINISHED SIZE
5½" (14 cm) point to point
before blocking.

HOOK
G-6 (4.0 mm).

GAUGE
First 3 rnds = 3½"
(9 cm) point to point.

COLORS
(A) #3732 Aqua
(B) #3800 Blueberry
(C) #3805 Colony Blue
(D) #3793 Indigo Blue
(E) #3718 Natural

notes

- Ch 1 at the beg of rnds does not count as a st.
- Try this motif in a set of cool colors or warm colors. Changing colors on every rnd makes the "petals" of this flower-like motif stand out.

With A, make an adjustable ring.

Rnd 1: (RS) Ch 3 (counts as dc here and throughout), 2 dc in ring, ch 3, [3 dc, ch 3] 3 times in ring, join with a sl st in top of beg ch-3—12 dc; 4 ch-3 sps. Fasten off A.

Rnd 2: With RS facing, join B with a sl st in any ch-2 sp, ch 3, (2 dc, ch 2, 3 dc) in same sp, *sk next st, sc in next st, sk next st**, (3 dc, ch 2, 3 dc) in next ch-3 sp; rep from * around, ending last rep at **, join with a sl st in top of beg ch-3—24 dc; 4 ch-2 sps; 4 sc. Fasten off B.

Rnd 3: With RS facing, join C with a sl st in any ch-2 sp, ch 3, (2 dc, ch 2, 3 dc) in same sp, *sk next st, sc in next st, sk next st, (3 dc, ch 2, 3 dc) in next st, sk next st, sc in next st**, (3 dc, ch 2, 3 dc) in next ch-2 sp; rep from * around, ending last rep at **, join with a sl st in top of beg ch-3—48 dc; 8 ch-2 sps; 8 sc. Fasten off C.

Rnd 4: With RS facing, join D with a sl st in any ch-2 sp, ch 1, *sc in ch-2 sp, sk next 3 sts, (3 tr, ch 2, 3 tr) in next st, sk next 3 sts; rep from * around, join with a sl st in first sc—48 tr; 8 ch-2 sps; 8 sc. Fasten off D.

Rnd 5: With RS facing, join E with a sl st in any sc, ch 1, sc in first st, ch 3, (3 dc, ch 2, 3 dc) in next ch-2 sps, ch 3, sk next 3 sts**, sc in next st; rep from * around, ending last rep at **, join with a sl st in first sc—48 dc; 8 ch-2 sps; 8 sc; 16 ch-3 sps. Fasten off E.

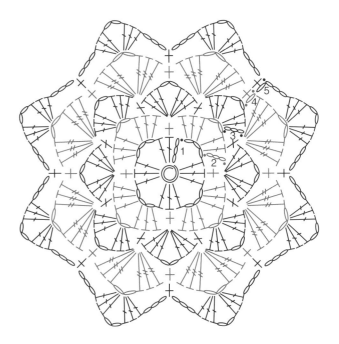

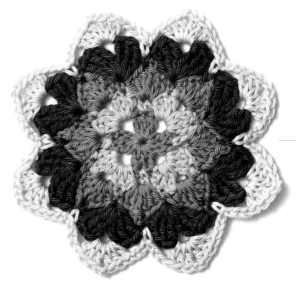

FINISHED SIZE
4¾" (12 cm) point to point before blocking.

HOOK
G-6 (4.0 mm).

GAUGE
First 3 rnds = 3" (7.5 cm) in diameter.

COLORS
(A)#3732 Aqua
(B) #3748 Buttercup
(C) #3704 Syrah

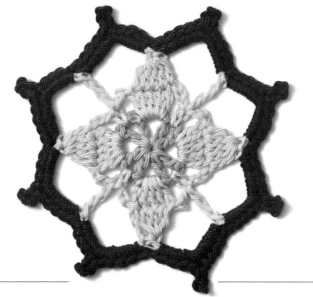

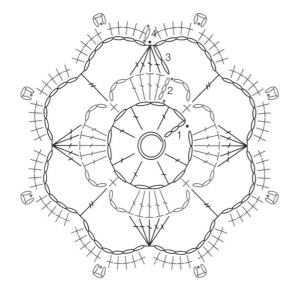

With A, make an adjustable ring.

Rnd 1: (RS) Ch 4 (counts as dc, ch 1), *dc in ring, ch 2, dc in ring, ch 1; rep from * twice, dc in ring, ch 2, join with a sl st in 3rd ch of beg ch-4—8 dc; 4 ch-1 sps; 4 ch-2 sps. Fasten off A.

Rnd 2: With RS facing, join B with a sl st in any ch-2 sp, ch 3 (counts as dc), 4 dc in same sp, *ch 3, sc in next ch-1 sp, ch 3**, 5 dc in next ch-2 sp; rep from * around, ending last rep at **, join with a sl st in top of beg ch-3—20 dc; 8 ch-3 sps; 4 sc.

Rnd 3: Ch 2, dc4tog over next 4 dc (counts as dc5tog), *ch 7, sk next ch-3 sp, tr in next sc, ch 7, sk next ch-3 sp**, dc5tog over next 5 dc; rep from * around, ending last rep at **, join with sl st in first dc4tog—4 dc5tog; 8 ch-7 sps; 4 tr. Fasten off B.

Rnd 4: With RS facing, join C with a sl st in any ch-7 sp, ch 1, (5 sc, picot, 5 sc) in each ch-7 sp around, join with a sl st in first sc—80 sc; 8 picots. Fasten off C.

◀ *Alternate Colorway for Motif #99*
(A) #3750 Tangerine
(B) #3711 China Pink
(C) #3802 Honeysuckle
(D) #3701 Cranberry
(E) #3764 Sunshine

THE
projects

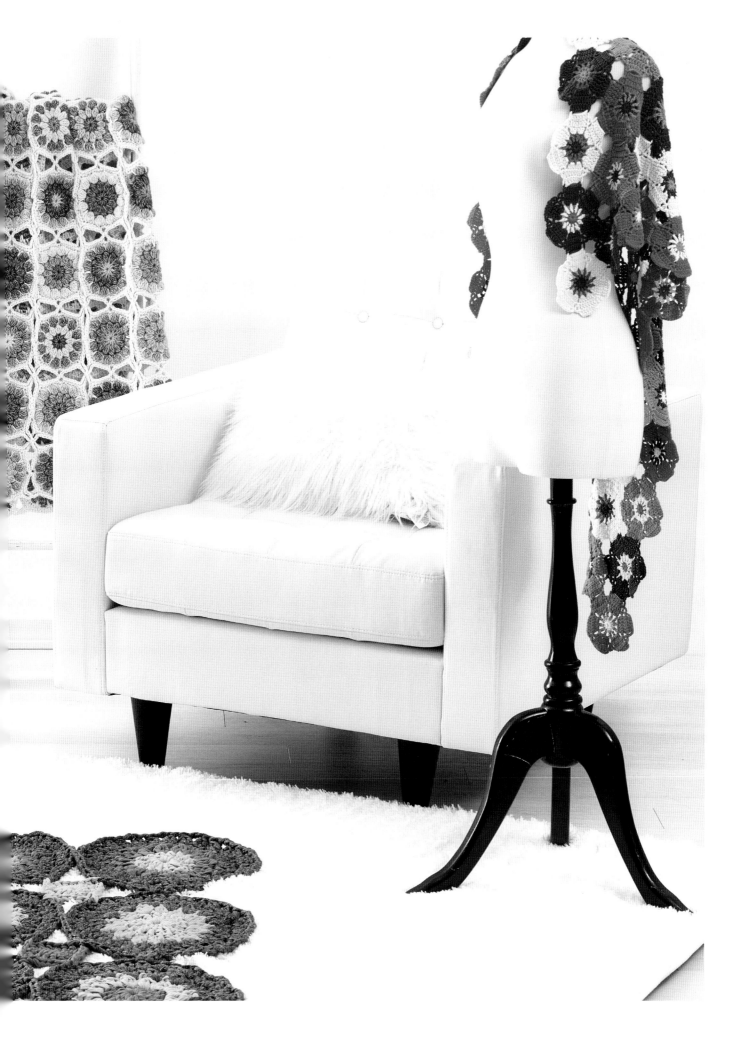

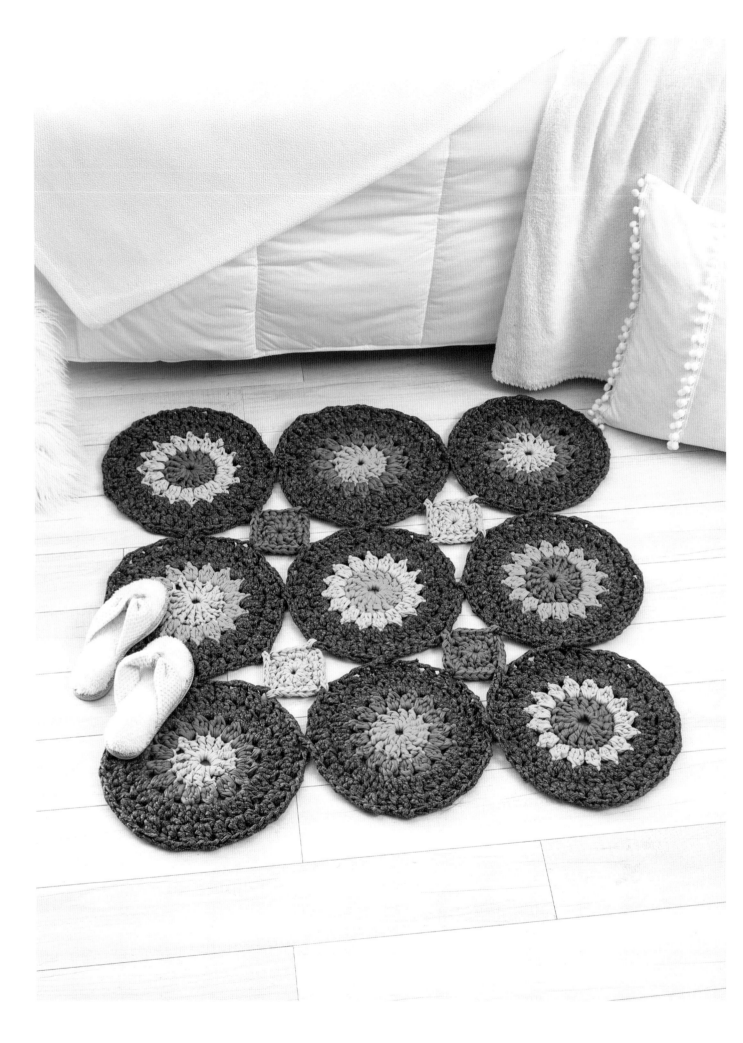

circles in a square rug

FINISHED SIZE
35″ × 35″ (89 × 89 cm) before blocking.

YARN
#6 Super Bulky

SHOWN HERE: Hoooked Zpagetti (90% cotton, 10% synthetic; 131 yd [120 m]/30 oz [850 g]): Optic Anthracite (Main Color A), 2 skeins; Passion Aqua (Contrast Color B); Shining Aqua (Contrast Color C); Ocre Spice (Contrast Color D), 1 skein each.

HOOK
P-15 (10 mm); J-10 (6.0 mm) for weaving in ends.

GAUGE
First 2 rnds = 7½″ (19 cm) in diameter.
Motif = 12″ (30.5 cm) in diameter.

notes
- This pattern uses Motif #4 (p. 18).
- This motif is designed to be joined as you go. When ready to join, use ch-2 spaces to join adjacent motifs. The square filler motifs are joined at the end.

Instructions

MAIN RUG

Make 9 of Motif #4 (p. 18). Work Rnds 1 and 2 of all motifs, then determine in what order you would like your layout to be. Rnd 3 is worked the same for all motifs. Motifs will be joined as you go (JAYG) on Rnd 4 as follows:

First Motif
(upper left-hand corner of the rug)

Rnd 4: Ch 2, dc in same st (counts as 2-dc cluster), *2-dc cluster in next 2-dc cluster, ch 2**, 2-dc cluster in next 2-dc cluster; rep from * around, ending last rep at **, join with a sl st in first dc—32 2-dc clusters; 16 ch-2 sps. Fasten off C.

Second and Third Motifs
(first row of the rug, working left to right)

Rnd 4: Ch 2, dc in same st (counts as 2-dc cluster), *2-dc cluster in next 2-dc cluster, ch 2**, 2-dc cluster in next 2-dc cluster; rep from * 14 times, 2-dc cluster in next 2-dc cluster, ch 1, drop lp from hook, insert hook in corresponding ch-2 sp on previous motif, pick up dropped lp, ch 1, join with a sl st in first dc—32 2-dc clusters; 16 ch-2 sps. Fasten off C.

Fourth Motif
(second row of the rug)

Work same as second motif, joining to side of first motif, leaving 3 ch-2 sps free from previous join.

Note: *There should be 8 2-dc clusters between this join and the join between first and second motifs.*

Fifth and Sixth Motifs
(second row of the rug, working left to right)

Rnd 4: Ch 2, dc in same st (counts as 2-dc cluster), *2-dc cluster in next 2-dc cluster, ch 2, 2-dc cluster in next 2-dc cluster*; rep from * to * 10 times, **2-dc cluster in next 2-dc cluster, ch 1, drop lp from hook, insert hook in corresponding ch-2 sp on previous motif, pick up dropped lp, ch 1**; rep from * to * 3 times; rep from ** to ** once, join with a sl st in first dc—32 2-dc clusters; 16 ch-2 sps. Fasten off C.

Seventh–Ninth Motifs

Rep fourth to sixth motifs.

Filler Motif (make 4)

With A, make an adjustable ring.

Rnd 1: (RS) Ch 3 (counts as dc), work 11 dc in ring, join with a sl st in top of beg ch-3—12 dc.

Rnd 2: Ch 1 (does not count as st), sc in same st, 2 hdc in next st, ch 1, drop lp from hook, insert hook in ch-2 sp of motif above and to the left (*Note: There should be 4 2-dc clusters between this join and the joins between circle motifs on either side.*), pick up dropped lp, ch 1, 2 hdc in next st, 1 sc in next st, 2 hdc in next st, ch 1, drop lp from hook, insert hook in ch-2 sp of motif below and to the left, pick up lp, ch 1, 2 hdc in next st, 1 sc in next st, 2 hdc in next st, ch 1, drop lp from hook, insert hook in ch-2 sp of motif below and to the right, pick up lp, ch 1, 2 hdc in next st, 1 sc in next st, 2 hdc in next st, ch 1, drop lp from hook, insert hook in ch-2 sp of motif above and to the right, pick up lp, ch 1, 2 hdc in next st, join with sl st to 1st sc—4 sc, 16 hdc, 4 ch-2 sps. Fasten off.

Finishing

Weave in all ends and block as desired.

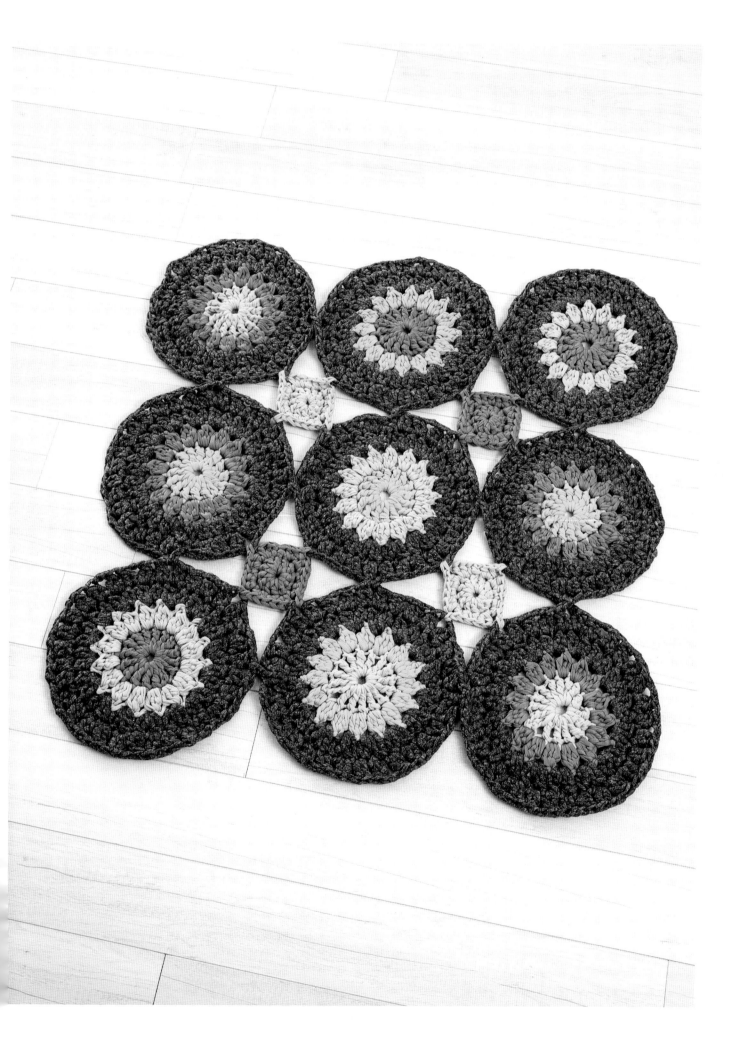

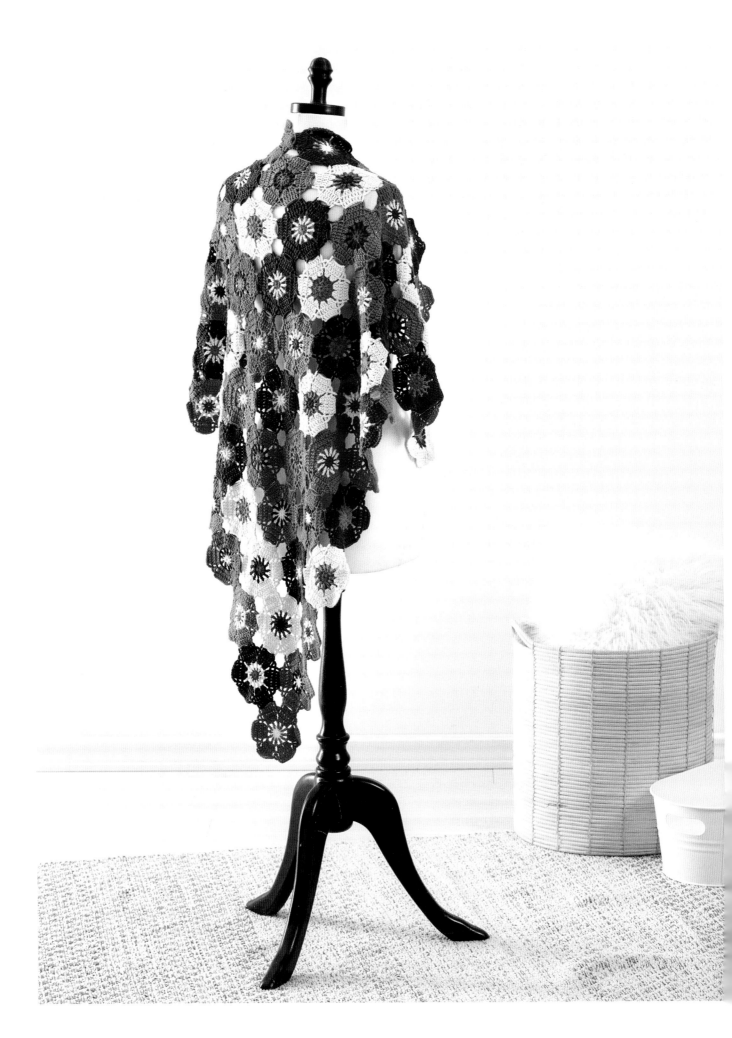

mod flower shawl

FINISHED SIZE
48" (122 cm) on each side before blocking.

YARN
Sport weight (#2 Fine)

SHOWN HERE: DROPS Safran (100% cotton; 175 yd [160 m]/1.8 oz [50 g]): #09 Navy Blue (A); #18 Off White (B); #28 Orange (C); #55 Cerise (D), 2 skeins each.

HOOK
F-5 (3.75 mm).

NOTIONS
Yarn needle.

GAUGE
Each motif = 4" (10 cm) in diameter before blocking.

note

- This pattern uses Motif #68 (p. 92).
- The motifs in this shawl are joined as you go (JAYG). If you want to play around with the motif arrangement before joining them, you can determine how much yarn is needed to work the final rnd of each motif by working a final rnd and then unraveling it and measuring. After working all but the final rnd in a particular color combination, measure out this amount (plus several inches to weave in at the end), and then cut your yarn.

Instructions

Work 78 of Motif #68 (p. 92). To calculate the maximum number of unique color combinations, multiply the number of colors you are using by 1 less than that number, and then again by 1 less than that number, until you reach 1. For example, if you are using 4 colors, the number of possible unique color combinations is 4 × 3 × 2 = 24. For this shawl, work 3 of each motif in the following color combinations, plus an additional 6 motifs in color combinations of your choosing:

ABC	ACB	BAC	BCA	CAB	CBA
ABD	ADB	BAD	BDA	CAD	CDA
ACD	ADC	BCD	BDC	CBD	CDB
DAB	DBA	DBC	DCB	DAC	DCA

Motifs for the shawl are joined in a triangle shape, with 12 motifs on each side of the triangle. To join motifs as you go, work 2 ch of the ch-3 on the right side of each "petal," drop the lp from the hook, and insert it into the corresponding ch-3 sp of the adjacent motif. Pick up the dropped lp, ch 1, and continue with the round as indicated. Work 1 ch of the ch-3 on the left side of each "petal," drop the lp from the hook, and insert it into the corresponding ch-3 sp of the adjacent motif. Pick up the dropped lp, ch 2, and continue with the round as indicated. Do this for each side of the motif to be joined.

Alternate Instructions

For each motif, work Rnds 1–4 as indicated in the pattern on p. 92.

Rnd 5: Ch 3, dc in each of next 5 sts, (ch-3, sl st) in each of next 2 ch-3 sps, *ch 2, drop lp from hook, insert in corresponding ch-3 sp on previous motif, pick up dropped lp, ch 1, dc in each of next 6 sts, ch 1, drop lp from hook, insert in corresponding ch-3 sp on previous motif, pick up dropped lp, ch 2; rep from * until all adjacent sides are joined, **(ch-3, sl st) in each of next 2 ch-3 sps, ch 3***, dc in each of next 6 sts; rep from ** around, ending last rep at ***, join with a sl st in top of beg ch-3—36 dc; 18 ch-3 sps; 12 sl sts. Fasten off C.

Finishing

Weave in ends and block as desired.

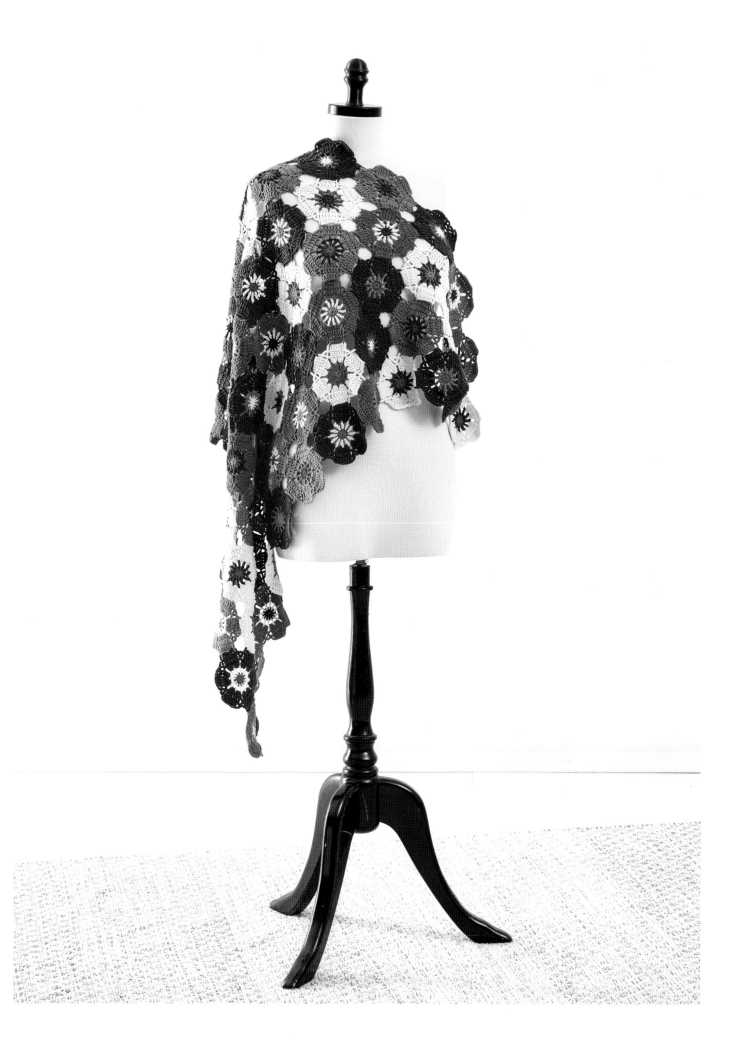

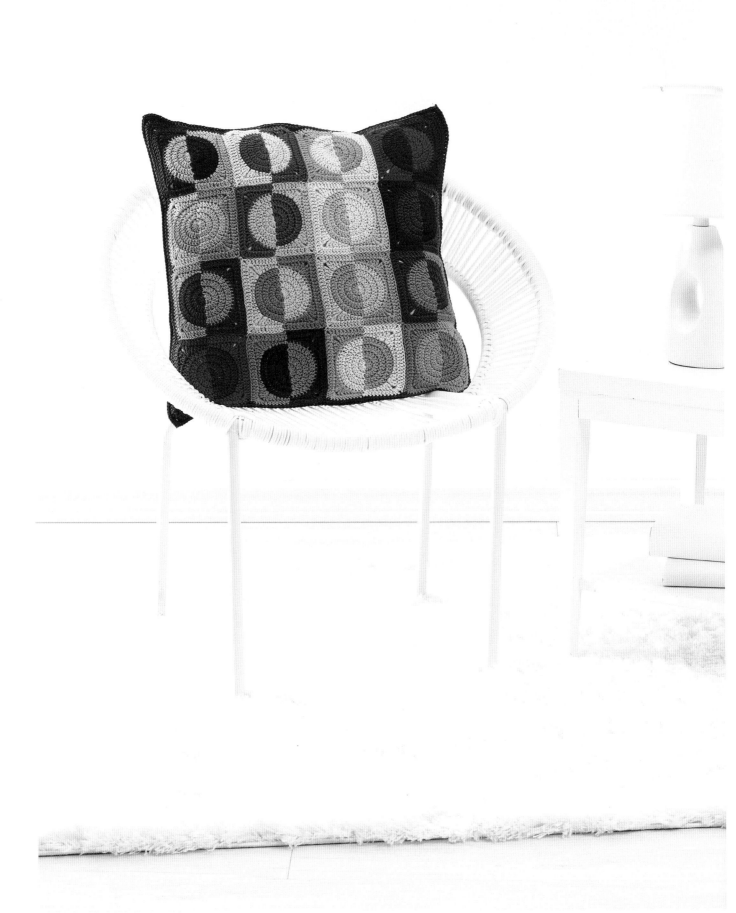

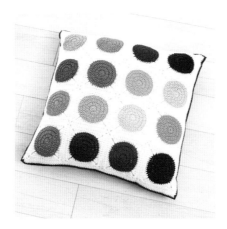

solstice pillow

FINISHED SIZE

Finished front and back covers measure 20″ (51 cm) across.

YARN

DK weight (#3 Light)

SHOWN HERE: Cascade Yarns Ultra Pima (100% cotton; 218 yd [200 m]/3.5 oz [100 g]): #3823 Tomato (A); #3755 Lipstick Red (B); #3771 Paprika (C); #3750 Tangerine (D); #3747 Gold (E); #3743 Yellow Rose (F); #3746 Chartreuse (G); #3738 Spearmint (H); #3736 Ice (I); #3774 Major Teal (J); #3775 Cool Mint (K); #3733 Turquoise (L); #3724 Armada (M); #3710 Orchid (N); #3776 Pink Rose (O); #3703 Magenta (P), 1 skein each; #3728 White (Q), 2 skeins.

HOOK

G-6 (4.0 mm) for motifs
H-8 (4.5 mm) (optional for joining motifs).

NOTIONS

Yarn needle; 20″ (51 cm) pillow form.

GAUGE

Each motif = 4½″ (11.5 cm) in diameter before blocking.

notes

- This pattern uses Motif #64 (p. 86) for the half-circle pillow and Motif #46 (p. 67) for the full circle pillow.

- Depending on how even your tension is, you may want to block the motifs before joining them to ensure uniform size. If you choose to join motifs by sl st them together, inc by 1–2 hook sizes from that used to work the motifs to avoid joining too tightly.

- Ch 1 at the beg of rnds does not count as a st.

Instructions

HALF-CIRCLE PILLOW FRONT

Work 16 of Motif # 64 (p. 86) in the following color combinations:

AB, BC, CD, DE, EF, FG, GH, HI, IJ, JK, KL, LM, MN, NO, OP, PA

Join motifs in a 4 × 4 square, using the "locking mattress stitch," which provides a nearly invisible join. Cut a length of neutral-color yarn that is approximately twice as long as the desired seam. All sts are made into the outer lp of the sts. Sew motifs together as follows:

1. With RS facing, insert needle from left to right through the first st of the motif on the left.

2. Insert needle from left to right through the corresponding st of the motif on the right.

3. Insert needle from right to left in the next st of the motif on the right.

4. Insert needle from right to left in the st previously sewn on the motif on the left.

5. Continue in this manner until you reach the end of the seam. When you reach a ch sp, sew into the ch sts in the same manner as the other sts.

6. Work all of the vertical seams first, and the horizontal seams next.

After the motifs are sewn together, make a border as follows:

BORDER

Rnd 1: With RS facing, join M with a sl st in any ch-2 sp, ch 1, *(sc, ch 2, sc) in ch-2 sp, [sc in each of next 20 sts, sc2tog over next 2 ch-2 sps] 3 times, sc in each of next 20 sts; rep from * around, join with a sl st in first sc. Do not fasten off—328 sc; 12 sc2tog; 4 ch-2 sps.

Rnd 2: Sl st in next ch-2 sp, ch 3 (counts as dc), (dc, ch 2, 2 dc) in same sp, *dc in each of next 85 sts**, (2 dc, ch 2, 2 dc) in ch-2 sp; rep from * around, ending last rep at **, join with a sl st in top of beg ch-3—356 dc; 4 ch-2 sps. Fasten off M.

Weave in ends and block as desired.

FULL-CIRCLE PILLOW FRONT

Work 16 of motif #46 (p. 67), using colors A–P for the center circles and color Q to border all of the circles.

Join motifs in a 4 × 4 square, either using the locking mattress stitch described above, or by slip stitching the squares together. With right sides facing, slip stitch through the outer lps only along each motif. Make 1 sl st in each ch-2 corner sp. Work all of the vertical seams first, and the horizontal seams next.

After the motifs are sewn together, using Q, work Border same as above.

Finishing

Crochet the front and back covers together as follows:

Work this round through both lps of the front and back covers. With WS facing, join M with a sl st in any ch-2 sp, ch 1, *(2 sc, ch 2, 2 sc) in ch-2 sp, sc in each of next 89 sts*; rep from * to * twice, insert pillow form and repeat from * to * once, join with a sl st in first sc—372 sc; 4 ch-2 sps. Fasten off M.

Weave in ends.

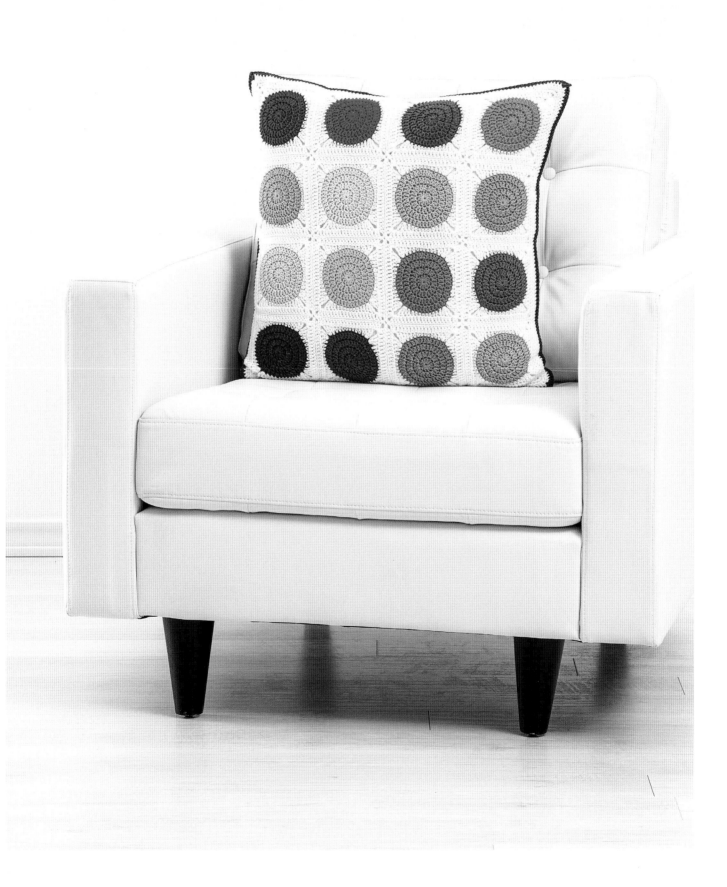

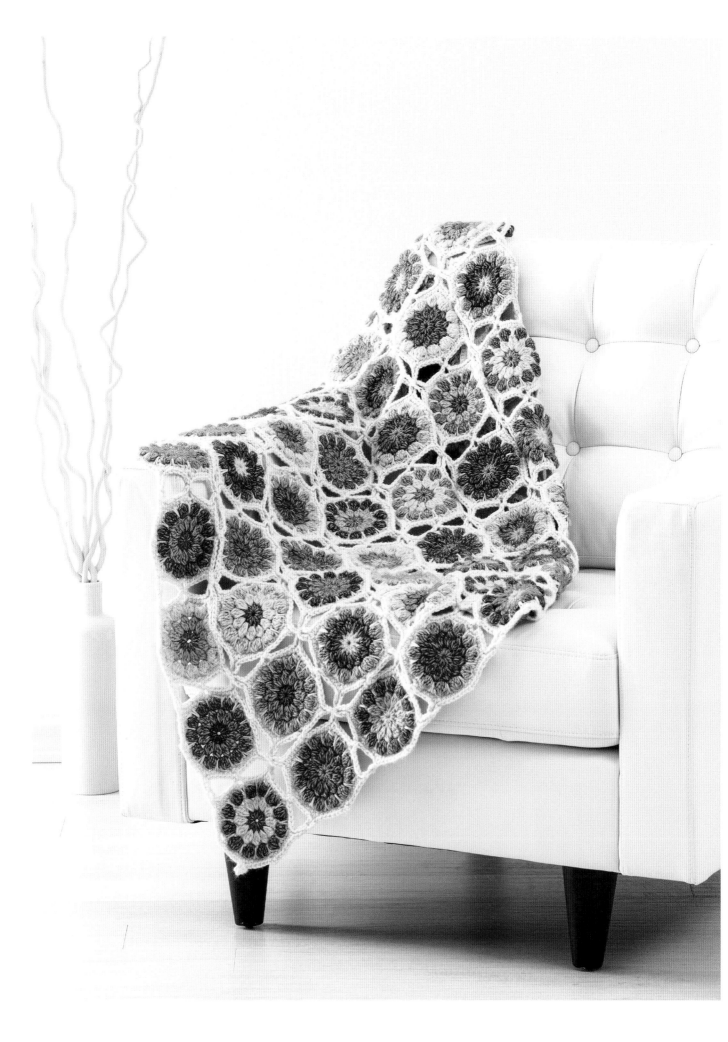

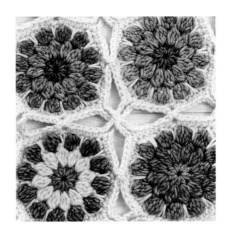

vintage bauble blanket

FINISHED SIZE

45″ × 55″ (114.5 × 139.5 cm)
before blocking.

YARN

#5 Bulky

SHOWN HERE: Scheepjes Stonewashed
XL (70% cotton, 30% acrylic; 82 yd
[75 m]/1.76 oz [50 g]): Main Color #841
Moonstone (A), 12 skeins; Contrast
Colors #860 Rose Quartz (B); #862
Brown Agate (C); #844 Boulder Opal
(D); #852 Lemon Quartz (E); #849
Yellow Jasper (F); #856 Coral (G);
#847 Red Jasper (H); #863 Cornelian
(I); #848 Corundum (J); #850 Garnet
(K); #851 Deep Amethyst (L); #858
Lilac Quartz (M), 2 skeins each.

HOOK

J-10 (6.0 mm).

NOTIONS

Tapestry needle.

GAUGE

First 3 rnds = 4″ (10 cm) in diameter.
Motif = 5″ (12.5 cm) in diameter.

notes

- This pattern uses Motif #19 (p. 34).

- The motif used for this blanket is designed to be joined as you go. When ready to join, use ch-3 sps to join adjacent sides, and ch-6 sps to join on the diagonal. I used a total of 12 contrast colors to make up the centers of the motifs, and 1 main color for joining. I chose colors at random for the centers of the motifs, but with regard for using approximately the same amount of each color throughout the project. One way to do this is to work all of the motifs one rnd at a time (i.e., make the starting rnd of all of the motifs first, add all of the second rnds next, etc.). You can then cycle through colors on each of the rnds across the motifs.

- I named this project "Vintage Bauble Blanket" as a nod to the vintage color palette. But if you like, you can experiment with more contemporary palettes, or even a rainbow of colors for the center of the motifs.

Instructions

Make 99 of Motif #19 (p. 34). Work all motifs from Rnds 1–3, then determine the order of your layout. Rnd 4 is worked the same for all motifs. Motifs will be joined as you go (JAYG) on Rnd 5 as follows:

First Motif
(upper left-hand corner of the blanket)

Rnd 5: Ch 1, sc in same st, sc in each of next 2 sts, *(sc, ch 6, sc) in next st, sc in each of next 5 sts, ch 3, sk next st**, sc in each of next 5 sts; rep from * around, ending last rep at **, sc in each of last 2 sts, join with sl st in first sc—48 sc; 4 ch-6 sps; 4 ch-3 sps. Fasten off D.

Second–Ninth Motifs
(first row of the blanket, working left to right)

Rnd 5: Ch 1, sc in same st, sc in each of next 2 sts, *(sc, ch 6, sc) in next st, sc in each of next 5 sts, ch 3, sk next st, sc in each of next 5 sts; rep from * twice, **sc in next st, ch 3, drop lp from hook, insert hook in corresponding ch-6 sp on previous motif, pick up dropped lp, ch 3, sc in same st, sc in each of next 5 sts**, ch 2, drop lp from hook, insert hook in corresponding ch-3 sp on previous motif, pick up dropped lp, ch 1, sk next st, sc in each of next 5 sts; rep from ** to ** once, ch 3, sk next st, sc in each of last 2 sts, join with sl st in first sc—48 sc; 4 ch-6 sps; 4 ch-3 sps. Fasten off.

Tenth Motif
(second row of the blanket)

Work same as second motif, joining to side of first motif.

Eleventh–Eighteenth Motifs
(second row of the blanket, working left to right)

Rnd 5: Ch 1, sc in same st, sc in each of next 2 sts, *(sc, ch 6, sc) in next st, sc in each of next 5 sts, ch 3, sk next st, sc in each of next 5 sts; rep from * once, **sc in next st, ch 3, drop lp from hook, insert hook in corresponding ch-6 sp on previous motif, pick up dropped lp, ch 3, sc in same st, sc in each of next 5 sts***, ch 2, drop lp from hook, insert hook in corresponding ch-3 sp on previous motif, pick up dropped lp, ch 1, sk next st, sc in each of next 5 sts; rep from ** once; rep from ** to *** once, ch 3, sk next st, sc in each of last 2 sts, join with sl st in first sc—48 sc; 4 ch-6 sps; 4 ch-3 sps. Fasten off.

Nineteenth–Ninety-ninth Motifs

Rep tenth–eighteenth motifs, joining 11 rows of 9 motifs each.

Finishing

Weave in ends and block as desired.

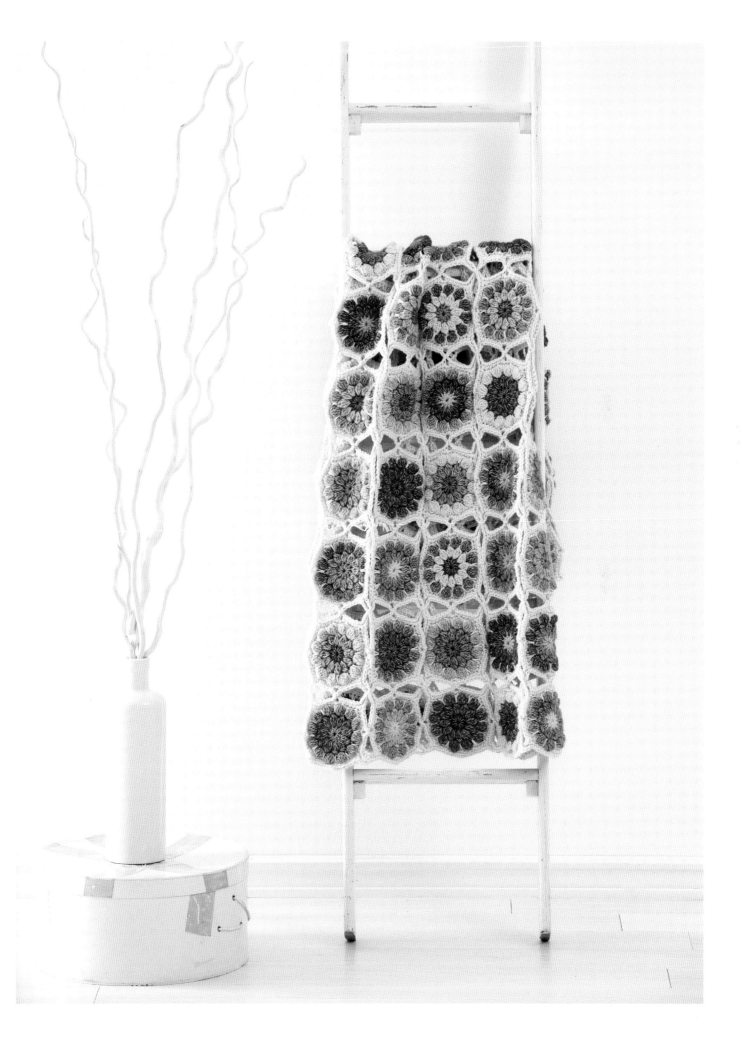

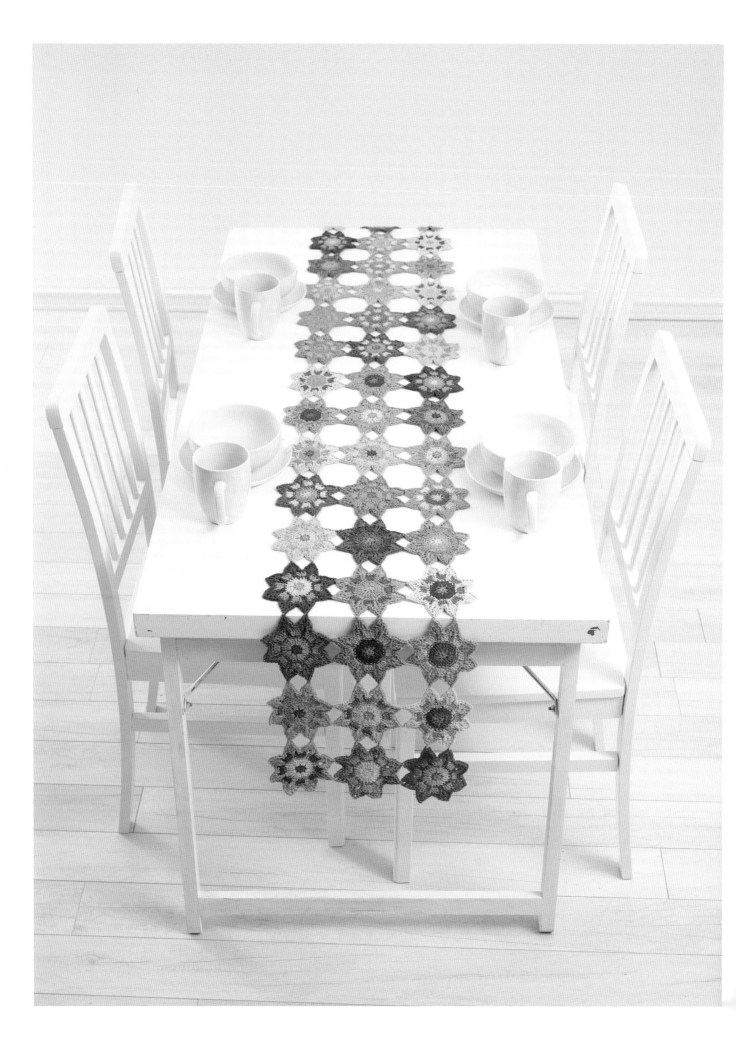

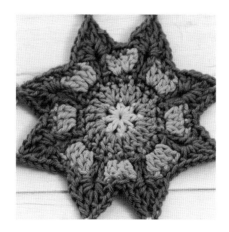

zinnia table runner

FINISHED SIZE
13½" × 85" (34.5 × 216 cm)

YARN
DK weight (#3 Light)

SHOWN HERE: Paintbox Yarns Cotton DK (100% cotton; 137 yd [125 m]/1.75 oz [50 g]): #434 Marine Blue (A); #440 Sailor Blue (B); #427 Slate Green (C); #412 Bright Peach (D); #417 Melon Sorbet (E); #418 Mandarin Orange (F); #429 Lime Green (G); #426 Spearmint Green (H); #454 Blush Pink (I); #456 Vintage Pink (J); #424 Mustard Yellow (K); #433 Washed Teal (L); #444 Raspberry Pink (M); #413 Tomato Red (N); #443 Tea Rose (O), 1 skein each.

HOOK
G-6 (4.0 mm).

NOTIONS
Yarn needle.

GAUGE
First 3 rnds = 2" (5 cm) in diameter. Motif = 5" (12.5 cm) in diameter before blocking.

note

- This pattern uses Motif #7 (pg. 21).
- The motif used in this project is designed to be joined as you go. When ready to join, use ch-2 sps to join adjacent motifs. I used 15 colors total and chose which to use for each motif at random, but with regard for using approximately the same amount of each color throughout the project. One way to do this is to work all of the motifs one rnd at a time (i.e., make the starting rnd of all of the motifs first, add all of the second rnds next, etc.). You can then cycle through colors on each of the rnds across the motifs.

Instructions

Make 54 of Motif #7 (p. 21). Work all motifs from Rnds 1–4, then determine in what order you would like your layout to be. Motifs will be joined as you go (JAYG) on Rnd 5 as follows:

First Motif
(upper left-hand corner of the runner)

Rnd 5: With RS facing, join C with a sl st in same st as join, ch 1, sc in first st, *sk next st, (dc, ch 1, dc, ch 1) around ch-9 sp of Rnd 3 and ch-3 sp of Rnd 4, (dc, ch 2, dc, ch 1) around ch-9 sp of Rnd 3 only, (dc, ch 1, dc) around ch-9 sp of Rnd 3 and ch-3 sp of Rnd 4, sk next st**, sc in each of next 2 sts; rep from * around, ending last rep at **, sc in next st, join with sl st in first sc—16 sc; 48 dc; 32 ch-1 sps; 8 ch-2 sps. Fasten off C.

Second and Third Motifs
(first row of the runner, working left to right)

Rnd 5: With RS facing, join C with a sl st in same st as join, ch 1, sc in first st, *sk next st, (dc, ch 1, dc, ch 1) around ch-9 sp of Rnd 3 and ch-3 sp of Rnd 4, (dc, ch 2, dc, ch 1) around ch-9 sp of Rnd 3 only, (dc, ch 1, dc) around ch-9 sp of Rnd 3 and ch-3 sp of Rnd 4, sk next st, sc in each of next 2 sts; rep from * 5 times, **sk next st, (dc, ch 1, dc, ch 1) around ch-9 sp of Rnd 3 and ch-3 sp of Rnd 4, (dc, ch 1, drop lp from hook, insert hook in corresponding ch-2 sp of previous, pick up dropped lp, ch 1, dc, ch 1) around ch-9 sp of Rnd 3 only, (dc, ch 1, dc) around ch-9 sp of Rnd 3 and ch-3 sp of Rnd 4, sk next st**, sc in each of next 2 sts; rep from ** to ** once, sc in next st, join with sl st in first sc—16 sc; 48 dc; 32 ch-1 sps; 8 ch-2 sps. Fasten off C.

Fourth Motif
(second row of the runner)

Work same as second motif, joining to side of first motif.

Fifth and Sixth Motifs
(second row of the runner, working left to right)

Rnd 5: With RS facing, join C with a sl st in same st as join, ch 1, sc in first st, *sk next st, (dc, ch 1, dc, ch 1) around ch-9 sp of Rnd 3 and ch-3 sp of Rnd 4, (dc, ch 2, dc, ch 1) around ch-9 sp of Rnd 3 only, (dc, ch 1, dc) around ch-9 sp of Rnd 3 and ch-3 sp of Rnd 4, sk next st, sc in each of next 2 sts; rep from * 3 times, **sk next st, (dc, ch 1, dc, ch 1) around ch-9 sp of Rnd 3 and ch-3 sp of Rnd 4, (dc, ch 1, drop lp from hook, insert hook in ch-2 sp of motif to the left, pick up dropped lp, ch 1, dc, ch 1) around ch-9 sp of Rnd 3 only, (dc, ch 1, dc) around ch-9 sp of Rnd 3 and ch-3 sp of Rnd 4, sk next st**, sc in each of next 2 sts; rep from ** to ** 3 times (*Note: On first repeat, insert hook in motif above; on second and third repeats, insert hook in motif to the left.*), joining to motif above and to the left, sc in next st, join with sl st in first sc—16 sc; 48 dc; 32 ch-1 sps; 8 ch-2 sps. Fasten off C.

Seventh–Fifty-fourth Motifs

Repeat fourth–sixth motifs, joining motifs in 18 rows of 3 motifs each.

Finishing

Weave in ends and block as desired.

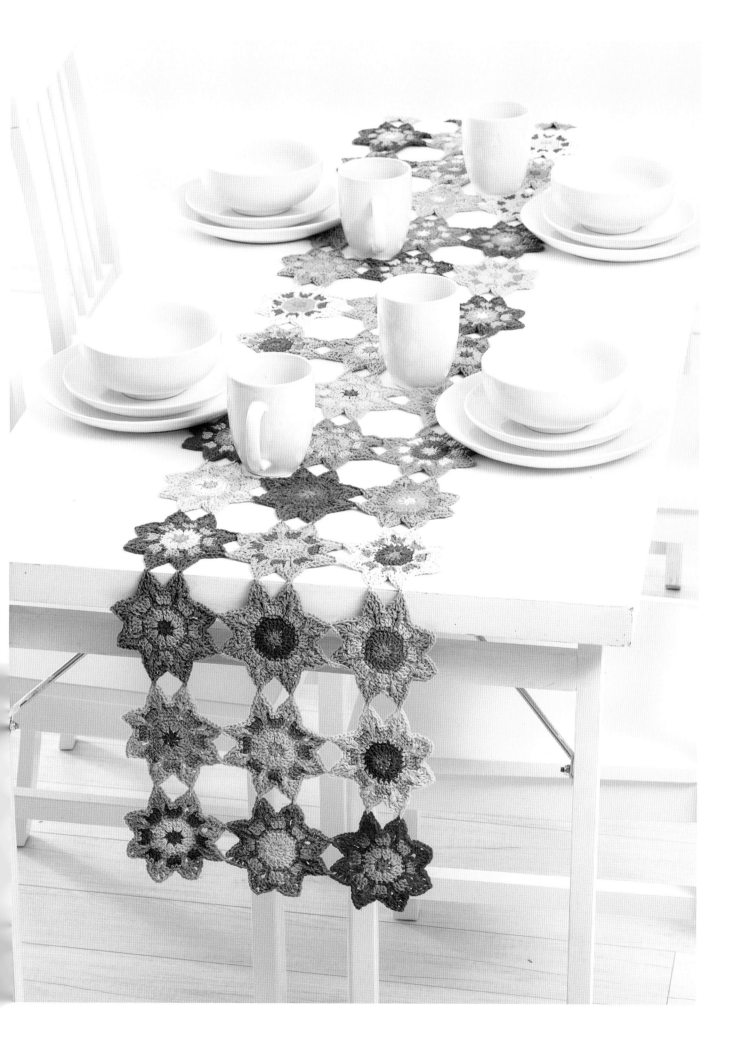

stitch key

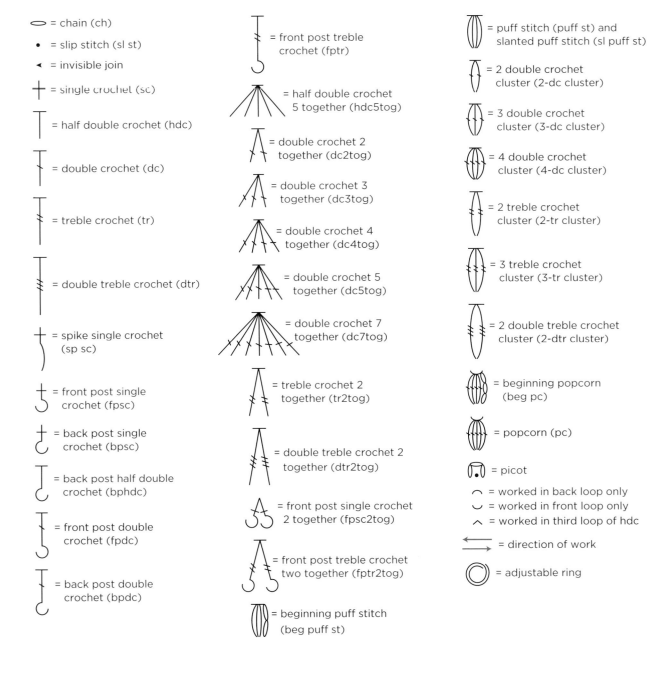

◯ = chain (ch)

• = slip stitch (sl st)

◄ = invisible join

✝ = single crochet (sc)

| = half double crochet (hdc)

✝ = double crochet (dc)

✝ = treble crochet (tr)

✝ = double treble crochet (dtr)

✝ = spike single crochet (sp sc)

✝ = front post single crochet (fpsc)

✝ = back post single crochet (bpsc)

| = back post half double crochet (bphdc)

| = front post double crochet (fpdc)

| = back post double crochet (bpdc)

⊤ = front post treble crochet (fptr)

⋏ = half double crochet 5 together (hdc5tog)

⋏ = double crochet 2 together (dc2tog)

⋏ = double crochet 3 together (dc3tog)

⋏ = double crochet 4 together (dc4tog)

⋏ = double crochet 5 together (dc5tog)

⋏ = double crochet 7 together (dc7tog)

⋏ = treble crochet 2 together (tr2tog)

⋏ = double treble crochet 2 together (dtr2tog)

⋏ = front post single crochet 2 together (fpsc2tog)

⋏ = front post treble crochet two together (fptr2tog)

❙❙❙ = beginning puff stitch (beg puff st)

❙❙❙ = puff stitch (puff st) and slanted puff stitch (sl puff st)

❙ = 2 double crochet cluster (2-dc cluster)

❙ = 3 double crochet cluster (3-dc cluster)

❙ = 4 double crochet cluster (4-dc cluster)

❙ = 2 treble crochet cluster (2-tr cluster)

❙ = 3 treble crochet cluster (3-tr cluster)

❙ = 2 double treble crochet cluster (2-dtr cluster)

❙ = beginning popcorn (beg pc)

❙ = popcorn (pc)

= picot

⌒ = worked in back loop only

⌣ = worked in front loop only

⋀ = worked in third loop of hdc

⟵ = direction of work

◎ = adjustable ring

glossary

BASIC STITCHES

Back loop: Work stitch(es) into the back loop only of the indicated stitch(es).

Front loop: Work stitch(es) into the front loop only of the indicated stitch(es).

Chain stitch (ch): Yarn over and draw yarn through loop on hook.

Slip stitch (sl st): Insert hook in next stitch, yarn over and draw loop through stitch and loop on hook.

Single crochet (sc): Insert hook in stitch, yarn over and pull up loop, yarn over and draw through both loops on hook.

Spike single crochet (sp sc): Working over previous row(s), insert hook in corresponding stitch in indicated row below, yarn over and pull up a loop to the height of the current round, yarn over and draw through 2 loops on hook.

Half double crochet (hdc): Yarn over, insert hook in stitch, yarn over and pull up loop (3 loops on hook), yarn over and draw through all 3 loops on hook.

Double crochet (dc): Yarn over, insert hook in st, yarn over and pull up a loop, [yarn over and draw through 2 loops] twice.

Double treble crochet (dtr): Yarn over 3 times, insert hook in stitch, yarn over and pull up a loop (5 loops on hook), [yarn over and draw through 2 loops on hook] 4 times.

Treble crochet (tr): Yarn over twice, insert hook in next stitch, yarn over and pull up a loop, [yarn over and draw through 2 loops on hook] 3 times.

Picot: Chain 3, slip stitch to 3rd chain from hook.

INVISIBLE JOIN

After making the last stitch of a round, cut yarn, leaving a 4″ (10 cm) tail, and pull through the top of the last stitch made. Using a tapestry needle or hook, pull yarn tail from front to back through the 2 top loops of the 2nd stitch of the round. Next, pull yarn tail from top to bottom through the center of the top 2 loops of the last stitch of the round. This will create a "false" stitch into which you can work in subsequent rounds. Weave in the remaining end.

DECREASES

Single Crochet

Single crochet two together (sc2tog): [Insert hook in next stitch, yarn over and pull up loop] twice, yarn over and draw through all 3 loops on hook.

Half Double Crochet

Half Double Crochet 5 Together (hdc5tog): Yarn over, insert hook in stitch, yarn over and pull up a loop (3 loops on hook), [yarn over, insert hook into next stitch and pull up a loop] 4 times (11 loops on hook), yarn over and draw through all loops on hook.

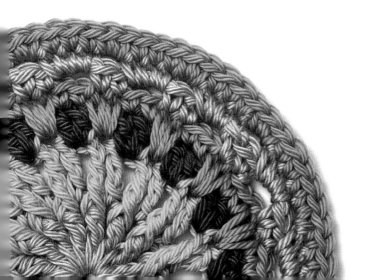

Double Crochet

Double crochet two together (dc2tog): [Yarn over, insert hook in next stitch, yarn over and pull up loop, yarn over, draw through 2 loops] twice (3 loops on hook), yarn over, draw through all 3 loops on hook.

Double crochet three together (dc3tog): [Yarn over, insert hook in next stitch, yarn over and pull up loop, yarn over, draw through 2 loops] 3 times (4 loops on hook), yarn over, draw through all 4 loops on hook.

Double crochet four together (dc4tog): [Yarn over, insert hook in next stitch, yarn over and pull up loop, yarn over and draw through 2 loops] 4 times (5 loops on hook), yarn over, draw through all 5 loops on hook.

Double crochet five together (dc5tog): [Yarn over, insert hook in next stitch, yarn over and pull up a loop, yarn over and draw through 2 loops] 5 times (6 loops on hook), yarn over, draw through all 6 loops on hook.

Double crochet seven together (dc7tog): [Yarn over, insert hook in next stitch, yarn over and pull up a loop, yarn over and draw through 2 loops] 7 times (8 loops on hook), yarn over, draw through all 8 loops on hook.

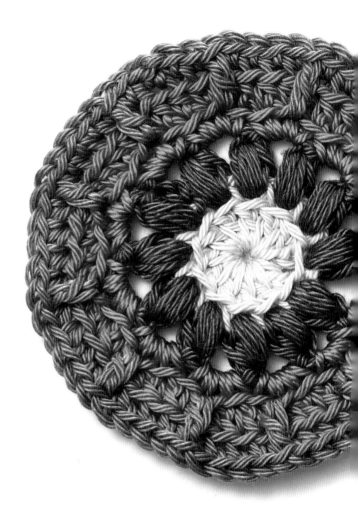

Treble Crochet

Treble crochet two together (tr2tog): [Yarn over twice, insert hook in next stitch, yarn over and pull up a loop, (yarn over, draw through 2 loops on hook) twice] twice, yarn over and pull through all loops on hook.

POPCORN STITCHES

Beginning popcorn (beg popcorn): Ch 3, work 4 dc in same stitch, drop loop from hook, insert hook into the 3rd chain of the initial ch-3, pick up dropped loop and draw through chain.

Popcorn stitch (popcorn): Work 5 dc in same stitch, drop loop from hook, insert hook into the top of the first dc, pick up dropped loop and draw through first dc.

PUFF STITCHES

Beginning puff stitch (beg puff st): Ch 2, yarn over, insert hook in same st, yarn over and pull up a loop (3 loops on hook), [yarn over, insert hook in same st and pull up a loop] twice (7 loops on hook), yarn over and draw through all loops on hook.

Puff stitch (puff st): Yarn over, insert hook in st, yarn over and pull up a loop (3 loops on hook), [yarn over, insert hook in same st and pull up a loop] 3 times (9 loops on hook), yarn over and draw through all loops on hook.

Slanting puff stitch (sl puff st): Yarn over, insert hook from right to left around post of the previous dc, yarn over and pull up a loop (3 loops on hook), [yarn over, insert hook from right to left around post of same dc and pull up a loop] 3 times (9 loops on hook), yarn over and draw through all loops on hook.

CLUSTER STITCHES

Double Crochet

Two double crochet cluster (2-dc cluster): [Yarn over, insert hook in st or sp, yarn over and pull up loop, yarn over, draw through 2 loops] twice in same st or sp (3 loops on hook), yarn over, draw through all 3 loops on hook.

Three double crochet cluster (3-dc cluster): [Yarn over, insert hook in st or sp, yarn over and pull up loop, yarn over, draw through 2 loops] 3 times in same st or sp (4 loops on hook), yarn over, draw through all 4 loops on hook.

Four double crochet cluster (4-dc cluster): [Yarn over, insert hook in st or sp, yarn over and pull up loop, yarn over, draw through 2 loops] 4 times in same st or sp (5 loops on hook), yarn over, draw through all 5 loops on hook.

Double Treble Crochet

Double treble two together (dtr2tog): [Yarn over 3 times, insert hook in next st, yarn over and pull up a loop, (yarn over, draw through 2 loops on hook) 3 times] twice, yarn over and pull through all 3 loops on hook.

Treble Crochet

Two treble crochet cluster (2-tr cluster): [Yarn over twice, insert hook in st, yarn over and pull up a loop, (yarn over, draw through 2 loops on hook) twice] twice in same st or sp, yarn over and pull through all 3 loops on hook.

Three treble crochet cluster (3-tr cluster): [Yarn over twice, insert hook in st, yarn over and pull up a loop, (yarn over, draw through 2 loops on hook) twice] 3 times in same st or sp, yarn over and pull through all 4 loops on hook.

POST STITCHES

Back-post single crochet (bpsc): Insert hook from back to front to back around post of corresponding stitch below, yarn over and pull up loop, yarn over and draw through two loops on hook.

Back-post half double crochet (bphdc): Yarn over, insert hook from back to front to back around post of indicated stitch, yarn over and pull up loop, yarn over and draw through all loops on hook.

Back-post double crochet (bpdc): Yarn over, insert hook from back to front to back around post of stitch to be worked, yarn over and pull up loop [yarn over, draw through 2 loops on hook] 2 times.

Front-post single crochet (fpsc): Insert hook from front to back to front around post of corresponding stitch below, yarn over and pull up loop, yarn over and draw through two loops on hook.

Front-post double crochet (fpdc): Yarn over, insert hook from front to back to front around post of corresponding stitch below, yarn over and pull up loop [yarn over, draw through 2 loops on hook] 2 times.

Front-post treble crochet two together (fptr2tog): [Yarn over twice, insert hook from front to back to front around the post of the indicated stitch, yarn over and pull up a loop, (yarn over, draw through 2 loops on hook) 2 times] 2 times. Yarn over and pull through remaining loops on hook.

For more crochet stitch information and how-tos, visit our online glossary at www.interweave.com/interweave-crochet-glossary/

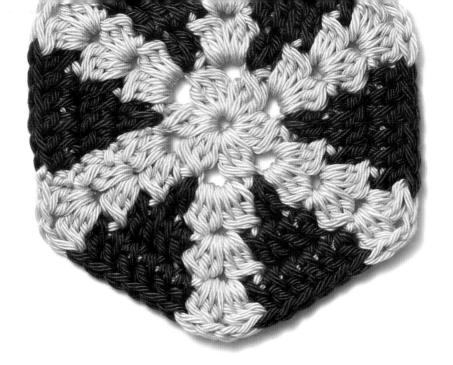

OTHER ABBREVIATIONS

beg	begin(s); beginning
blo	back loop only
cm	centimeter(s)
lp(s)	loop(s)
mm	millimeter(s)
patt(s)	pattern(s)
rnd(s)	round(s)
RS	Right Side
sk	skip
sl	slip
WS	Wrong Side
yo	yarn over hook
*	repeat starting point
**	repeat all instructions between asterisks
()	alternate measurements and/or instructions
[]	work bracketed instructions a specified number of times

METRIC CONVERSION CHART

TO CONVERT	TO	MULTIPLY BY
Inches	Centimeters	2.54
Centimeters	Inches	0.4
Feet	Centimeters	30.5
Centimeters	Feet	0.03
Yards	Meters	0.9
Meters	Yards	1.1

resources

ONLINE COLOR RESOURCES

Pantone app

This app can extract colors from photos, create palettes, help you identify harmonious colors, and more.
www.pantone.com/studio

Adobe Capture CC app

This app allows you to take a photo of anything that inspires you and extract colors from it to make palettes or use in other applications.
www.adobe.com/products/capture.html

Design seeds

This website boasts a pletora of pre-made color palettes you can browse by theme or color preferences.
www.design-seeds.com

Mosaic App

Many photography apps have options to create collage or mosaic images. I personally like to use Moldiv. This is a photography app, but it has a great mosaic feature.
www.jellybus.com/moldiv

YARN RESOURCES

Cascade Yarns

cascadeyarns.com

DROPS Yarns

garnstudio.com/yarns/

Hoooked Yarns

hoooked.co.uk

Paintbox Yarns

paintboxyarns.com

Scheepjes

scheepjes.com/en/

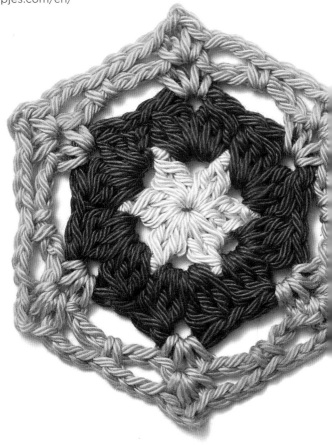

colorway
DETAILS

I used Cascade Yarns Ultra Pima (100% cotton; 218 yd [200 m]/3.5 oz [100 g]),
chosing from these colors, to create the 100 motif patterns in this book.

#3714 Burgundy	#3747 Gold	#3807 Jasmine Green	#3797 Dark Sea Foam
#3823 Tomato	#3764 Sunshine	#3762 Spring Green	#3774 Major Teal
#3755 Lipstick Red	#3748 Buttercup	#3760 Celery	#3775 Cool Mint
#3771 Paprika	#3743 Yellow Rose	#3763 Water Lily	#3736 Ice
#3750 Tangerine	#3746 Chartreuse	#3738 Spearmint	#3735 Jade
#3822 Vibrant Orange	#3739 Lime	#3761 Juniper	#3732 Aqua

#3733 Turquoise

#3726 Periwinkle

#3711 China Pink

#3729 Grey

#3734 Teal

#3778 Lavender

#3792 Brick

#3808 Light Grey

#3793 Indigo Blue

#3779 Pansy

#3701 Cranberry

#3798 Suede

#3725 Cobalt

#3704 Syrah

#3802 Honeysuckle

#3759 Taupe

#3800 Blueberry

#3703 Magenta

#3767 Deep Coral

#3717 Sand

#3772 Cornflower

#3710 Orchid

#3752 Coral

#3718 Natural

#3727 Sky Blue

#3776 Pink Rose

#3753 White Peach

#3728 White

#3805 Colony Blue

#3712 Primrose

about the author

Sandra Eng is a freelance crochet designer and color enthusiast living in Minneapolis, Minnesota. She learned to crochet after the birth of her first child, and she hasn't set her hook down since. Her work is featured in *Modern Crochet Mandalas*, published by Interweave, and magazines such as *Simply Crochet*. Sandra also practices as a licensed psychologist, and is a proponent of the therapeutic benefits of crochet and other fiber arts. You can find her patterns on her website, mobiusgirldesign.com, as well as on Ravelry and Etsy. Follow her day-to-day crochet exploits on Instagram @mobiusgirl.

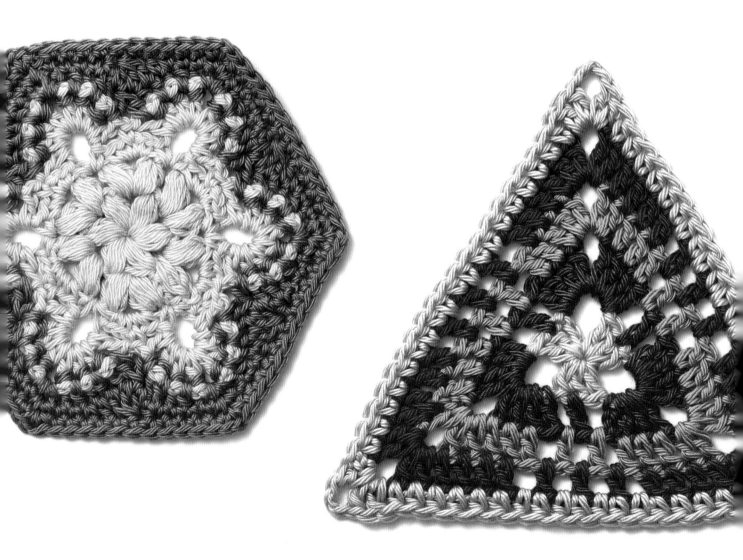

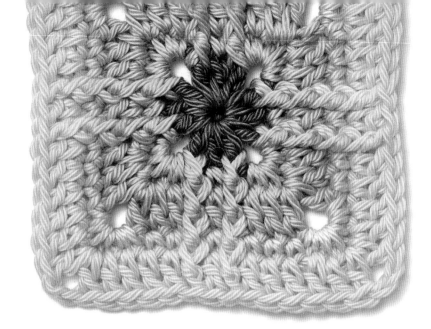

acknowledgments

Writing this book has been a labor of love. It's been fueled not just by my love of crochet and color, but also by others' love and encouragement of my creative process. There are so many people I have to thank!

First and foremost, thank you to all of the fabulous editors at Interweave, without whom this book would never have come to fruition. Thank you to Kerry Bogert and Stephanie White, acting acquisitions editors, for first proposing the project to me and believing in my capacity for writing an entire book. Maya Elson, my content editor, has been an invaluable partner in shepherding this book through the publication process. Thank you also to Karen Manthey, technical editor extraordinaire, for your painstaking editing and diagram creation skills.

When I consider my evolution as a crochet designer, there are also a number of people to acknowledge. I need to begin, of course, with my mom, Susan, who was my first and best crochet teacher. I never would have started this journey without your patient guidance (and perhaps understanding that learning to knit was beyond my capacity at the time). Thank you for your steadfast interest in and encouragement of my work. My dad, Tin, has also always been an advocate (even when he didn't know exactly what he was talking about). The entire Instagram community has been instrumental in honing my identity as a designer; thank you for your feedback, encouragement, and friendship. Although my Insta-friends are too many to name, Susan, Karyn, Kelly, Marianne, Marit, and Mandy have provided so much inspiration and support. When I have found myself mired in self-doubt or uncertainty, Krista has always been there with a hand to guide me out of the depths. Thank you for your unwavering support and presence, and your affirmation of my development as a designer.

My children learned at a young age that I am happiest with a hook in one hand and yarn in the other. Thank you to Bryson for your shared love of color and creation, your technical edits of my chapter on color, and your willingness to talk at length with me about the creative process. Adeline, your burgeoning love of "yarn bombs" and desire to share in my love of all things fiber-related have been heartwarming beyond belief. Thank you to both of you for your help in choosing colors for some of the motifs in this book!

I also want to say thank you in advance to the readers of this book. It is through shared interest and engagement that we construct a crochet community that spans the entire world. May we all continue to delight in each other's creations. Crochet on, fellow fiber lovers!

ALSO AVAILABLE FROM INTERWEAVE